ROTATION PLAN

FRED'S WAR

FRED'S WAR

ANDREW DAVIDSON

SHORT BOOKS

First published in 2013 by Short Books
3A Exmouth House
Pine Street
EC1R 0JH

10 9 8 7 6 5 4 3 2 1

A CIP catalogue record for this book is available from the British Library.

ISBN 978-1-78072-181-1

Printed and bound in the UK by CPI Colour.

Cover and text design by Two Associates

For Rosa and Ivor, and all we have lost.

CONTENTS

I never knew my grandfather. He died two days after I was born and was, by all accounts, a conscientious, hard-working doctor, proud of the general practice he built up and the sons he raised who all took careers in medicine.

He never talked about the wars he fought in and the friends he lost. But he did pass down the items that now sit in front of me: three photographic albums and a set of binoculars monogrammed FCD. He also left a framed collection of medals – now replaced by replicas, the originals having been lost to the family.

The albums, containing 250 photographs, cover the period 1914–15, when the young Frederick Davidson was a 25-year-old medical officer with the 1st Cameronians, part of the British Expeditionary Force that sailed across the English Channel to fight the Germans at the start of World War One. The pictures, which end abruptly in April 1915, are all the more remarkable for being taken at a time when it was forbidden, under Army orders, to use a camera while serving at the front.

This is their story.

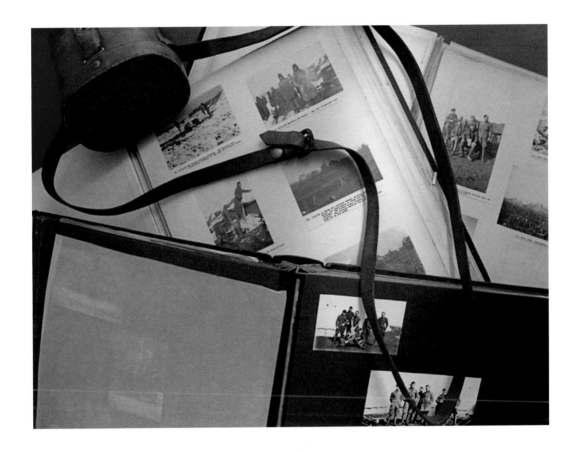

PROLOGUE

It is a fine ship that takes them – some 500 feet long, double-funnelled, twin-screwed, built to carry 1,450 passengers on the New York run. The SS *Caledonia* has been requisitioned by the British Army from its owner, Anchor Line in Glasgow, and now sails from Southampton, making the short hop to Le Havre which nightly brings the British Expeditionary Force to France. Scottish-built and Scottish-filled, it is crammed with the men of 1st battalion Cameronians that Friday night in August 1914. The soldiers have spent a day hunkered onto four trains moving slowly down from the north, and they sail to fight, but have little clue what awaits them.

For months before, the whisper in the mess at Glasgow's Maryhill barracks has been Ulster, not France. That has not sat well with the men of the famously Presbyterian regiment who worry they will have to fight Ulstermen protesting against Irish Home Rule. Some would have flatly refused. Others might even have joined the renegade force being raised by Sir Edward Carson, leader of the Ulster loyalists.

Facing the Germans, who have already pushed into Belgium, is more to their liking. They know the German Army is three million strong, superbly equipped, and rarely beaten, but the British Army is a professional unit, built around a core of long-serving officers and men. It is standing side by side with the vast French Army. They fancy their chances. They also understand why they are there, stopping the Germans from shutting the English Channel and turning off the tap of trade on which the great British Empire depends. They just wonder where and how the forces will meet.

Few sleep, despite the long 24 hours of travel behind them. The ship slips through the sea with lights out, no smoking on deck, in case a German attack surprises them. Officers take cushions and sit out in the inky night, lost in their thoughts, watching the searchlights playing along the English coast as it fades from view. Then they wait for the first signs of France, grateful they have got a proper ship to settle in – other battalions are not so lucky.

The ranks are left below. Many had seen service with the regiment in India and South Africa, so travel is nothing new. They are the toughest of men, hard-drinking, foul-swearing, utterly loyal to the regiment – drawn

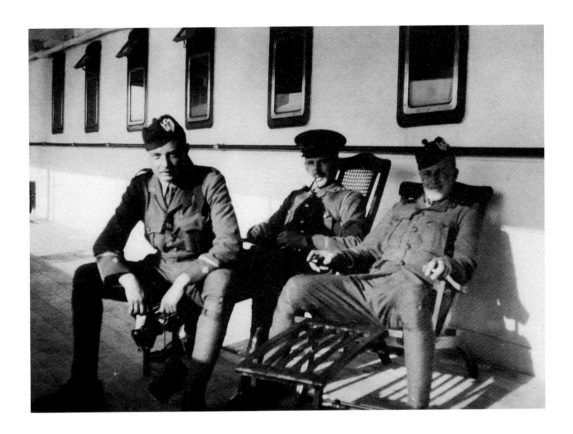

from Lanarkshire coal mines and Glasgow slums, but including Geordies and Cockneys too. Some are old hands, reservists called in at a time of need, pleased to see familiar faces, exhausted from three weeks of fitness training. All have had a nervous laugh at Kitchener's Guidance to British Troops, the leaflet thrust into their hands before departure.

In this new experience you may find temptations both in wine and women. You must entirely resist both temptations, and, while treating all women with perfect courtesy, you should avoid any intimacy.

Somewhere the battalion's young medical officer, always thorough, always remembering, checks his supplies again. He is anxious about his position among new friends, anxious as he has never set foot abroad before, and curious about what is coming.

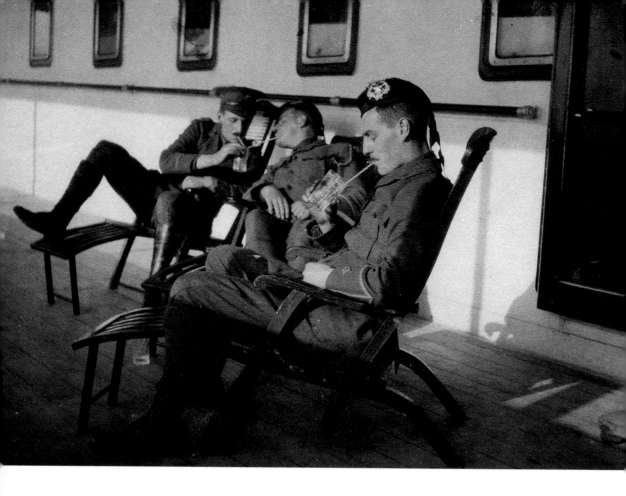

Yet he is also a man apart – a medic in a band of old sweats – used to making his own way. His father is a preacher of many words. He will be a doctor of few. His mother has gone now, but is always there, nudging every step.

And as ever, a camera is wedged deftly among his surgical equipment. It had been out earlier, as he larked on deck with fellow lieutenants, waiting for the sun to slip down, sharing lemonade on the ship's loungers, playing up for snapshots. Photography in the coming war is expressly forbidden – in case pictures offering valuable information fall into the hands of the enemy. But the battalion runs to its own rules, and like young men stretched across the new century, these officers devour the latest technology: the Ansco and Kodak folding cameras, the Royal Enfield motorbikes, the new Ford automobiles rolling off production lines in Manchester. This is the age of invention, and more than one camera is carried illicitly on board that night.

Photographs offer an opportunity to show they have made their mark – providing they have a commanding officer happy to turn a Nelsonian blind eye. For every man worries that they won't have time to make an impact. Germany versus Russia in the east, simultaneously taking on France and Britain in the west, is a recipe for a very short war. The maps they packed at Maryhill were not just of Belgium and France, but northern Germany too. Who would know they had been there, if they didn't have photographs to prove it?

So the ship steams on, all aboard oblivious to what lies ahead. It docks in Le Havre at 6 am the next day, disgorging its khaki load onto the now rainy French quayside, winching the battalion's heavy horses one by one over the side. And two years later the SS *Caledonia* is sunk by a German U-boat 125 miles east of Malta.

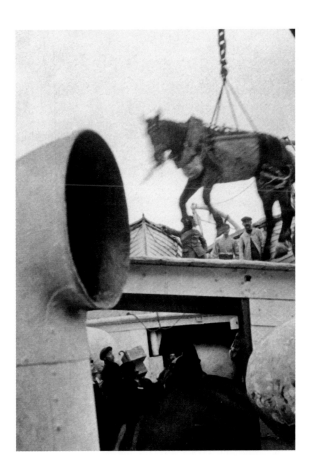

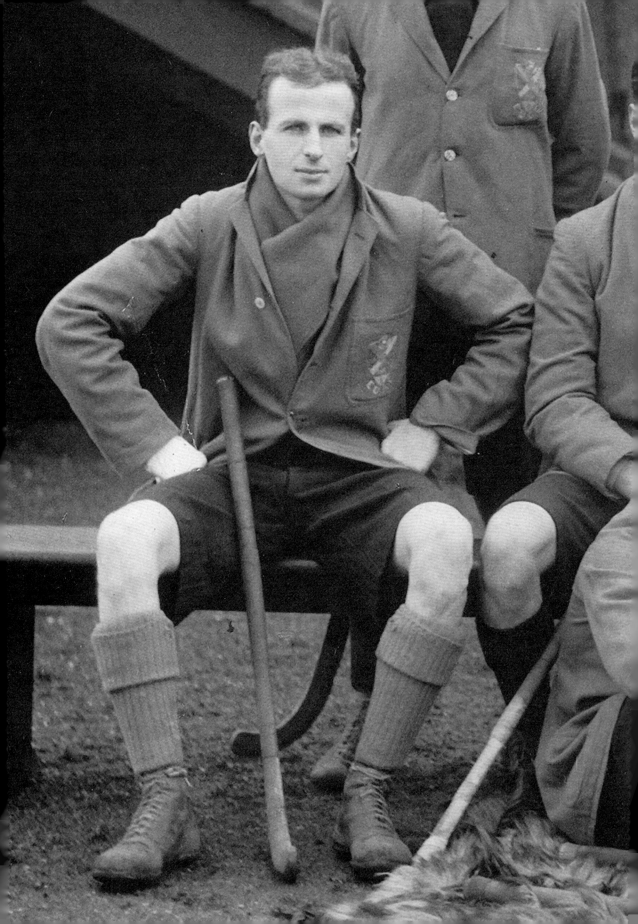

1

AS IT WAS IN
THE BEGINNING

Davidson fed the centre forward well, playing a good
game, though he should try not to give so much advice.

– REPORT ON FIRST TEAM HOCKEY, EDINBURGH
UNIVERSITY V NORTHERN COUNTIES, DECEMBER 1910,
THE STUDENT MAGAZINE.

FRED DAVIDSON sits and listens. His father's words, then the wheezing of the organ, then the gusts beyond and the battering of the old oak doors, bang, bang, bang, as if the wind envies them their shelter. The congregation waits, wrapped in the minister's sermon, oblivious to the elements. Easter is coming but there is still snow on the ground outside. In the manse along from the kirk the same gale shakes the long sash windows. Heavy curtains sigh in the draught, great piles of coal shipped up from Midlothian are shovelled onto fires.

But here, in the family pew, only your brother warms you. The kirk is an act of defiance, perched on a cliff, battered by wind, rooted into red sandstone, steeply steepled and visible for miles from land and sea, a beacon for man on horse or boat. Outside it is circled by gulls and crows, buffeted by the North Sea gales that blow so very cold from Norway. Inside Fred sits with Ned, Rex and Harry around him, with them but set apart, by his uniform, by his schooling, by his life away from the manse and St Cyrus, with its village intrigues and tough, edge-of-the-world stoicism. Only Bertie and Jack, his elder brothers, are absent – Bertie away with the Royal Army Medical Corps, and Jack out west, in Alberta, Canada, for nine long years. These sons of the manse all miss Jack, sent away as a cure for rheumatic fever, and destined never to return. They yearn for him to come home, none more so than their father.

He is in the pulpit now, addressing the congregation. The kirk, 50 feet long and 40 feet wide, balconied and tightly pewed, can fit 300, and the Reverend Robert Davidson may get that on the grand days, high days and holidays. Today, a cold March Sunday in 1914, with snow still flecking the ground, the crowd is sparser. They are not great singers, but they come to listen. Reverend Davidson can preach. His forehead domed, his hair greying, his moustache now bushy, he has stood in that pulpit since 1884 – 30 years of ministering to one parish, overseeing one school, christening and marrying so many, there is little he does not know about his people.

And his is a speaker's church, dominated by pulpit, plainly undecorated with white walls, pine panelling and named pews, long, clear Gothic

windows pointing like fingers to the sky. Ahead, no cross hangs, but a silver-piped organ sits centred on a small stage, pushing up to the blue ceiling, the altar table before it, the congregation set out in rows 12 deep to the back, and six deep above, with a sightline leaving the preacher visible from every seat.

Fred has known this Mearns kirk for 25 years, his whole life, and heard gales at the door for as long, felt their force in honing the very character of the assembly: stoic, determined, persistent, unemotional, unforgiving. Some work the land, others net for salmon, all start at the village school built beside the kirk. The children of the better-off then take the short rail trip to affluent Montrose for its Academy. Except Fred, plucked away, and sent to Edinburgh, 100 road miles south. School, university, medicine, army, away from his brothers. His father finishes:

–We will now sing, "There Is A Green Hill Far Away".

The great organ starts, the small choir stands, the congregation follows. Fred can remember his mother playing the harmonium, then came the organ, part-paid by a Carnegie gift, the rest raised by worshippers who wanted to see what they had bought, not tuck it away to the side, so there it is, multipiped, raised on a dais, centre-stage behind the humble altar table. No cross. Just an organ, with a professional organist, paid by the kirk, and a bassy timbre, rumbling over the hymn's stalking introduction, up and down that hill. Then they sing.

There is a green hill far away,
Without a city wall,
Where the dear Lord was crucified
Who...

Five months since his mother died. Fred can see his father is still bereft, his brothers too. Harry, the youngest, 20 now, what will become of him? Ned and Rex will be ministers, because Bertie, Jack and Fred weren't. Harry is down for medicine, but has a wild streak, he's still the boy who rides the steam train to Montrose on top, jumping from roof to roof to impress his friends. He won't stick it. Maybe impending war will offer a solution.

We may not know, we cannot tell
What pains he had to bear

Reverend Robert watches his boys as they sing. Fred, hair swept back from his high forehead, so confident in his lieutenant's uniform, new moustache

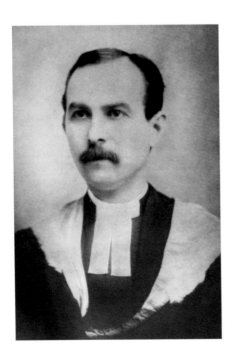

bristling. Ned, Rex and Harry around him, standing proudly. He sees little of himself in Fred now, the brightest of his bright boys, sent away on a special scholarship to Fettes aged 10 at Susan's insistence. It was a different boy who returned each holiday, grown apart, Anglicised, above the scrum, becoming a man who watched his words but always knew best. His brothers quickly nickname him God Almighty Davidson.

Robert is guilty of that too, proud of his son, compact, wiry and strong, but resentful that he has lost him. He jokingly calls him Thomas, after Randall Thomas Davidson, the Scot who became Archbishop of Canterbury in 1903 – another lost to the true Presbyterian church. It is meant in affectionate tease, but it sticks.

Robert Davidson has made his own jump, the

son of an industrious Kineff carpenter, brightest of a brood, prize-winning pupil at Aberdeen Grammar, star student at Aberdeen University, then teacher, then bachelor of divinity at Edinburgh University, then out to the parishes. He has married a minister's daughter, Susan Cunningham, whose father is shortly to become principal of St Andrews' divinity college. The Cunninghams are a family with intellect, money and connections – Robert is seemingly destined for the top. And then?

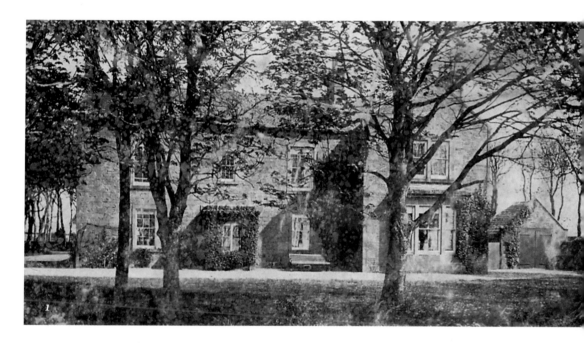

He stops when he reaches St Cyrus. He has children, six boys, born between 1886 and 1893, and there is talk later of a stillborn daughter – though he and Susan never discuss it with others. The parish comes with a fine, five-bedroomed manse [1], ringed by stout, free-seeding sycamore trees, perched on the cliff, 200 feet over the village's vast, white sandy strand [2]. Beside the house Robert builds a beautiful fruit garden bounded by sandstone walls, where he digs and plants in his abundant spare time.

He holds one service a week at the kirk. He oversees the village school. He pays out the gift to Dowry Brides – a bequest left to the parish by a benevolent bachelor which divides the annual interest among the tallest, shortest, oldest and youngest brides each year. He works methodically around his parishioners, often knocking on doors if kirk attendance has

been missed, and has plenty of time for his scholarship, writing in his book-lined sitting room overlooking the bay to Montrose, watching its fleet piled high with sailcloth and linen setting out for the Baltic. He gets on well with the Porteous family, leader among St Cyrus's heritors and related to his wife Susan – her mother was a Porteous. They contribute to his £292 stipend and pay for the schoolteacher and keep their own mausoleum in a ruined chapel amidst the kirk's graveyard.

In short, the genial, patient, scholarly Reverend Robert takes root, because conditions are ideal, and maybe he is too proud to chase a post at more prestigious kirks. He even befriends the minister at St Cyrus's rival, independent church, just a short walk from his own. He is in love, with a place and its people. On a summer's day, when the wind drops, and the sun cuts through the briny air to bathe his defended garden in warmth – yellow beach, green sea, blue sky, walled abundance – it is as close to heaven as you can get. And he never moves, for 52 years.

For Susan Cunningham, whose father John later becomes Moderator of the Church of Scotland, whose brother Daniel becomes one of Britain's pre-eminent medical academics – author of the world-famous *Cunningham's Manual of Practical Anatomy* – whose nephew Andrew, long after her death, goes on to be Admiral of the Fleet, it is perhaps a very different life to the one she expected. She is a striking figure, full-bosomed, strongly featured, hair pulled back, confident in manner and industrious by instinct. She turns the manse into a functional, friendly home, with a large dining room downstairs, an elegant sitting room upstairs, the boys sharing bedrooms overlooking the sea, taking the 15-minute train-ride to Montrose and school every day. There is a cook, a maid, and garden help, and the parish's sick and old to visit. Susan also works tirelessly to raise money for the kirk, which is always deteriorating, abraded by every storm. Her bazaars, opened by dignitaries, packed with varied stalls, help fund the new organ in 1902 and a major renovation in 1905.

But most of all, she has her boys, and the power that any mother of many sons will have. They, in turn, are devoted to her, and have a steady home to grow up in, often full of visitors, with dogs, boats and bicycles, beach games in the summer and sledging through the freezing, windswept winters. Susan spots Fred's gifts at an early age, his ability to learn by heart long screeds of text, not just from psalms and hymns, but Sir Walter Scott's *Ivanhoe* and *Waverley*, his tinkering with bikes and machinery, his nimble fingers pulling apart Victorian gadgets. All her sons are clever, but Fred is cleverer still, with faculties highly prized by an education system that values learning by rote. When her brother Daniel points out that Fettes, Edinburgh's fashionable, English-style boarding school – opened in 1870 – is offering bursaries to the brightest of ministers' sons, she pushes Fred forward. He is already attending Montrose Academy with Bertie and Jack, but off he goes, the only child of six brothers sent away to board.

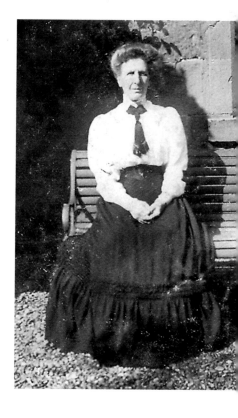

At least, being away, the pressure is off. To grow up a son of the manse has its own stresses, the constant watching, the expectation, the reports back to your parents, the insistence that you are first in church, freshly scrubbed, shoes shined, every Sunday, setting an example. The Davidson boys are playful as puppies on their own, but brought up to be careful in front of others, not to complain, rarely to reveal their feelings, to put on a good front when the world is watching. Every Sunday a minister's wife will hear the question:

–I didn't see your son this morning, is all well?
–Aye, but he is away ...

At Fettes, Fred is always away, and entering a world far broader than his small Kincardineshire village.

Fred arrives at Fettes aged 12 in September 1901. His certificate of admission notes that Frederick Churchill Davidson was born in January 1889, has twice been vaccinated, never suffered smallpox or scarlet fever, had whooping cough in 1898 and measles in 1899, but is in general good health. He enters a school that is confidently different – a bizarrely turreted fortress in style, blending Scottish baronial with French Gothic architecture. It sits on a hill north of Edinburgh, huffing with assertive disdain at the classical New Town spreading slowly towards it.

It is also determinedly English in influence, melding an emphasis on rugby, learning and duty with Oxbridge-educated teachers and a purposeful sense of its own mission, ascetic yet kindly. It has seen only two headmasters since its foundation, and refuses to employ clergy. Great English literature is read, but not taught. Fettes prioritizes Greek and Latin – as do the English universities – yet is becoming more adept at the sciences. Edinburgh, the Athens of the North, has a university that for a century has outstripped Oxford and Cambridge at medicine. It sits on the other side of New Town, within the city's medieval heart, and Fettes is slowly increasing its influence there.

Fred is set apart even in school, joining the house for Foundationers, where boys are necessarily from less well-off families. He sleeps in a cubicle, tongue-and-groove partitioned, one of many in icy, long dormitories. He wakes to a hip bath of cold water, and integrates quickly into a brutal fagging system that knocks out any quirks. Up at 7 am Monday to Saturday, down to make cocoa for prefects, brief chapel, breakfast, lessons, the whole school assembled for lunch in the dining hall, then games all afternoon, either inter-house or against rivals Loretto, Merchiston and Edinburgh Academy. If weather is bad, a run is organized to the third milestone on Queensferry Road and back. Tea at 6 pm, then prep. Sleep for the young ones from 9 pm. Four Sundays a term pupils are permitted "up-town" to visit family. Otherwise they are marched to church – St Stephen's in St Vincent Street for the Presbyterians. Episcopal Holy Trinity at Dean Bridge for the Anglicans. And then back.

As a Foundationer, Fred is surrounded by the sons of ministers and widows, deemed worthy of the school's support – "poor boys" to the fee-payers, privileged to outsiders, walking out in their bumfreezers and top hats, learning to be gentlemen. Most are Scottish, others from families living south or abroad. Regardless of background, it is a generation immersed

in the new mechanical age, obsessed with the arrival of motor cars, motorbikes, cameras, machine-guns and ongoing attempts to build a flying machine. As yet, there is no Officer Training Corps – only introduced in 1908 – but many are set for the Army, and take gym instruction from a veteran of the Crimean War, full of stories. They know what is expected, how to take orders, how to lead, how to suffer for King and country, how never to brag, never to let down your brothers ... and Fred thrives. By the time he leaves aged 18, gaining a Governors' Exhibition to Edinburgh University, he is in the top set of most subjects, adept at Latin, Greek and Maths, less good at French, but brilliant at Chemistry. He is also the hockey team's fast right wing.

At home in St Cyrus, the family is dispersing. Fred left for Fettes in 1901, Bertie for St Andrews University in 1905, Jack for Canada in 1906, after a battle with rheumatic fever. His condition, presumed to be worsened by damp and cold, calls for a drastic solution, so Robert and Susan send him to a friend of the Cunninghams in the high, dry plains of Alberta. There new towns are being hewn out of North America's wilderness and business is booming. Jack, who had started training in Edinburgh to be a banker, soon finds work as a bookkeeper. He has followed the trail of Scots looking for a better world in the west. It is a two-month journey that discourages a hasty return.

In his baggage Jack carries a number of battered photographs taken by his brothers with their first Box Brownie camera. The device, launched in America by Eastman Kodak in 1900, has become a runaway success across

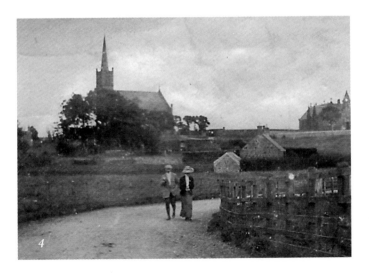
4

Europe. The Davidson boys, eager participants in this new technology, are soon developing their own prints. Jack has photos of his home, his village, his mother and his brothers. One captures the view from St Cyrus station to the church and school, the unpaved road curling right towards the manse, a view Jack saw every day returning from Montrose [4].

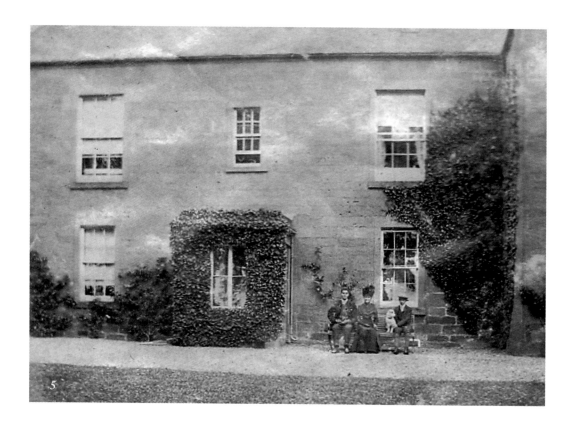

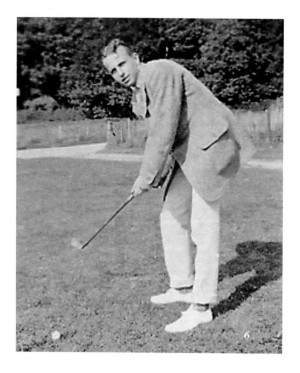

In another, Susan sits informally on the bench beside the front door, in white shirt and full skirt, looking stern but so anxious [3]. In a third she is smiling, buttoned up stiffly in jacket and hat, off to another kirk event [5]. Edwin, 15, sits chunkily to one side of her. On the other sits Rex, a year younger, nicknamed Skipper after his love of boats. Behind them, poignantly, the home is still full of life, the windows open, blinds half down, rooms beckoning, ready for Jack to walk back into.

Jack also carries a picture of Fred, aged 17, practising his favourite sport, golf [6]. His younger brother has an

eye for a ball, and the coast below St Cyrus is peppered with links courses – Carnoustie less than 30 miles to the south, Royal Montrose on his doorstep. Fred poses mid-drive, white trousers rolled, pockets of his tweed jacket bulging. It looks a size too big, another hand-me-down from brother to brother.

Fred follows Bertie's lead in reading medicine. At Edinburgh that puts him under the eye of his uncle, Professor Cunningham, head of the university's medical school and himself a son of the manse. Fred starts a five-year course, taught by many of Europe's finest doctors and scientists: Sir Edward Sharpey-Schafer, founder of endocrinology; Sir Isaac Balfour, co-creator of the Edinburgh's botanic garden; Sir Halliday Croom, pioneer of clinical teaching in maternity hospitals; James Ewart, famed for his experiments in animal cross-breeding; William Greenfield, inventor of the first vaccine against anthrax; Alexis Thomson, author of the widely read *Manual of Surgery*; Charles Hunter Stewart, pioneer in public health; Cargill Knott, renowned expert in seismology; Sir Henry Harvey Littlejohn, the forensic surgeon whose father had taught Arthur Conan Doyle – another Edinburgh student – and inspired Sherlock Holmes.

Fred's world is a long way from St Cyrus now. Edinburgh's bankers and accountants have made the city rich, underwriting the British Empire and lending to the rail companies opening up America. Their profits have paid for electricity and main drains, telephones and buses, dining clubs and intellectual societies, wide modern streets, grand homes and a sense of Scottish pride to add to the history of academic achievement. Fred takes student digs in Ramsay Lodge beside Edinburgh Castle and befriends a doctor's son, Dick Fawcitt, who marvels at the Davidson ability to retain information. Fred can recite whole passages from his uncle's lectures as a party piece, impressing fellow students, male and female.

Professor Cunningham's fame gives Fred a fillip too, and his home in Haymarket's elegant Grosvenor Terrace, built 35 years before, just 10 minutes' walk from Ramsay Lodge, offers regular dinners. That winter of 1908 he sups with his uncle every month, and they talk.

–Let me show you this.

One evening Cunningham passes a small brown album to his nephew. He watches as Fred starts to turn the pages, studying the photographs inside.

They depict individuals, places, battlefields, hospitals, tent cities and medical wagons, all part of a tour of South Africa the academic had made as part of a Royal Commission investigating medical services in the Boer War. The fighting had exposed the Army's lack of investment in training and equipping military doctors – a factor in the Crimean War too – and by the time Fred arrives at Edinburgh University, his uncle is heavily involved in overhauling the system.

They have eaten well, and returned to the parlour to discuss the profession of medicine, and inevitably, Fred's own future. Cunningham, lean and thoughtful, sports a moustache whitened with age, and winces as he sits, victim to nagging pains. At 58, he works with the fervour of a man who believes he is running out of time. As well as heading Edinburgh's medical school, the most prestigious in Britain, and editing his *Manual of Practical Anatomy*, the first editions of which have made him renowned, the professor has thrown himself quite willingly into Army affairs, sitting on a committee looking at standards required for recruits, as well as helping to establish medical services for territorial soldiers in Scotland.

Cunningham's photo album, kept as an aide-memoire, shows the better-ordered aftermath of war, not its carnage, but he has brought it out with a purpose. His nephew, after a careful flick through the pages, is back to the beginning, and the inside front inscription:

Royal Commission on Medical Services in War in South Africa 1900. DJC was a member of the commission.

–What was it like?
–Hot, says Cunningham with a rueful smile. And a long boat journey.

But, he continues, it was the start of significant change. He believes that, with ongoing reforms, the Army will offer doctors a good living in an uncertain world. For Fred, bright enough to be an academic but perhaps the least outgoing of his nephews, it may be a route to a career.

–The problem is this, says Cunningham, who likes to list his points. The most able graduates from medical schools have been avoiding Army doctoring as the pay is poor, the system of rank is out of step with regular officers, and the opportunities to study are poorly provided.
–So how do you keep abreast of new findings?

–You don't. The Army simply hasn't thought medicine is important enough to take seriously. That is now changing, but in truth, many combatant officers find the idea of study unmanly. They do not attend university. Sandhurst has many strengths, but academic achievement is not one of them.

Fred watches the fire, already ramped high with coal. The pictures in his lap of the sandy, sun-scorched veldt seem a world away, yet carry the clues to his future. His uncle continues.

–What the Royal Commission achieved was a recommendation of remedies. You can now judge how successful those recommendations have been. We are seeing a reform of Army medical services, and an enlarging of the Royal Army Medical Corps. You don't have to think of your future yet, but it is a possibility.

Fred turns a page and focuses on the photograph of a shack with the nameplate "Ayrshire Ward", somewhere gritty with heat, uncaptioned, very far from Ayrshire itself. Is this what he wants? Traipsing around behind the soldiers, patching up their brawl wounds, salving their sexual diseases, offering remedies for the drinking-till-they-drop?

Yet it is a career, and an income, and it offers status and respect, especially as the threats to Empire grow day by day. His 25-year-old cousin Andrew, Uncle Daniel's second son, is already rising fast in the Navy, commanding a torpedo boat, the most exciting of the fleet's armada of new vessels.

–Think about it, reaffirms Cunningham, smiling. The Army is changing. It will have better recruits, more money for training, it is a new world, one of science and machines and a greater reliance on learning.

Fred nods, unconvinced. But by the time Cunningham dies of cancer in 1909, his influence has persuaded elder brother Bertie to look beyond hospital work and join the RAMC in 1910. For a family with many sons and constrained resources, the path offers financial security. For Fred, it will be a serious option too.

By then, he is already involved in Edinburgh University's new Officer Training Corps, which holds regular summer camps for student medics at Aldershot. There he can get a first taste of field hospital work, and

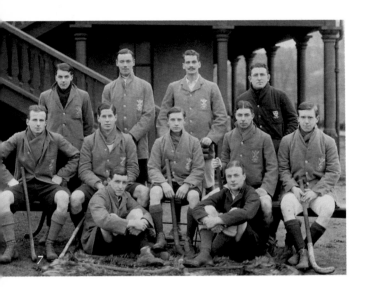

the Army's inevitable love of manoeuvres. Sardonic reports in Edinburgh's Student magazine suggest not everyone was convinced of their efficacy:

Work with the regulars was very interesting, and gave one an extremely good idea of real warfare, as we simply marched backwards and forwards along the roads, pitched and unpitched an ambulance station when ordered, and did our own little bit with booming guns and cracking rifles all round, but in absolute ignorance of what was happening elsewhere.

The same magazine also runs regular sports updates. By 1910 Fred is the star winger for the university hockey team, fast, diligent and dexterous. The report on the team's 3-1 win over the Northern Counties in December that year remarks on the reliability of Fred's passing to his centre forward, and his insistence on knowing what's best.

The team photograph for that year shows as much, Fred sits far left, arms akimbo, hands impatiently on hips, wanting to get on with it [7]. His jacket is missing most of its buttons and held together with a pin. He would probably be happier taking the picture himself.

* * *

So the organ wheezes, the congregation takes an intake of breath, and up that hill they go, ready to roll down again, through that last verse of obligation, duty, and ambition.

Oh dearly, dearly has He loved,
And we must love Him too,
And trust in His redeeming blood,
And try His works to do.

The hymn closes, the worshippers shuffle, then kneel and pray. Reverend Robert Davidson bows his head. Fred, deep in thoughts of his uncle, his mother, his brother, all gone or away, bows his head too. By the time he is kneeling there, that Sunday in 1914, he has made his choices, and others have been made for him.

He is 25, he has been a lieutenant in the RAMC for nearly a year, he has trained in Aldershot, London and Glasgow, and he has been assigned to a battalion, the 1st Cameronians (Scottish Rifles) – a regiment with a long and proud tradition. After university, he could have dodged the Army and pressed on to be a general practitioner, spending years earning little, working his way into a practice, dogsbody to an experienced physician. Or he could have followed a more academic route, clinging to a professor in hope of clinical research, or scratched for a role at a hospital linked to a workhouse or charity. He has worked in hospitals for his degree, assisting with 25 births in Dundee, part of the practical midwifery requirement, overseen by the avuncular Sir Halliday Croom, yet another son of the manse.

But the opportunities are haphazard; hospitals and universities work apart, decently paid jobs are impossible to find. Bertie had toiled at Dundee's Royal Infirmary as a physician and house-surgeon, and still moved on. The Liberal government's 1911 National Insurance Act, which promises workers access to a medical practitioner, has yet to convince doctors that reporting to the state is an attractive option.

And for Fred, money is a problem. Like many students at Edinburgh, he brought bags of oats from home to supplement his provisions, and found life in the city expensive, especially when you have Fettes friends to entertain. And while his hard-pressed father supports his studies, the Reverend Robert only loans, he rarely gives, and he expects to be paid back. Fred wants income, status, advancement and a life away from St Cyrus, which he had left emotionally half a lifetime before. And the RAMC provides it.

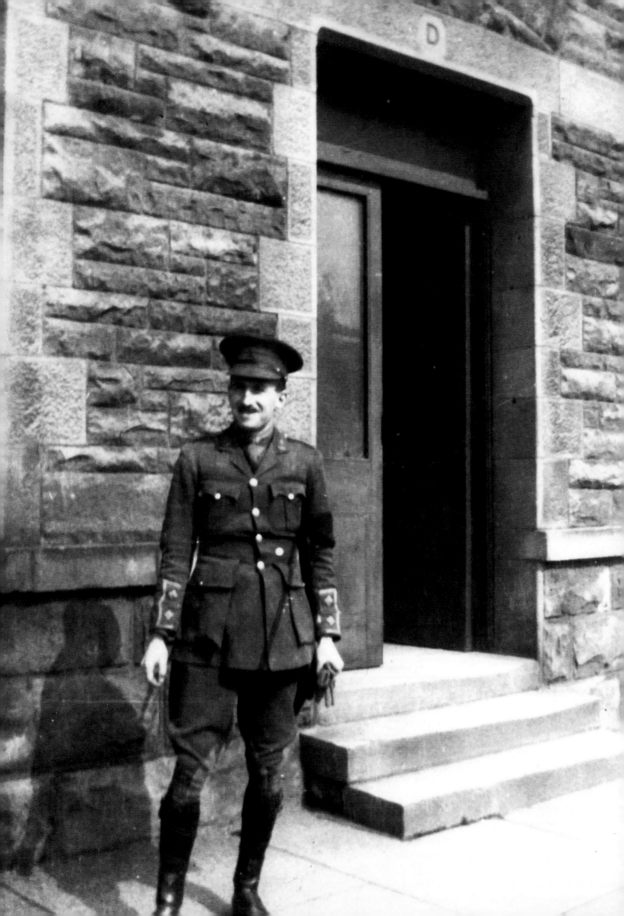

2

IN THE ARMY

A specification-tally will be filled up and attached to each wounded man after first aid has been afforded. The nature of the wound (or wounds), eg "gunshot", "shell", "bayonet", etc, its situation, eg "chest", "neck", "right thigh", etc, and any special conditions, eg "haemorrhage", "fracture left humerus", etc, should be entered briefly on the tally. The man's number or name, and rank or regiment should be inserted according as such information is available from the man himself or from his identity disc. Any precaution required in transit, and the fact of an opiate having been given and its amount will be noted. The counterfoil should be ...

– EXTRACT FROM THE ROYAL ARMY MEDICAL CORPS
TRAINING BOOK, 1911

THE ROYAL Army Medical College, a clutch of four-storey, brick and stone buildings designed in the imperial baroque style, sits squatly by the river Thames on London's Millbank atop the site of an old criminal penitentiary. Opened in 1907, the college has the grandest of mess rooms for dining functions, retiring rooms for senior and junior officers, generous drill ground, copious barracks, a military hospital – just the other side of the National Gallery for British Art – and various lecture theatres to educate the brightest of medical graduates prepared to devote their working lives to King and Country. It is, in short, a very visible statement of the Army's commitment to improving military medicine.

For Fred Davidson, attending the college at the start of 1913, it is yet another term of book-learning, more lectures, more demonstrations, but now with a military edge, adding Mess-talk and hierarchy and saluting. There are also topics beyond his ken. Sanitation, for one. Fred sat in Hunter Stewart's talks at Edinburgh, where Britain's first department of public health was established – not for nothing was the city, with its stinking sewers, once dubbed Auld Reekie – but never once did he think that latrine-digging was to become his speciality. For a newly qualified doctor, straight from university, it is a leap into another world.

The Army has learnt its lessons in South Africa, and wants its medical officers to advise on all sides of military life. It has also decided, after observing the Russo-Japanese War in 1904–5, that disease will be a greater killer than bullets. Prevention of wastage is key. A whole curriculum of study is devised to combat this, and Fred faces months of training before being assigned to a regiment as a medical officer. First he is sent south to barracks in Aldershot to learn how to be an officer, and then to Millbank to attend lectures on hygiene, disease prevention and administration – lots of that, as the British Army, with an Empire to oversee, prides itself on its planning, and that comes with copious paperwork, even for the wounded. The RAMC is committed to a system of zoning its work with casualties – collection zone, evacuation zone – that requires systematic recording,

regardless of conditions. Fred can add the lecture on tally filling, with its litany of clerk-work, to his long list of subjects committed to memory.

In camp, administration is left to others. Instead, Fred must march, ride, drill, be shown how to give and take orders. The riding is relentless – up at dawn, on parade at 6.30 am, gymnastics in the morning, on horseback for the rest of the day. No stirrups, riding over jumps, trot, gallop and wheel. The Army relies on horses for its officers' mobility, and Fred will need to ride proficiently to follow a battalion on the march.

He knows that, anyway. He is taking the same path forged by elder brother Bertie, already trained, already posted by the RAMC to Britain's Indian Army, to work as a doctor in its Meerut Division. Bertie had complained of the endless riding drill and the privations at Aldershot: freezing huts on the hill, tiny stoves to keep warm, the saddle sores, the trick riding, the constant fear of falling. All necessary, Bertie acknowledges, because if he is sent to a remote hill station he will have to travel by the roughest of roads.

But it is very different from the doctoring practised outside the Army, where Britain's post-Edwardian health system relies on a patchwork of state and charity hospitals, company doctors, private general practices, esteemed specialists and fee-paying patients. In the military, your duty as medical officer is not to put the patient first, but the battalion. Malingerers must be weeded out, "swinging the lead" reported, the wounded patched up and sent back to action, even if it worsens their condition. Triage on the battlefield is a necessity, prioritising treatment for those most likely to fight again, leaving those beyond help to die.

That is a long way from the Hippocratic Oath which Fred, as a scholar of Greek, could happily translate from the original. It is also a more brutish world than he might have expected in civilian life, with field punishments No 2 (in fetters) and No 1 (in fetters and tied to a gunwheel) common measures to combat drunkenness and disobedience among the ranks. Flogging had only been abolished 30 years before. The gulf between officers and others was wide. Many officers held that you should never even speak directly to the ranks, as to do so would undermine the NCO's authority.

For a boy brought up in a small village, among a strong congregation where all spoke their part, in a community with farm labourers' cottages

stretching down the lane just beyond the manse, it might seem restrictive. At least the medical officer speaks to everyone – yet even that could lead to suspicion among his combatant peers.

* * *

Fred's mother dies in November 1913. Susan has been suffering from cancer for a decade, its slow progression wearing her down from the inside, just as the rain and wind batter the outside of her husband's church. Her pain had been leavened only by regular trips to the Bridge of Allan spa near Stirling, the Victorian resort once frequented by Robert Louis Stevenson.

That cold Christmas, after her passing, Fred returns to St Cyrus to support his father. Reverend Robert has built his wife a plain granite cross for a tombstone in the corner of the churchyard, striking in its difference to the slabs around. He also leaves space for his own name. The holiday is a sombre one. Fred, his instinct for tradition honed by Fettes, wears a black armband to denote his mother's passing. His brothers, boisterous denizens of the seaside manse, are less formal.

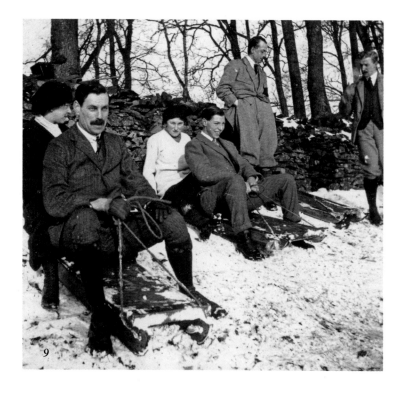

9

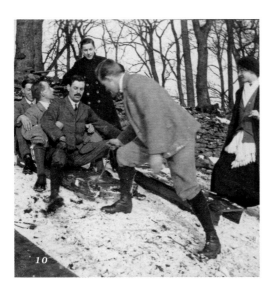

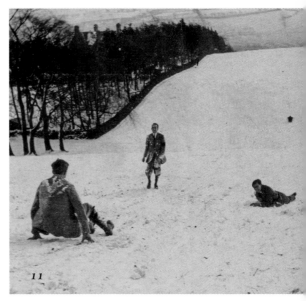

Harry has charge of the boys' old Kodak Box Brownie camera to take photographs of the family's traditional sledging day in the Garvock hills above St Cyrus, with Cunningham cousins in attendance. May and Olive Cunningham are the daughters of Susan's brother William, a Glasgow solicitor and honorary Colonel in the 1st Lanarkshire Artillery who shot himself in 1894, suffering depression. Fred's mother had always kept an eye on the girls, perhaps with a thought to finding suitable wives for her sons, and the families are close. The girls recur in photographs sent to Jack and kept by Fred, easy in their intimacy with the Davidson boys.

That day Fred and Harry take turns with the camera. In the first of the Brownie's distinctive, square shots, Bertie sits across one sledge, moustached and solid, while Fred stands behind, hands in plus-fours, black armband on his left arm, disengaged from the group [9]. In a second, Fred takes the camera and Harry stands in dark peacoat, waving brothers and cousins onto a sledge [10]. In a third, Fred trudges up a long, rolling hill, grinning as brothers and cousins skid past [11]. The template for recording the informal joy of an encounter, and a place, is established.

Fred has finished his RAMC training now, and has been allocated a Glasgow-based infantry regiment, the Cameronians (Scottish Rifles), in which to work. When he returns to their barracks that winter after Christmas, he makes a substantial new purchase: an imported, folding Buster Brown camera, costing £3. Smaller than the Box Brownie, built by

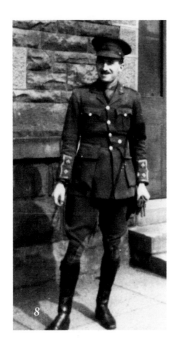

American photographic giant Ansco – later Agfa – it has a drop-down front with bellows rolling out to lock a fixed-focus lens into position, plus a choice of shutter speeds and apertures, allowing a greater range of pictures. It uses a 6-picture cartridge taking negatives measuring 2 ½ by 4 ¼ inches for postcard-size prints.

In early spring Fred starts taking photographs around the Maryhill barracks where the Cameronians are based [12–20]. They are casual photographs of new friends, young, combatant officers who have joined at the same time. They pose in doorways of Maryhill's granite blocks, grinning shyly, in uniform and civvies, larking with tennis rackets, or just sitting relaxed. Within the very formal world of the regiment, with the likelihood of war already a topic in the mess, they seem nonchalant, oblivious to confrontation. Only Fred's black band of mourning, still pinned to his left sleeve, close to his heart, offers an omen for the future [8].

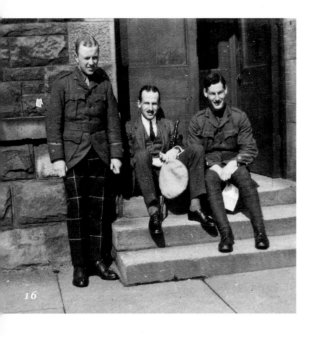

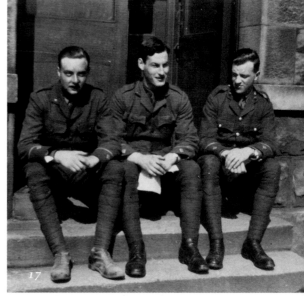

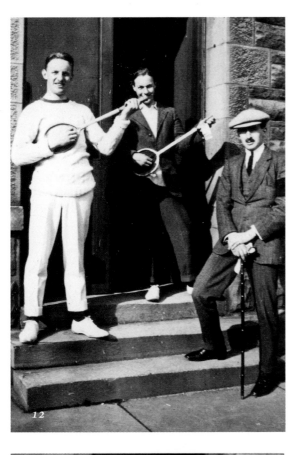

12

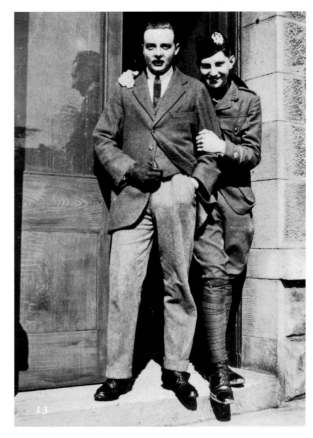

13

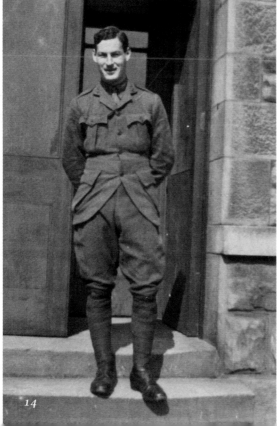

14

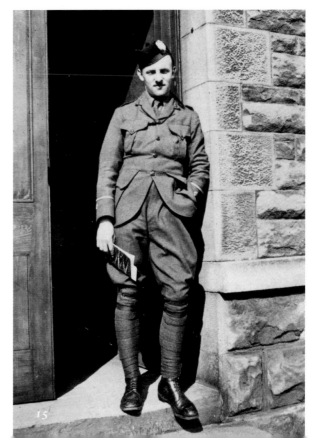

15

There are also more formal photos of Fred's medical team and the barracks hospital [21–23]. Fred is an implant, heading a team of five RAMC soldiers – one NCO and four men – who will oversee the Cameronians' medical and sanitary needs, passing on the sick and badly wounded to RAMC Field Ambulances that will follow the battalions in battle. He takes the rank of lieutenant, though at 25, he is a good five years older than many lieutenants in the Cameronians who have arrived straight from Sandhurst's military college. He is also the only university graduate, thrust into a culture where brains are not often seen as an asset.

Fred has already shown the photos to his young brothers, offering a window into the world he has entered. On his rare visits home, across the

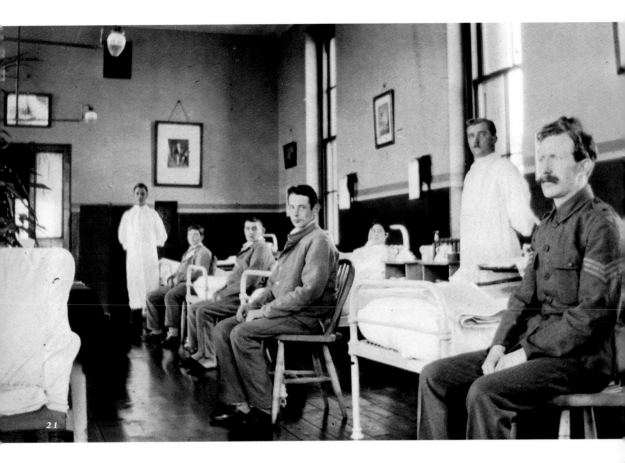

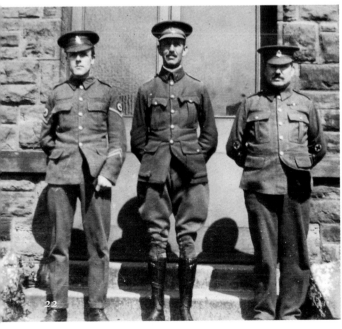

lowlands to Edinburgh then up the coast to Montrose and St Cyrus, he has held them entranced with his dry description of Cameronian quirks. Now Bertie and Jack live abroad, he is the eldest, and his progress keenly watched. Sitting upstairs by the fire after Sunday service, Fred holds court, explaining the intricacies of Army life. Harry, in particular, hangs on his every word.

–The progression of ranks you know: privates, lance-corporals, corporals, sergeants, sergeant-majors, lieutenants, captains, majors, colonels, brigadiers, generals – then there are refinements like 2nd lieutenants, lieutenant colonels, major generals and lieutenant generals easily tacked on. The organisation of units is similarly fixed within flexibilities: two or more squads in a platoon, two or more platoons in a company, two or more companies in a battalion, three or more battalions in a brigade, three or more brigades in a division, two or more divisions in a corps, two or more corps in an army. A battalion can number anything from 400 to 1,000 men at its full fighting strength, with four companies, and 16 platoons ...

Fred has a meticulous style of talking: concise, numerate, nothing missing. It comes from those years of learning by rote, and is already infused with the bureaucracy that binds the Army together, followed with the same diligence that built an imperial and commercial Empire.

His brothers already know the history of Fred's new regiment, Presbyterian to its core. Amalgamated from the 26th Cameronian Regiment and 90th Perthshire Light Infantry in the 1881 reorganisation of the British Army, it can trace its roots back to the original Covenanters who fought the attempts of Charles II and his brother James to stamp out Presbyterian doctrine.

–That, points out Fred, is why they still bear arms in church, still remain seated to toast the King, and still issue bibles to new recruits.

The rest of the Army oddities are eagerly lapped up by his brothers. Lieutenants, for their first six months, are not expected to address a senior officer in the mess unless spoken to first. An officer is not allowed on the rug in front of the ante-room fire until he has three years' service. He must also stand when the Colonel or a Major enters the room. All officers are banned from discussing regimental business in the mess. It is also forbidden to mention women by name.

–A prohibition stemming from the old days of duelling, adds Fred sternly.
–But how can you not discuss regimental business?
–You can outside the mess, it is simply thought unwise to do it in front of
the mess servants. They may tell others, and gossip moves speedily in a
regiment.

Fred relights his pipe. His brothers nod sagely.

For Fred it is not a difficult world to understand, simply a return to the
codes and hierarchies of Fettes – a public school background he shares
with nearly all the Cameronian officers, alumni of Charterhouse, Rugby,
Wellington and the better-known Scottish schools. The younger officers
share his obsessions with cars and cameras, the older ones fret over
hunting, racing and shooting. But there are also traditional rivalries to
assimilate.

–So, says Fred, clenching his pipe. The regiment operates with two regular
battalions, one kept overseas, one at home; and six more on call, made up
of territorials and reservists – former soldiers who have agreed to rejoin
in time of war. The two regular battalions, however, are not best of friends
because of their history, the 1st battalion having been drawn from the 26th
Cameronians, the 2nd from ...

–The 90th Perthshire Light, says Harry nodding, completing his sentence.
–So while soldiers move regularly between the two, each thinks itself the
better of the other, and both better than all.
–But they are hardly Cavalry or Guards, are they Fred?

Ned and Rex will not let him get away with any boasting. Fred has to
concede that, to the status-conscious, the Cameronians are only a middle-
ranking Army regiment at best, way below the elite, and not an expensive
regiment to join.

–We all contribute £10 or more a month towards mess comforts ...
That, he explains, pays for a decent cook and decent food, and decent wine,
spirits come on top.

–And a 2nd lieutenant earns?
–£95 a year. If you do the mathematics, Harry, you will see it doesn't add
up. Officers must also supply their own uniforms – full dress, mess dress,

and service dress. So you need at least a small income to pay your way. Cavalry and Household brigades require far greater contributions.

The brothers look at each other. Their father's financial tightness goes without saying. Since their mother died, there appears to be more money available to buy them a better future, but nothing is certain. For Fred, who must compete with five siblings for family resources, it is still a financial stretch. The traditional pastimes of Army officers – polo, steeplechasing and fox-hunting, especially – are out of his reach. Photography is attractively cheap in contrast.

–So tell us about the Colonel, says Harry, who has his heart set on a military career.
–Well, says Fred smiling, what can I tell you? Colonel Philip Rynd Robertson, aged 48, schooled at Charterhouse and Sandhurst, eldest son of General JHC Robertson, veteran of India, married to the daughter of John Stuart Beresford, chief engineer of the Punjab government ...

Fred, as always, is an encyclopaedia of facts. He might have added that the tall, gaunt Robertson, "Blobs" by his Old Carthusian nickname, is a professional soldier so loyal to his battalion that he has earlier sidestepped a transfer to the 2nd Cameronians. Like most commanders, he is brusque and testing, a stickler for duty and quick to spot slacking, but he prides himself on knowing all his men, and is a far warmer character than his severe façade suggests. For Fred, who as medical officer has to work closely with the battalion chief, he is a paternal figure very different to his own father: short on words, wary of outsiders, obsessive in his love of polo and field pursuits. But Robertson is also a man comfortable among his own people, and good at praising the able. When he sees young officers touting the latest folding cameras from America, he encourages them to take photographs.

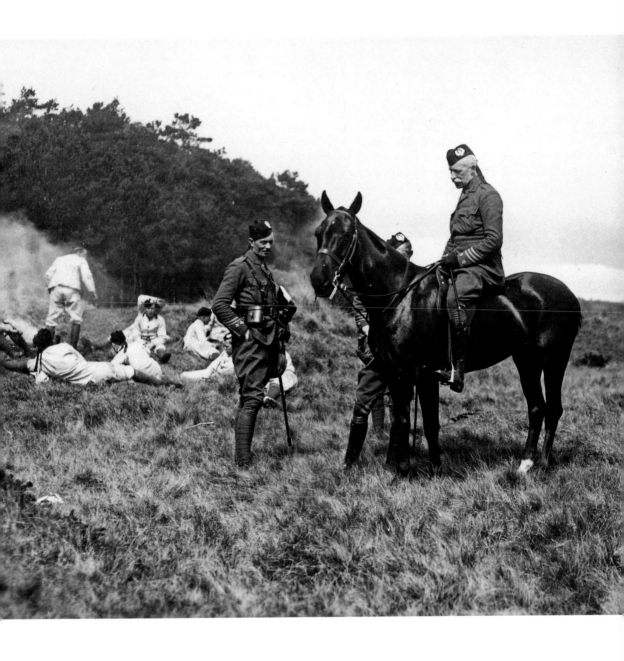

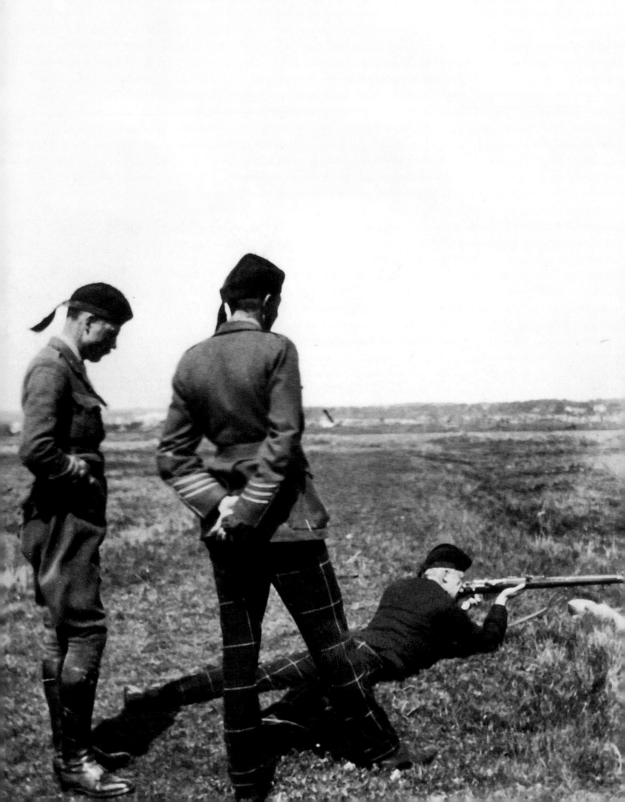

3

MOBILISATION

Everything we read and heard made it quite clear that
there would be war, and that the Germans would
invade Belgium. Our frustration was further increased
by listening to some of our seniors discussing a war,
that according to them could not possibly last longer
than six months. At the rate things were moving, it
would all be over before we got to France ...

– MEMOIR OF 2ND LIEUTENANT JD HILL, C COMPANY,
1ST CAMERONIANS

FOR A second Fred Davidson forgets where he is. All is dark, only noise, a wailing, painful deflation comes closer, underscored by the thumping of his heart, like shells falling, crump crump crump. He worries someone, somewhere needs help, he must go to them, he must do his job, but still he lies motionless. He was hitting the ball, so sweetly, then there was this, then … a new thought. He tries to remember what he drank the night before, in town with the other lieutenants. Just beer, he thinks. Maybe a VAT69 …

Now the pain is lessening, moving off, out and away, before he can even get out to his medical cart. And then he realises exactly where he is – in bed in his tent at Barry Camp, the Army rifle ranges above Dundee – and exactly who is wailing: the battalion pipe band waking the camp with its 6 am rendition of "Hey Johnny Cope". Later he is told the drummer invariably strengthens his thump as he passes the officers' tents – an opportunity denied him at Maryhill, with its sturdy granite walls. Fred makes a mental note to have a word. All the band will report to him as stretcher bearers. Unless they want to enjoy a stint in sanitation, it is not beyond them to keep an eye fixed on where his tent is sited. And avoid.

That Easter of 1914 has fallen early in April. Fred has been home to see his father, and answered bluffly his queries as to how his third son was coping. The Reverend Robert sees Fred as an easy integrator, ambitious to get on, never quite revealing his hand – even to his own family. Sending him away to Fettes achieved all that.

From St Cyrus he swaps trains at Montrose to travel south to Barry, already familiar, close to the golf links at Carnoustie. He wakes that first dawn to the band's reveille on his camp bed in his spotless white bell tent, fresh from dreams of hitting the little white ball. Then he is up and out to breathe in the sea air. His fellow officers are already gassing. They are a reasonable crowd, young for him, but bearable, and a couple are good for conversations about bikes and cars. He's spotted a Rudge Multigear motorbike in camp, and an AJS. He's seen Money, the machine-gun officer, with an up-to-date Kodak, too.

The day before Fred had posed for a group photograph of young officers, marking their arrival in camp [24]. Six had stood informally, four sit on the grass in front – Fred cross-legged, meticulous in his RAMC cap and riding boots, pipe in mouth, signet ring on pinkie, half a decade older than the rest and one of the first to sport a moustache. He likes to cut a dash, more so than his new friends, who giggle, grin and slump. But he is comfortable with the crew, too. The team list reads Graham No 1, Hill, Pollock, Rooke, Briggs, Ferry standing. Davidson, Graham No 2, Moncrieff Wright and Cotton-Minchin sitting.

So that's Pollock from Scottish Fusiliers, only here short-term, and Briggs, off to another battalion, likewise the sterner Graham. With the other six, he is already on first-name terms: impish artist Charles "Frankie" Rooke, just 20, educated at Stoneyhurst, descendant of the Admiral Rooke who captured Gibraltar in 1704; cheery Douglas Graham (seated), also 20, schooled at Glasgow Academy, nicknamed "Noisy"; Humphrey Cotton-Minchin and Douglas Moncrieff Wright, both 20 – "Munchie and Wrightie", Harrow and Glenalmond, observers and chroniclers of all around them; then Darrell Hill, 23, stocky, methodical, former law student; and lugubrious London-born Ernest Ferry, 21.

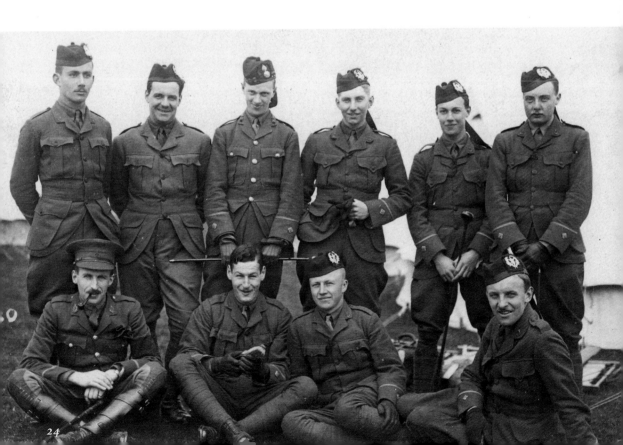

In fact, not many Scots for a Scottish regiment, but that's the Army for you. Above them is a cast of older officers who Fred already knows by sight. The Quartermaster "Tubby" Wood, a Cockney promoted from the ranks, the getter and giver of everything you need; Lieutenants Harry Becher, Ernest Hobkirk and Robin Money, closer to Fred's age, joiners of the battalion in 1909 and 1910; Captains Francis Hamilton, James Jack, Harry Lee, Ronnie Macallan, Thomas McLellan, Thomas Riddell-Webster, Ronald Rose and John Stormonth Darling, all ambitious career soldiers, helpful if you help them; Majors James "Bull" Chaplin, Richard "Skin" Oakley, and Crofton Vandeleur, heading for the top, waiting for their own battalions, you don't want to cross them; and over all, the Colonel himself, white-haired Blobs Robertson – though you would never use his nickname – setting standards, emphasising priorities and, in Fred's opinion, managing the men in a far cleverer way than he outwardly affects.

Robertson reports to the regiment's chief, Major-General James Laye, but writes his own rules. Fred must advise him daily on the men's health and well-being. So far, it seems as if Robertson is no more than gently amused by the earnest young brainbox sprung on him by the RAMC. Doctors in the Army are a rum one, thinks Robertson, and many around him agree. It makes Fred at once part of and apart from the officers he befriends. In that, his life so far has offered him useful preparation.

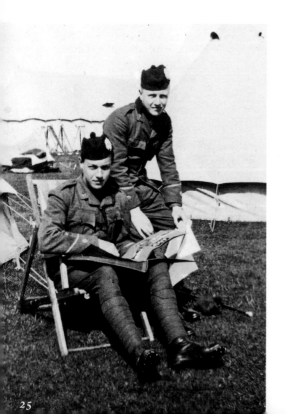

So, after sick parade, and a degree of testing by the ranks – "I cannae march any more, doc ..." Next! – Fred makes himself busy with his new Ansco, detailing off-duty life, attempting to understand his new family. He photographs fellow officers lounging, chatting, shaving, already at ease with the camera [25–39]. The Cameronians have long taken formal photographs at ceremonial events; and informal pictures have followed too. The new vocabulary of photography – "shooting" photos, taking "snapshots" – fits the military mien. The officers even bring their picture albums to the camp. In one of Fred's pictures, Briggs sits in a deckchair, studying the pages, Wright at his shoulder [25].

Elsewhere golf, dogs, cars and bikes predominate, symptomatic of Fred's interests. He takes no pictures of the ranks – they will be spending their free time on the rifle ranges, practising for the marksmen awards that promise higher pay – nor of the senior officers, nor yet of any military manoeuvres. Just those men he knows. These are the young officers with whom he stands anxiously in the mess room, as they jointly wonder with whom they can start a conversation.

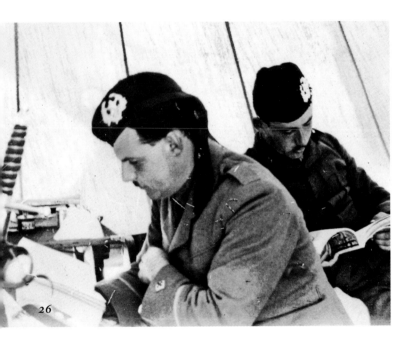

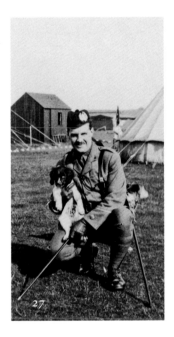

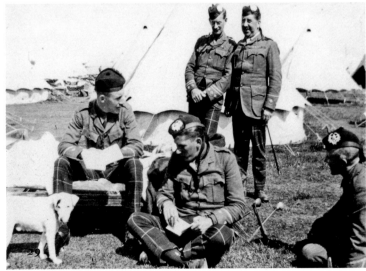

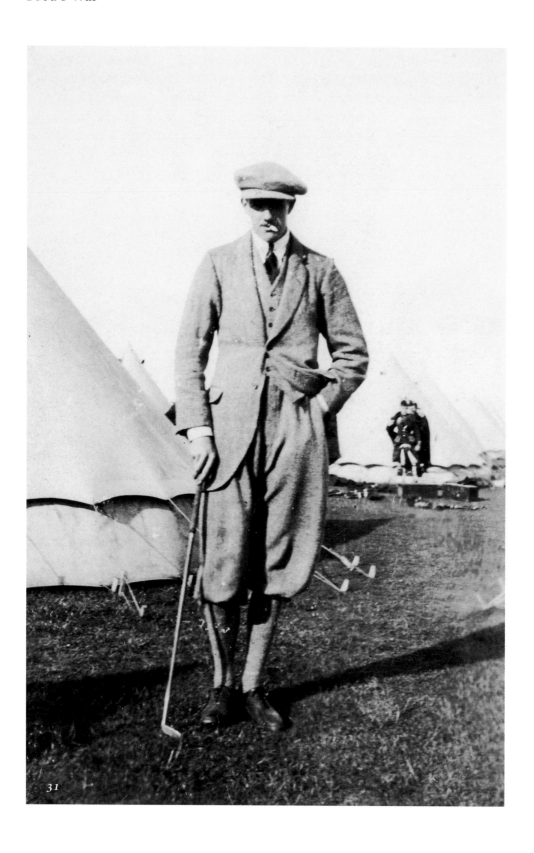

31

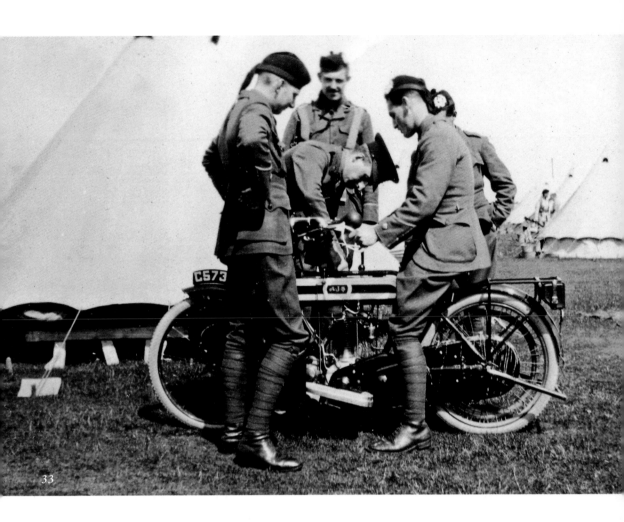

33

30

32

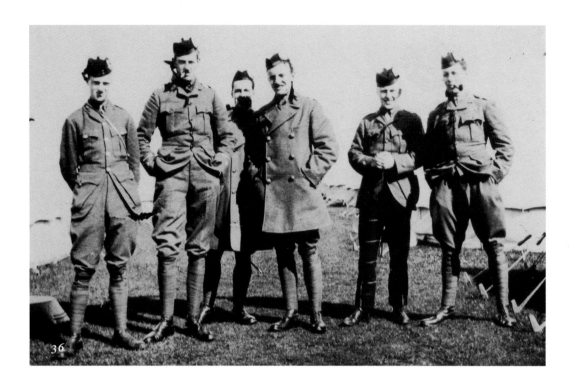

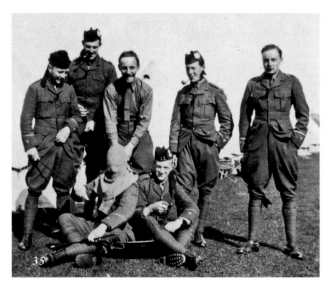

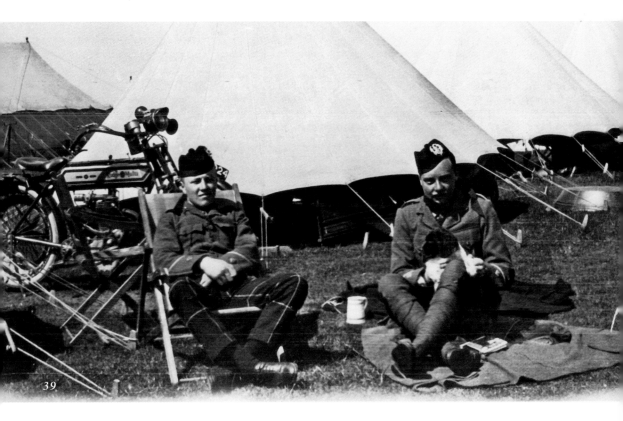

They are not, however, complicated men to understand. Fred has already learnt the virtues of duty, dedication and resilience at Fettes. The British Army officer is hewn from the same stone, expected to hold himself erectly, behave courteously, dress the part, never to brag, play games well, tolerate discomfort without complaint, keep a cheerful atmosphere, eat and drink moderately, come from a good family and school, and always put his men first – in reverse order, probably. He is also bonded to his regiment as if in a marriage. In fact, married officers are in the minority, such is the stress placed on the primacy of being a Cameronian. The payback is the lifestyle it gives you.

It is a position in which brotherhood is valued over brains, so Fred knows he must tread carefully. Bonding is all. Hence that constant divisibility into smaller units as you tighten the relation with the men around you – regiments into battalions, battalions into companies, companies into platoons, platoons into units. As part of that bond, young subalterns – 2nd lieutenants and lieutenants – are even required to inspect their men's feet on a weekly basis, to keep them fit for marching. One less thing to do on Fred's list. He has noticed, however, that tactical training for these young officers is rudimentary. Beyond marching, marksmanship and bayonet practice, little else seems to be studied. Fred has already heard the jokes from Money and others, asking what exactly they were expected to do after running in with bayonets. Sandhurst had never told them.

And war is coming, they all sense that, it is the topic they come back to again and again in the mess. German and Austrian Army officers have been openly discussing war since 1900, and the race to build battleships is now part of a national debate. The British Empire, the engine of the country's economic success, must be protected. Newspapers had taken up the slogan "We want eight and we won't wait" to back calls for more dreadnaughts to counter German naval expansion. Yet the Germans are anxious that if they don't counter British power at sea, they risk blockade – as was openly threatened during the Boer War, to counter possible interference in Transvaal.

But few fear war. Even Fred, who would likely see the worst effects of any fighting, knows that it brings opportunity. The worry is that it will start without them, or with them in an Army where chances for advancement are lessened by a deluge of new recruits who will inevitably dent the reputation of the respected, professional soldiers. Just a year earlier Lord

Roberts, former commander-in-chief of British forces and vanquisher of the Boers – and an old friend of Fred's uncle Professor Cunningham – had advocated conscription in a much-quoted speech at Glasgow City Hall.

–I seem to see the gleam in the near distance of the weapons and accoutrements of this army of the future, this Citizen Army, the warder of these islands and the pledge of peace and of the continued greatness of this Empire ...

This Citizen Army is not something many in the mess have much time for. Like the women's suffrage movement and union rights, it comes up in conversation to be given short shrift by older officers, who are not habitual advocates of modernisation, inside the services or out. Besides, the issue of Ireland is also bubbling under, which feels much more pertinent. The Liberal government's attempt to push through a Home Rule bill, offering Ireland devolved government, in appeasement to the Catholic south, has already been voted down twice by the House of Lords, and led to the raising of the Ulster Volunteers, a Protestant armed militia opposed to any change. In March 1914, there are rumours that Army officers in Ireland have threatened to resign rather than comply with orders to disarm the Volunteers, many of whom are fully trained reservists.

Speculation that the Cameronians would be ordered to Ireland to help suppress this unrest does not go down well with the men around Fred. Sending a staunchly Presbyterian regiment, whose ranks include Ulstermen recruited in Glasgow, seems insensitive, even by War Office standards. Fred can hear officers in the anteroom before mess dinner promising they might even offer their services to the Protestant militia. Some say the battalion's machine-gunners have already been approached by the Volunteers.

With the assassination of Arch Duke Franz Ferdinand and his wife on 28th June the focus changes again. The Austro-Hungarian empire, robbed of its heir, declares war on Serbia. One by one, Europe's major powers start to mobilise their armies. By July the Cameronians are on manoeuvres at the Duke of Atholl's estate in Perthshire, training with the 2nd Argyll and Sutherland and the 1st Cameron Highlanders, part of the Army's Scottish Command. They are camped beside the Garry, one of the most beautiful rivers in Britain, and wake encircled by the Grampians' granite mountains to blue-skied, sultry sun. The atmosphere is buoyant – for the old hands,

the format is as regular as a summer holiday: reveille at 6 am to those pipes and thumping drums then exercises, breakfast, marching, musketry and bayonet practice, war games with other battalions, then a prompt stop at 2 pm, leaving most afternoons free for officers to play tennis at Blair Castle and refuel at the Atholl Arms. Some have even brought along their cars and motorbikes for added mobility.

For Fred, conversely, it offers a better chance to know the ordinary soldier. The 1st Cameronians are experienced fighters, proud of their toughness, many brought up in poverty and devoted to the stability and income which the regiment provides. For the battalion doctor that means three things: fewer malingerers, too much drunkenness, and injuries that are invariably accidents. But most of the soldiers are more than willing to acknowledge the usefulness of a good medic, knowing the cost of one in the outside world. The tradition of drinking to oblivion is hard to unteach, however. Fred has to counsel moderation, usually in vain. Older hands in the RAMC advocate the use of pill bottle No 9, a colocynth extract that purges the system – effectively a laxative as punishment to "clear" the hangover.

This was especially popular among orderlies, who like to prescribe their own treatments. Fred notes how soldiers happily believe it rids them of any poisons. He had offered his opinion that varying their bread-and-potatoes diet might help their bowels, but the men just laugh that off.

Out on manoeuvres, Fred is finally immersed within them, getting an invaluable chance to see how they operate as a disciplined unit, and where that discipline fails. It also shows him how important mobility

will be. As the men march, he and his unit follow on, two-wheeled Maltese cart in tow, carrying surgical haversacks, field medical panniers, reserve dressing box, camp stools, camp table, operating tent, operating table, operating lamp, paillasse cases, stationery box blankets, groundsheets, buckets, flags, tags, Eusol, morphine, carbolic ...

Fred is more confident with his camera now, capturing the steep gorges and ravined rivers on his Ansco [45, 46], and Robertson on horseback inspecting the men, with the battalion pipe band leading the march [40, 41]. There are photographs of

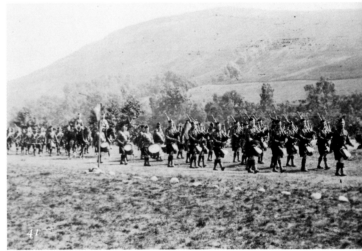

new equipment too: the Barr & Stroud rangefinder made in Glasgow [42], issued to the infantry just months before, and the men practising musketry [43, 44]. There is even a photograph of Fred with officers at a tennis party, a regular event held by the Duke of Atholl [47]. Fred, not a player, sits determinedly in his tweeds, surrounded by men in whites, ever the man among but apart.

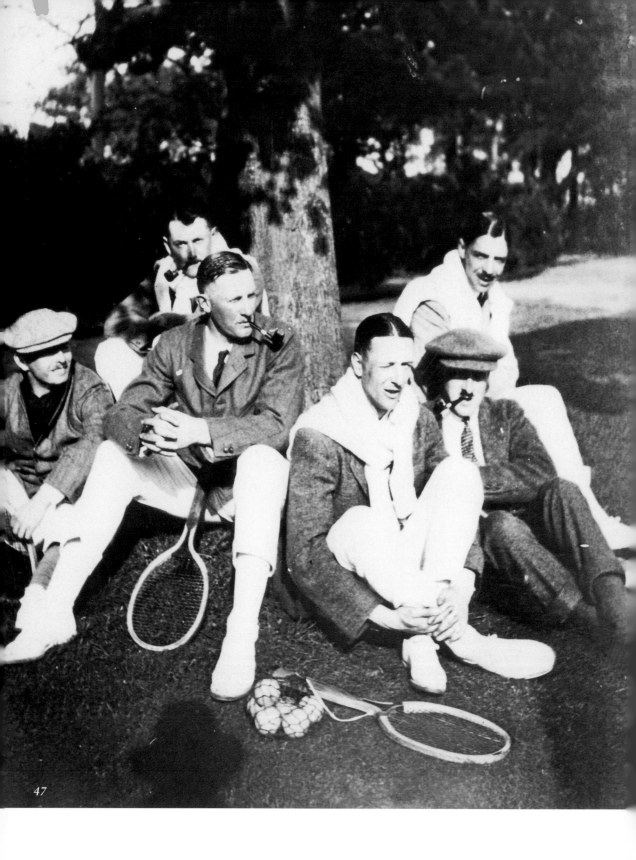

47

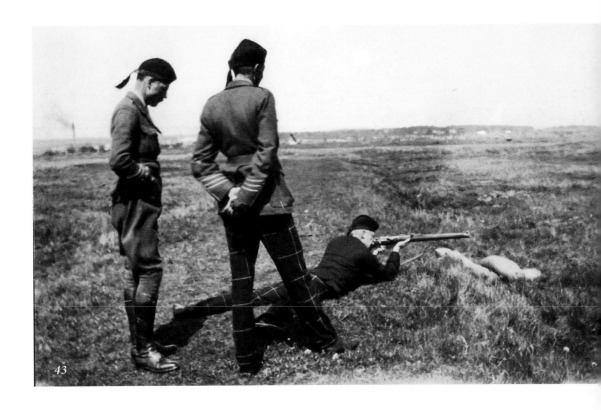

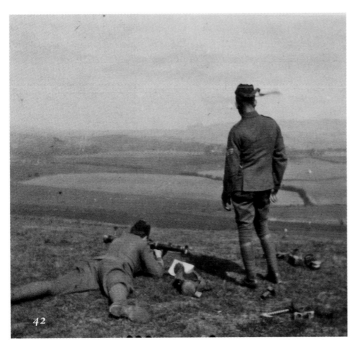

The call to return to Glasgow comes on 29th July, just a day after Austria declares war on Serbia. A telegram is delivered to the Atholl estate while the junior officers are on court. Fred watches Captain Jack, the senior officer present, read the contents. The battalion must return to barracks immediately, prior to full mobilisation. Back at Maryhill the realisation sinks in – what some had predicted to be a small fracas confined to the Balkans was spreading. On 30th July Russia, Serbia's traditional ally, mobilises its armies along the Austrian border. On 1st August Germany, Austria's ally, declares war on Russia. Two days later it also declares war on France, Russia's ally, and begins pushing its forces over the Belgian border, part of a long-prepared plan to sweep down from the north of France to capture Paris. On 4th August, after issuing an ultimatum that Belgium's neutrality must be preserved, Britain declares war on Germany. The dominos are falling, one by one by one.

In the mess at Maryhill the word quickly spreads that the Cameronians will form part of the first expeditionary force to France. Maps are pored over, handbooks on the French and German armies sought, likely disembarkation points discussed. Since the battalion returned from Africa in 1911, the 2nd has been posted abroad, stationed in Malta as part of a garrison force – now there is talk that they might return too.

For Fred, there is a mix of excitement and apprehension. With less than two years' experience under his belt, he is entering a major European war. He studies the mechanical, so he has a sense of the weaponry waiting to wreak death and destruction on all sides – field guns, machine-guns, howitzers. But so much of his training has focused on bayonet and bullet wounds, he wonders if the RAMC, with its carefully thought-out systems of casualty evacuations, really knows what it will face. The next few months will tell.

His fellow young officers have less doubts. Most are champing at the bit, worried by predictions that the war cannot last longer than Christmas, and impatient at the endless preparations now under way, with stores pouring into Maryhill, and reservists joining up. Daily route marches are introduced to build fitness, kit is scrutinised, bayonets and officers' swords handed to the armourer's shop for sharpening. The reality of what awaits them is beginning to sink home. The methodical Hill, commanding a platoon of C Company under Oakley, confesses to Fred that he hadn't even envisaged using his sword. He thought it was purely ceremonial.

–I've never been taught to use it. You can't cut with it, only thrust. I've got a pistol, six bullets in the chamber, but I'd be more offensive with a rifle, I'm a first-class shot with that, 10 rounds in the magazine, one up the spout …

Fred can see the edginess in his eyes. Hill adds that the bullets issued for the pistols have flattened ends – dumdum bullets devised to stop fanatical Dervishes in the Sudanese war. A sergeant has told him they enter the body like a pencil and "come out like a soup plate".

That gives Fred pause for thought. Around him nervous energy builds. The return of the reservists, remeeting old friends, has added a new warmth to the barrack blocks, bleak at the best of times. Old stories are recounted, old jokes enjoyed again. The sense of the power of the group grows, seeing the battalion lined up to attention, waiting for orders, 1,000 soldiers, who will wheel and stamp at one command, move, march, fight, creating something greater than the individual.

The subalterns are now packing and inspecting, packing and inspecting, on a continual loop, ensuring every man in each platoon has every item of equipment required, filling in pay books, checking identity discs, rifle oil, field dressings. Everything not required for active service must now be sent away. Then everything is checked again by the company commanders, mistakes spotted, reprimands issued, praise grudgingly dispensed, with a twinkle in the eye.

The lieutenants must decide what to take for themselves. Each junior officer is restricted to 35 lbs in kit, weighed at the quartermaster's stores, in which anything inessential such as books and tobacco must be included. Mounted officers, above lieutenant level, are allowed 50 lbs. Boots are dubbined, new saddles oiled. Fred has his own worries: a round of inoculations against Typhoid A and B to organise for the men as a move to France looms, serums ordered, syringes unboxed, men queueing by platoon and company.

–Woll'a hurt doc?
–Just a little prick.
–Seen plenty o' those…

But Fred also has time to compare cameras with Money, the machine-gun officer, who he notices stalking the transport section as it prepares its

horses. Money – Robin to his friends – is hawk-faced and amiable, old Army by roots, his father a Colonel in the King's Own Yorkshire Light Infantry, and hardly bookish like Fred. He makes a point of telling everyone, in his clipped Wellington School vowels, that he failed repeatedly to make the cut for Sandhurst's entry.

–Only 36 vacancies and for two years I was 37th! I have been bloody paying for it ever since.

But Money is irrepressible in his enthusiasms and boldly charming, too. He is also, like Fred, obsessed with the new technologies emerging in an industrialised world. He already heads the Cameronians' machine-gun section, with its two heavy Maxims, and is touting a new lightweight Kodak, the aluminium "vest pocket" No 1 folding camera. The camera, costing 50 shillings, takes 1 5/8 inch x 2 ½ inch negatives, and comes with ball bearing shutter, meniscus achromatic lens, four shutter speeds, all foldable into a size that measures 4 ½ inches by 3 inches by 1 inch, and is, as its catalogue promises, "capable of the highest grade of work".

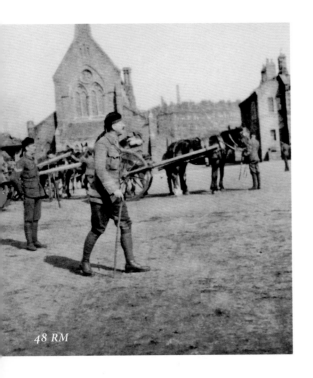

48 RM

Money has been taking shots out on the lochs that summer, and of the preparations at Maryhill. Fred now sees him photographing 28-year-old Riddell-Webster, who spends his days checking horses and limbers. The officer's anxiety is etched in every heavy-legged step [48]. He is a brilliant steeplechase rider and, in consequence, has been given charge of the battalion's transport, the wagons and carts that must carry all their equipment, from tents to ammunition to field kitchens. He thus has far more to organise than anyone else at Maryhill. Money has already nicknamed the fretter "Julia", and given Fred a description of his act.

–Riddell and his circus: the perfect combination of new men, new horses and new harness provide any amount of amusement for spectators. With the usual luck of the British Army, no one will get hurt!

Fred asks if Money is packing his Kodak for France. The carrying of cameras, he points out, has already been forbidden in General Routine Orders – the value of captured photographs falling into enemy hands being obvious. But at 25, like Fred, Money is feeling old for a junior officer, and less inclined to worry about the rule book. His advice is simple.

–Pack it and let's see, old chum.

Then he runs through the shutter options on the Kodak – near, average, distant, clouds/marine – and compares them with the Ansco, asking Fred how much he paid. Both men are conscious that camera prices are tumbling, as American firms sense an opportunity in European markets.

They are not the only ones. Three hundred and forty miles away in London, Lord Northcliffe, Britain's first press baron, owner of the *Times* and the *Daily Mail*, is under pressure from the new *Daily Mirror*, which has pledged to run photographs in its pages. He sees the growth of amateur photography as a way of hitting back. Kodak's vest-pocket camera has been the subject of lengthy advertising campaigns in Northcliffe's titles, with £1,000 – more than ten times a lieutenant's salary – offered as a prize for the best snapshots.

The American company, itself engaged in bitter commercial rivalry with Ansco – which has just launched an advertising campaign in America to find the country's "loveliest women" – wants to make Britain its own. That July it has intensified its press advertising, pinpointing in quarter-page ads the importance of memorialising events.

Have your Kodak ready to snap every incident of your holiday right from the start – a farewell picture at the door – the luggage scramble on arrival – the first glimpse of the sea – the old boatman you haven't seen for a year Remember: a holiday without a Kodak is a holiday wasted.

By August, with war threatening everyone's holidays, the ad campaign has been pulled. But the strapline, so close to what became the defining memorial line for World War One, has made its mark.

Kodak pictures never let you forget.

Fred spends that week taking a series of photographs of Maryhill's escalating round of practices and parades [49–54], culminating in a long route march on 13th August for the whole battalion, a 1,000 strong, with all its transport – horsed limbers, field kitchens and medical unit.

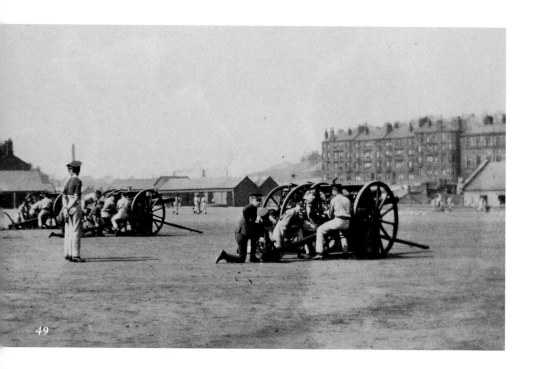

49

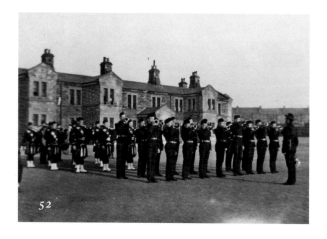

52

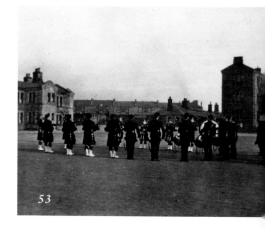

53

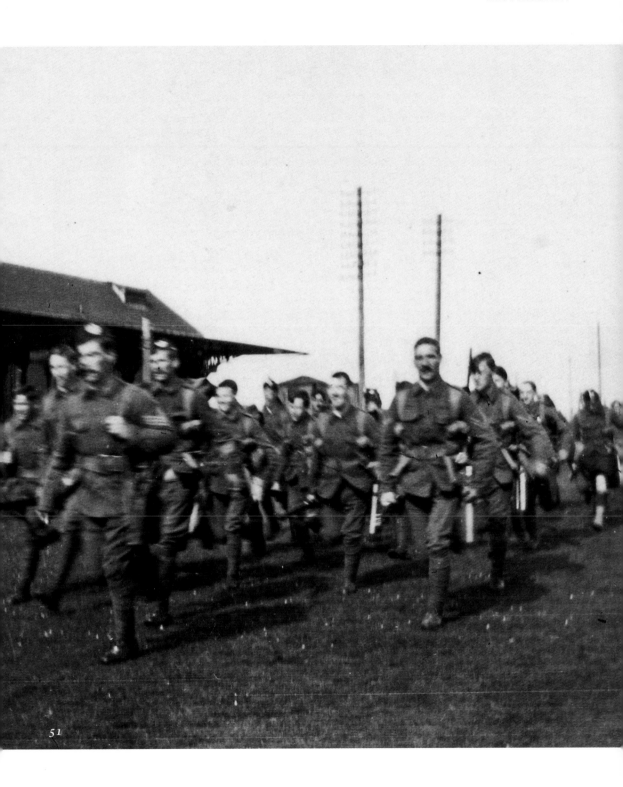

51

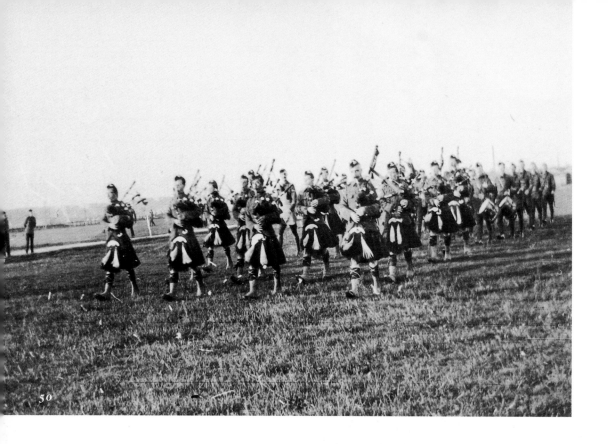

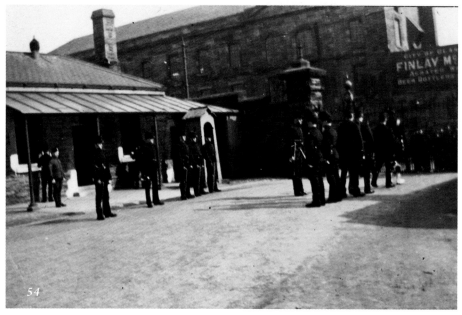

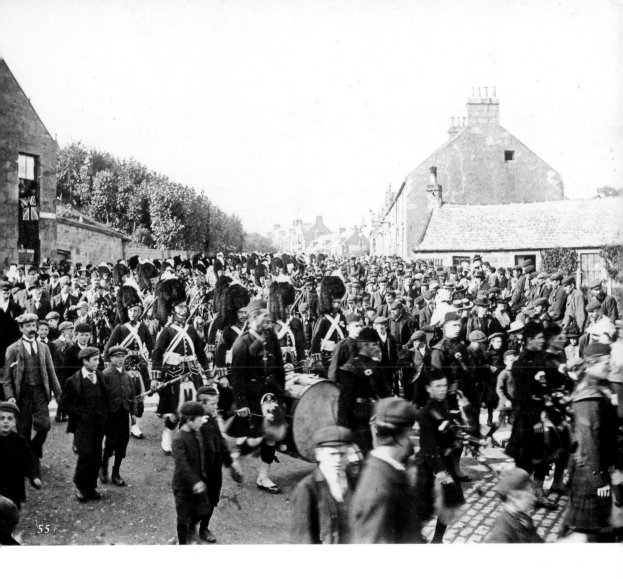

55

Swinging back into the Maryhill Road on its return, pipers at the front, the battalion's band launches into the Black Bear, the traditional marching tune for returning to barracks, punctuated by a double beat of the drum, with a pause then a huge HURRAH from the whole battalion. The noise draws Maryhill's inhabitants onto the streets to watch the troops swing past [55].

Robertson rides to the front and waits at the Quarter Guard block to take the salute from all his men. The barracks gates are locked. The telephones are disconnected. Outside, wives and loved ones cluster, sensing that something is imminent. Tonight, Robertson tells the assembled soldiers, they embark for France.

4

THE COMING

Mons canal, yes ... we were told to take up an
outpost position. Well, there was the canal and there
was one bridge across it and the commanding officer
decided to put two companies on the far side of the
canal, and the headquarters and remainder on the
near side. There was nothing to indicate a war was
on, no sounds or anything of that sort, and some of
the young officers were unwise enough to take their
bedding to the far side of the canal ...

– LIEUTENANT ROBIN MONEY, COMMANDER MACHINE-
GUN SECTION, 1ST CAMERONIANS, REMEMBERING THE
WAR 60 YEARS LATER, IN CONVERSATION WITH
PETER LIDDLE.

IL PLEUT. Fred Davidson speaks little French – Latin and Greek were his languages at Fettes – but he knows enough, watching Le Havre approach, to articulate the change in weather. The *Caledonia* takes its berth shortly after dawn on Saturday 15th August, squeezing between the armada of ships jostling for position. The quay below is soon a scrum of muscular dockers and weekend gawpers.

"Vive Les Ecossais!" screams the crowd. "A bas les Boches!" The French love the British soldiers – they have yet to let disappointment stoke the old rivalry. And the Cameronians are still feasting on their first sight of the French Army: the Garrison Artillery on the breakwater sings a rousing Marseillaise as the ship comes into dock. Emotions are running high. Le Havre has laid on a full civic reception, top hats and tricolour sashes everywhere. Colonel Robertson disembarks through a full Guard of Honour, as French troops sing God Save The King and the Marseillaise. The mayor wipes away a tear as he embraces the surprised officer.

Robertson's men wipe away a smile.

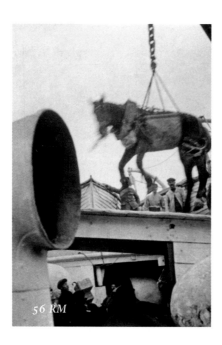

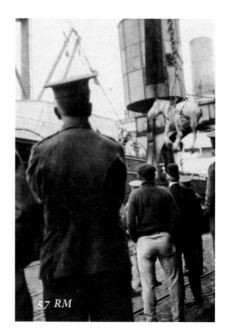

56 RM

57 RM

It has been 36 hours since they marched silently out of their Glasgow barracks to Maryhill station, barely a window opening as the battalion had queued to board lengthy trains that rolled slowly south, arriving in Southampton the next afternoon. Four of the new draft horses had died en route, cramped into cattle trucks unsuited for their size. Then they had to unload and wait for darkness, no lights, no cigarettes, no turning back. The great *Caledonia* had been fully provisioned for a transatlantic run so there was, at least, no shortage of food. But it was a muted atmosphere, soldiers left to work through their fears, wondering what the next day would bring. And now they were here.

The battalion disembarks: 1,050 men, 28 officers. The quayside cacophony rises – French shouts, English commands, the terrified snorts of the battalion's 60 horses as they are winched from deck to dock. Every officer has a mount, the transport has more again for its limbers, the animals coming over the side in slings one by one, slithering on the wet quayside. The ranks follow, first fed on board then mustered on the quay, drilling with a sharpness that draws applause from the crowd, transfixed by the pipe band. A fishwife, circling behind, attempts to lift the Pipe Major's kilt, and receives a sharp slap as reward, delighting watchers.

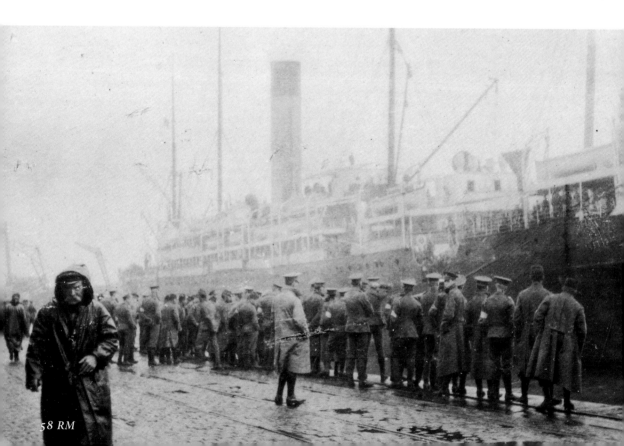

The men move into the giant goods sheds, a mass of khaki, piling their arms and loading lorries, as more battalions arrive off the boats. The Army's usual mix of chores, boredom and anxiety fills the long, wet afternoon, giving the soldiers a chance to study the other ships wedged into port, and their new allies' gaudy Guard of Honour. The French Army still dresses like peacocks – red kepi cap, blue greatcoat, red trousers, the uniform of the Franco-Prussian War in 1870. Three years fighting the Boer sharpshooters on the veldt would have put paid to such idiocies.

Lieutenant Money has recognised a familiar figure stalking the quay. His father is holding forth to a group of senior officers. Colonel Money has been made a commandant at Le Havre's camp, a vital transit point for the incoming British Expeditionary Force, and is tasked with meeting every boat that comes in. Emboldened by his father's position as officer-in-charge, Money starts taking photographs on his Kodak. Horses in slings hang precariously over the quay [56, 57]. Men and boats, drab in the drizzle [58]. Money is everywhere, turning on the roguish charm to which all succumb. He is a favourite of Robertson's, and somehow persuades all the senior officers present to ignore the Army's ban on cameras. Soon he and Fred and others will all be snapping away, leaving a unique legacy for their battalion. It also defies common sense at a time when spies were already being shot.

Come 5 pm the battalion marches out, through the thronged, cobbled streets, up onto higher ground beyond Le Havre where Colonel Money's tented town is laid out – Rest Camp – already boggy from rain. Each company is allotted tents. Each officer notes there are no tent boards, so wet ground awaits. Welcome to France.

* * *

The Cameronians wake to find themselves surrounded, many of Le Havre's inhabitants are already up and out, determined to visit their new friends. Girls dare each other to poke their head through the tent flaps, checking who is where. Soon the Rest Camp fields are a throng of well-wishers, offering souvenirs for sale – a mantra that is to haunt their first fortnight [59].

The rain has gone. The 16th August is bright and dry. Money, Rooke and Becher have had dinner with Money's father the night before, and have a fair idea of what lies ahead. All the officers are told to give short lectures to

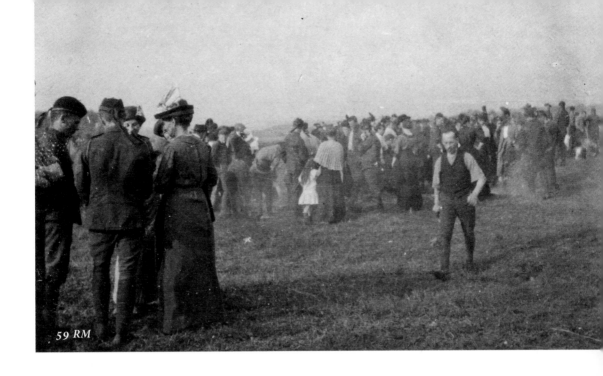

59 RM

occupy the men [60]. Hill makes his men write down the French words for bread, eggs and beer, and "what is your name?" Fred wonders if he should talk about sex, then decides, better not. He runs a brief sick parade, the first sore feet, the remnants of queasiness from the *Caledonia*. He has his team to look out for, NCOs and orderlies, and that range of responsibilities which stretch from health to sanitation and, if he feels like it, the men's entertainment. But that was before anyone got shot.

60 RM

The other officers are already censoring the ranks' letters, a daily task that irritates all. It seems impossible to write anything that doesn't offer information to enemy intelligence. The men clean up and ready themselves for the order to move. It comes at 6 pm as the battalion is told to fall in and march back through Le Havre to the rail station. The men find their platoons and set off, fully laden. They move away from the docks this time, a different route, long and slow, with stops of 30 minutes that no one down the line can account for. They reach the station after midnight, where a mile-long train awaits them.

Each goods wagon carries the clearly stencilled sign: *40 Hommes, 12 Chevaux.*

–Do they mean us? goes the banter.
–Aye, the weary refrain.

The train stretches beyond where the eye can see, swallowing the battalion and its transports. Ranks ride in the freight trucks, officers in carriages. At 6 am the train starts, slowly, slowly. The men wait for it to pick up speed. It never does, crawling at 15 mph for hour after hour. Later they joke this habitual crawl is done deliberately to stop any other train overtaking.

But it means the men can ride with the freight doors slid open, watching the flat countryside pass, and whistling at the women. Whenever the train stops, old soldiers run to the front with their mess tins, tapping the engine for hot water to make tea. Locals press presents through the open doors and windows – ham, pears, more tea. The train stops at Rouen, where the yards are stuffed with cattle. Coffee and cognac is laid on by the French, but the ranks, unused to the taste, won't touch it. By 11 am the train reaches Amiens. Colonel O'Gowan boards, one of the staff officers for Lines of Communication, the logistics section to which the 1st Cameronians has been allocated. That rankles some, who would prefer a fighting role from the off. But the British Expeditionary Force has a complex job of organisation to oversee just getting its six infantry divisions and five cavalry brigades into the theatre of war. It needs men on the ground pushing that flow through. The complainants will be less bellicose later.

O'Gowan brings with him news of an incident at Amiens just hours earlier: General Grierson has dropped dead of an aneuryism on a train passing through. The officers mull the loss. Sir James Moncrieff Grierson was not

just one of the Army's most talented leaders, he was also a former military attaché to Berlin, and one of the few with real insight into German methods and tactics. It is a blow.

* * *

Amiens, Villers Bretonneux, Ham, St Quentin – places pass that the men will know all too well later on. People cheer their progress. Outside the towns, the countryside is now rolling downs, perfect for battle. They stop at Busigny [61], nestling on the edge of the Pas de Calais, 20 miles from the Belgian border, after 7 pm. Final destination.

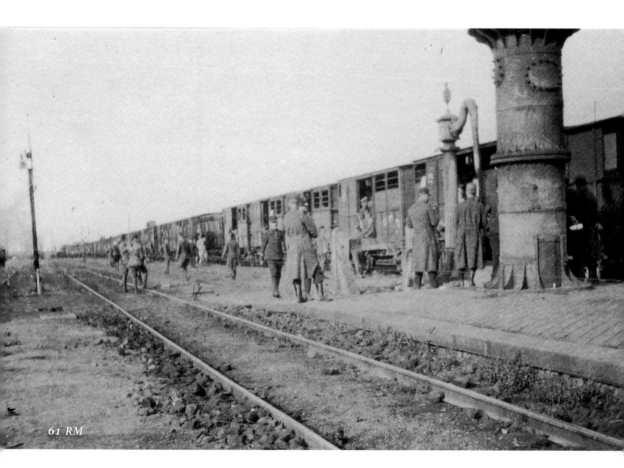

61 RM

Lines of Communication is a summation of purpose – you keep things moving, you get battalions from A to B, you organise and direct and unload and pile and generally oil the cogs of war. For the Cameronian officers, this means taking turns overseeing the station, which has much of the British

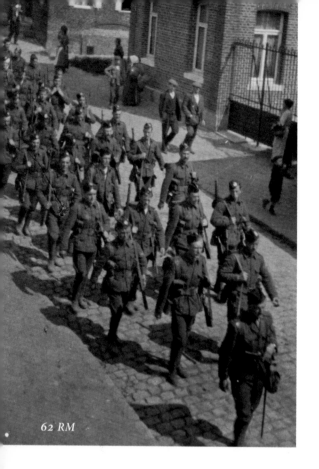

62 RM

Expeditionary Force passing through. C Company is left behind, and the rest of the battalion march the old Roman Road from Busigny to Maretz, two miles away, where the town has turned out to greet them. The battalion forms up in the square outside the Mairie, draped in Allied flags, the mayor makes a speech in English and French, flowers are given to the officers, then there are drinks inside, toasts raised, to England, to Scotland, to France, the British Army, the French Army. Rule Britannia is sung by schoolgirls. Then out again to allocated billets in town, locals showing the way, officers in beds, men more likely in stables. As billeting laws provide home owners with hard cash, claimable from the Mairie – one Franc per night for an officer supplied with bed and linen, 20 centimes for NCOs supplied with bed, and one sou per man for covered lodging – there is, as yet, no resentment. It is after midnight when the party ends.

The 18th August dawns clear again. The Germans are getting closer – it's a fortnight since they invaded Belgium and not long now, the officers and men know, until their two forces interlock. But in Maretz the welcome is so warm, the cafes are open, the weather is fine, war still seems far away. Money continues to take photographs, as the Cameronians march the streets [62], impressing the local weavers, embroiderers and farmers. Few speak English, yet good humour reigns. All are suffused with hope of an easy victory, and with confidence in the auld alliance. If only they knew what was coming, just a week away.

Fred already has a pile of paperwork, already wonders if as medical officer he is more clerk than physician. He understands that accounts must be kept, he knows the importance of taking stock, he certainly doesn't want to run out of Eusol – the "Edinburgh University solution", made from chlorinated lime and boric acid, that he uses as all-purpose antiseptic, a little touch of home. But he certainly knows more about burning excrement and chlorinating water than he probably should.

In front of him sits the complicated algebraic formula for estimating the yield of a well versus the yield of a stream. If his men are on the move, and if the Germans have a chance to poison supplies first, fresh water is going to be a problem.

Cleansing and disinfecting of wells taken over from the enemy:
- *Clear from debris*
- *Half a barrel of freshly burnt lime should be thrown into it and stirred up.*
- *Well should then be pumped out, allowed to refill, and a second supply of lime added, after which the well water is allowed to stand for 24 hours.*
- *It is again pumped out, until the water is free from lime. Where lime is not obtainable, chlorinated lime may be used in a 1% solution.*

He could be back in class at Millbank, enjoying the RAMC facilities. Around him, though, is the clatter of orderly room life. Outside Maryhill, with the battalion on the move, he becomes one of the team working closely with the Colonel as part of his HQ, a bunch of officers overseeing special functions: Vandaleur, Robertson's No 2; Darling, the adjutant who puts into action all Robertson's orders; Riddell-Webster, the transport officer who must ensure all ammunition, kit and cooking gear follows efficiently behind; and Money, the machine-gun officer who oversees the

63 RM

battalion's most valuable weapons. As the only two lieutenants on the team, Fred Davidson and Robin Money are now regular billet partners, both with access to all companies, and both happy to load the film in each other's cameras. As Medical Officer, Fred has his cart to carry his supplies, with so many bottles and tins among the bandages and gauze that camera films are easily added.

Money photographs the Cameronian officers clustered outside the orderly room set up in Maretz's main square, at ease in the sun, awaiting orders [63]. From there, the battalion dispatches its companies on route marches to toughen the reservists' feet, or as

unloading parties for the supply trains clogging nearby stations. Rose takes men to Maubeuge. Lee to Landrecies. Hill is made assistant railway officer at Busigny, given table, chair and a mass of papers and told to get on with it, besieged by officers and men of various units asking where to go, where to get food, where to find the MO. Fred returns morning and afternoon, dispensing advice, already dealing with sore throats and hay fever symptoms. Field kitchens dispense tea. Trains arrive day and night, shifting the Army forward. A corporal in the military police asks Hill what he should do about the "ladies". Women from the town are parading outside the station, leaning through the railings, shouting to the men. For money or for fun? The Gendarmerie are called.

But they are easy days. Outside Maretz, the men route march past sunny fields of corn, beet and potato. Girls garland them with flowers, muzzled dogs run after them. Hill knows something is up when he is approached by an angry General, frustrated after a day's slow travel.

–Where is the HQ of the 19th Infantry Brigade?
–There is no such formation, sir, in this town.
–Don't be a fool, boy, your battalion belongs to it!

General Drummond, head of the 19th, a Brigade that will be kept independent of the BEF's main divisions, has arrived. The Cameronians' short stint as Lines of Communication troops is over. They will join the 1st Middlesex, the 2nd Argyll and Sutherland Highlanders and the 2nd Royal Welch Fusiliers in the Brigade, and they are heading for the front.

Robertson receives orders to take the battalion 25 miles north to Valenciennes. On 21st August, C Company goes first, entraining at Busigny. The battalion follows 24 hours later. The train zigzags, Le Cateau, Landrecies, Le Quesnoy. Everywhere they can see troops on the march. They reach Valenciennes, the heart of northern France's coal and steel industry, at 11 am. The town is rammed with French soldiers. For the first time they can hear guns. The front is very close.

The battalion takes billets in a university, and the officers later dine at the Hotel de Commerce, while pickets are sent out at night to detect any enemy advance. Uhlans – Prussian cavalry used as scouts – have been seen nearby. At 8 am on Sunday 23rd, the 19th Brigade marches out of Valenciennes heading for the Mons canal, 12 miles to the north. For the Cameronians, it is

familiar turf. Back in its long, battle-studded history, the 26th Cameronian Regiment of Foot has fought at Blenheim under Marlborough, and Corunna under Wellington, and in Egypt against Napoleon, and in China in the opium wars – it had also fought the French near Mons. Every name resonates with history for an old regiment.

Robertson has orders to defend the southern bank of the canal, with the 1st Middlesex to his right. He notes later in the battalion war diary – a torn-out scrap from a signalling pad on which he has rewritten events after losing the original – "Message received to hold position at all costs."

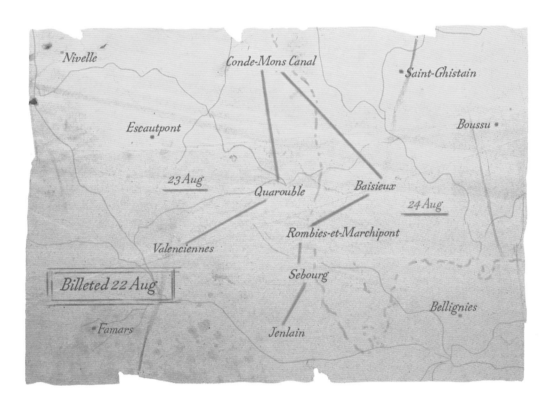

red = advance to Mons blue = retreat from Mons

The battalion is marching on paved roads through countryside bisected with drainage ditches. Slagheaps and chimneys loom on the horizon, farms to left and right. Thick black dust covers the roads. French cavalry peep round the corners of buildings. Officers scan the way ahead with fieldglasses and see flickers outside a farm – people waving white cloths.

Are they waving for attention, or surrender? Or can they see something beyond the Cameronians' sightline?

The gunfire gets louder, and the troops pick up pace, like hounds on the scent – this is what they came for, this is war. For Fred, on horseback, with his wagon of supplies and his orderlies, it is a time for patience, and anxiety. He is trained for a standing fight; casualties get sent back down the line through the field ambulance system. So you set up an aid post as battle commences, then as the wounded come in, you select those you patch up, those you send back and those you leave – beyond help. The walking wounded take themselves back to the advanced dressing station, those on stretchers to lorries that bounce the same way. The worst go back further to the main dressing station, and the hospitals beyond. It is this system of triage and ambulances and concentrated resources that fed through the Army, three decades later, to Britain's National Health Service. But while the troops are on the move, the chain is less easy to establish.

North of Vicq the battalion leaves the road and moves by track to the canal that runs between Condé and Mons. All is flat, beautiful and quiet, sun dappling the oily waters. The men, sore from forced marching, bathe their feet. Robertson briefs the company commanders. The right flank is engaged with the enemy which is pushing hard to capture Mons. The canal must be held at all cost. At any moment the enemy is expected here, as it moves to encircle Mons.

The canal, 50 feet wide, is crossed by just one narrow suspension bridge, single-file only. The battalion digs in, two companies on the far bank, one on the near, one in reserve 100 yards back in old mine buildings, and Robertson with his HQ team, including Fred, in between. French territorials hold the position to their left. The Middlesex to the right. Across the canal, to the north, the plain is flat, rising to a wooded ridge, studded with birch and oak. From there the Germans will come.

They sit and wait. Money and Darling ride to Condé to see the French Commandant, hoping for more information. Darling, the son of a wealthy Kelso accountant, is a big man, ursine and plain-speaking, well-liked by other officers for his ability to get things done – or perhaps for just being adjutant, a paper-heavy job that some would rather duck. He had thrown in his law studies to join the Cameronians in 1900, and it is his willingness

to organise which knits the men together. He and Money get on well, one an earnest stickler, the other a vivacious charmer. But at Condé they can squeeze little information out of their allies, except that the Germans are coming, en masse.

At dusk, waiting by the canal, tense with expectation, the Cameronians hear the jingle of harness then see rows of French Chasseurs in their sky-blue coats riding past behind them– a sight almost from the Franco-Prussian war. With nightfall, company commanders call their subalterns in, conscious that, for some, tomorrow will bring the first fight they have seen. Oakley, a veteran of India's north-west frontier, pulls out a bottle of port from his saddle bag to share, and his lieutenants drink to absent friends, before retiring to sleep, armed and booted, alone with their thoughts. The men are jittery, they know they have no artillery support, and the full might of the German Army about to descend.

<p style="text-align:center">* * *</p>

The night is hot, punctuated by firing to the east as the battle moves closer. At 2 am a runner from Brigade HQ reaches Robertson, and tells him to pull his battalion out fast. They cannot hold the Germans. The Colonel sends runners on to the company commanders. Frantic packing, bewilderment, even anger, as the troops had wanted to engage, not to run before even seeing the enemy. At 3 am the battalion is ready, but no D Company, still across the other side of the canal. Robertson pauses, worried, then tells B and C to move off in file, and A to line the embankment as cover. HQ officers and ranks, Fred and his team follow. Then out of the low morning mist Hamilton, Macallan and the rest of D Company suddenly appear like scuttling apparitions – they have abandoned much of their kit, and now chase after the others. Ahead, sporadic firing is getting louder, more menacing in its percussive irregularity. Darling rides down the column whispering to company commanders on their horses:

–Keep the pace up, keep the pace up, we must clear the canal bank by dawn.

They feel his urgency, they know Robertson never panics, they understand how serious their situation must be. Later they find they are making a flanking march across the enemy, just a mile away. The Germans, vastly outnumbering the British, are waiting for dawn to reveal them. The retreat from Mons has begun.

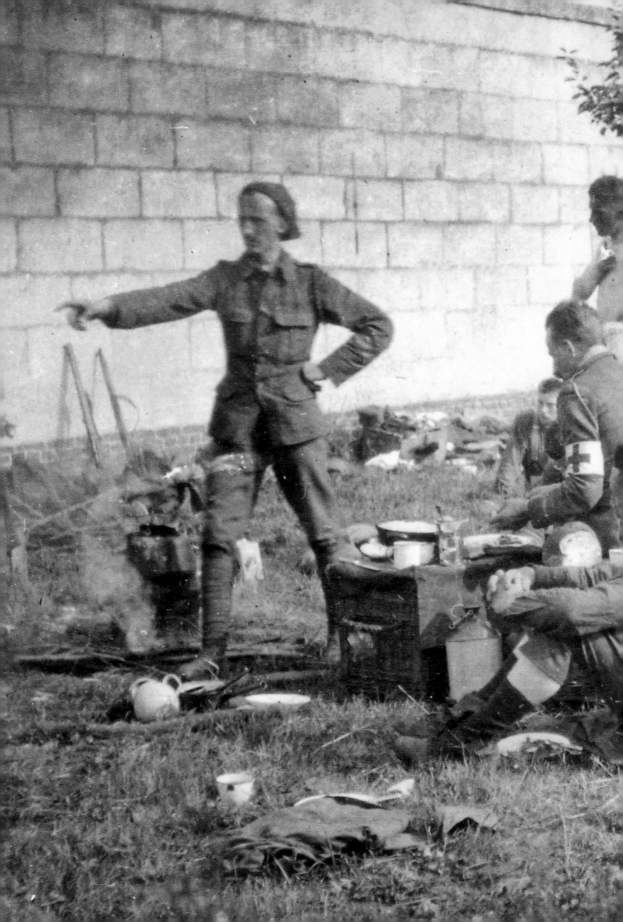

5

THE GOING

The night of 26th August was a nightmare for all
ranks. Men were dropping with exhaustion and had to
be got on their legs again and kept moving. Added to
this, we knew, to say the least of it, that we had not
won a victory ... Captain Rose remarked to me that our
prospect of winning a medal in this war was remote,
with which I was apt to agree.

– DIARY OF CAPTAIN HH LEE, COMMANDER OF
B COMPANY, 1ST CAMERONIANS

FOR THE British Expeditionary Force, it is nearly over before it has begun. The 1st German Army under General Von Kluck, with 160,000 men and 600 artillery guns, has swept all before it. The BEF, 70,000 men, 300 guns, is close to being overrun. If the Germans had struck quickly and outflanked the British, they might have changed the course of the war.

But the Cameronians know only what's around them. They move a mile and a half along the enemy front before passing through the Argylls, their old sparring partners. Like the Cameronians, the Argyll & Sutherland Highlanders were created in 1881 by regimental amalgamation. Their 2nd battalion still refers to itself as the 93rds, due to its origin as the 93rd Sutherland Highlanders.

–Ye had enough? come their taunts, as the Cameronians pass.
–Noo, we're jest movin' behind to stop the 93rds runnin' ...

And on they march, soldiers with greatcoats, 60 lb packs, woollen Glengarries as the heat of the summer day rises above 90 degrees. The scene is surreal. Either side, farmers still work the fields, reaping corn; and church bells can be heard, punctuating the screech of artillery. The battalion strikes east from the Valenciennes road, crossing into Belgium west of Quiévrain then turning south to Baisieux. Robertson has orders to march to Jenlain, 15 miles from their position on the canal, zigzagging in and out of Belgium. The men can already see a mass of French troops following behind. It's not a rout, they tell themselves, just a planned fall-back to a heavily fortified position. They hope.

Outside Jenlain they halt at a farm, exhausted. Men lie under the orchard, boots off, while officers scan the skies. A Taube, the first monoplane mass-produced for the German Army, circles overhead. Money unclips his camera from his belt and catches Vandeleur, scion of an Irish military family and a fluent German speaker, turning his binoculars to the sky, following the follower. Robertson, cigarette dangling, just stares at the photographer, self-appointed documenter of the chaotic retreat, lost in thought [64].

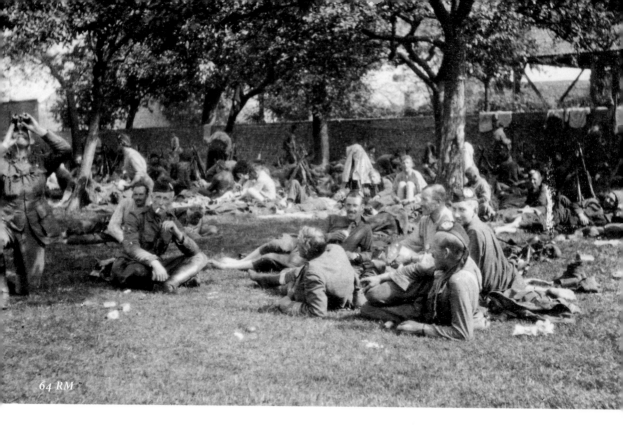

64 RM

Dig in, the men are told. They scrape shallow trenches. The tools they carry, short steel spades with a pick at the handle end, make heavy work of the stony ground. General Drummond arrives in a taxi stacked with farm tools, requisitioned for the digging. Old farmers then turn up to help, their wives bringing bread and water – the Cameronians want to tell them to go, they seem to have little conception of the danger they face. The men dig and dig. The position, on a slight rise, is excellent, French troops on their right flank dig in too. And they wait.

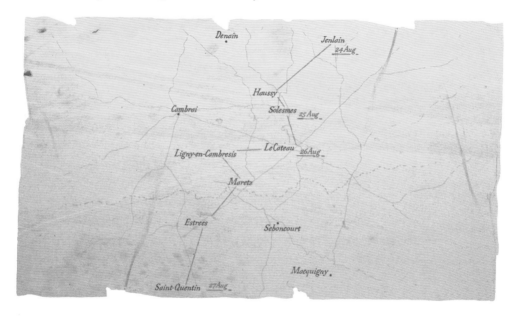

At 2 am Robertson receives orders to fall back again, the battalion hastily packs up again amid cursing, firing has already started from an advance picket 300 yards up the road. In the distance they hear the sound of horses galloping past on dark farm tracks, harbingers of some grim reaping. Quickly they start to march south-west. Later they can hear the enemy shelling the trenches they have left.

By dawn the mood of the local inhabitants has changed, and the country roads are crowded with refugees, wheeling barrows, carts, prams, rammed with possessions, even pulling farm wagons in harness. The Cameronians march on in file, having sent their transport wagons on ahead. The Middlesex and the Welch are in front, the Highlanders behind. Up above, the lone German plane still circles, watching, always watching.

The men march, then stop, march then stop. Some are now throwing away their kit in the heat. Confusion is palpable. Riddell-Webster has to clear a cart of officers' bags from the road, stuck on an incline, horses incapable of pulling it further. He hurls the cases into ditches. Further on French families sit weeping by the side of the road, desperately asking the Cameronians what should they do? Where should they go? The men have no answers. Just keep moving. Shells are bursting only a mile away. For the first time, the Cameronian officers realise they are off-map – they have not a clue where they are, but can only follow others blindly south. Robertson consults his officers, company by company, accompanied by Darling. Money captures them looking north, following the enemy, D Company's Macallan on his horse, leaning in, listening, waiting, hanging on the unflappable Colonel's reaction [65].

Out of the chaos General Allenby, in charge of the BEF's Cavalry division, covering the retreat, appears with staff. He tells Robertson to keep going till Le Cateau. An aide hastily traces a map then Allenby's men move through, leaving the Cameronians as rearguard, watching the glamorous cavalry retreat. Shells are now falling on the road, and Fred Davidson is bandaging the first wounded, getting those he can onto wagons, a few on stretchers. The men are footsore and thirsty after hours on the road.

They march south-west to Haussy then south to Solesmes, with its famous old Abbey. The Argylls are now marching with them. Everywhere French and British troops are in retreat, and refugees streaming through. The crush makes Solesmes impassable. They wait to the north, braced for

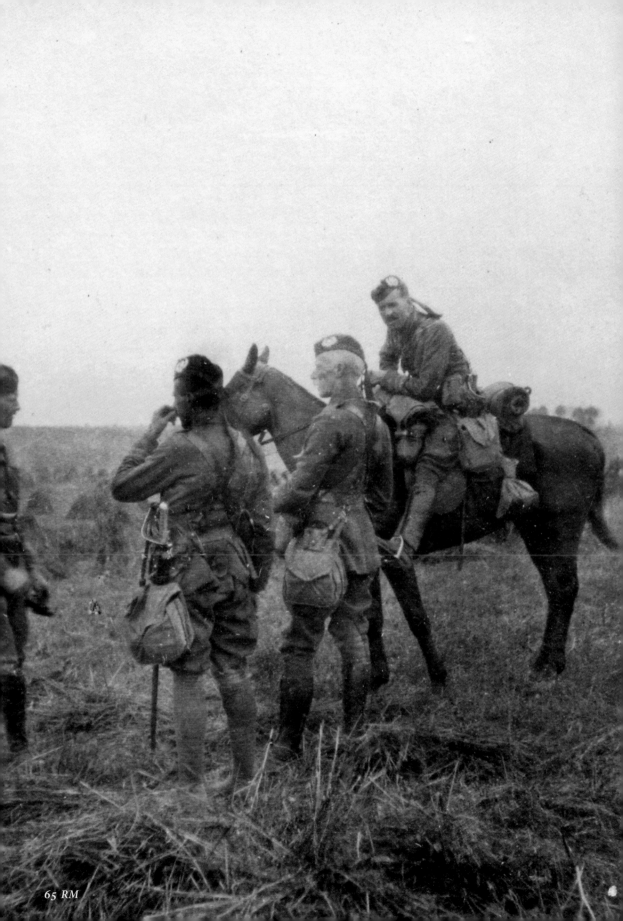

German attack, then file through the town, weaving between abandoned wagons, guns, limbers and families. Pushing through the other way comes a French cavalry corps on bicycles, sabres at the hip, plumed helmets atop, pedalling in mud-splattered boots to take up a position. Incongruous as they look, they will buy the British forces precious time.

The battalion stops and goes, stops and goes, desperately trying to push its way back through the refugees massing in fear. It has only just cleared Solesmes when more German shelling begins. They move on south, through Neuvilly, down congested roads, spurred by the rumour that support is on its way, another division has landed from England and marched to Le Cateau. There the British Army will make a stand. Night falls as they enter Le Cateau. The town is nervous. Doors open, just a crack of light appears as inhabitants watch the passing troops -- then they shut firmly. Military police shout instructions.

–19th Infantry Brigade to the station!
–Where the fuck is that?
–Straight through! Straight through!

And on and on they straggle, reaching the station at 10 pm. It is another scene of chaos as civilians fight for trains, and station staff work through the night to send rolling stock south, out of German hands. The Cameronians collapse in goods sheds and sidings. They have marched 20 miles from Jenlain and can walk no more.

Sweet tea is made, tinned beef passed round. Fred gets to work with his orderlies, moving from platoon to platoon, checking injuries, working on the blistered, bandaging. Men sleep where they fall, some between those rail lines that remain unused. Rain starts, and when dawn breaks after 4 am it reveals a desolate scene of exhausted anxiety, men unsure what the day will bring, but determined.

Robertson orders an inspection of rifles and feet. Fred moves round with his orderlies again. At 6 am the battalion falls in, and retraces its steps through the town to the main square. All is quiet, the men start to sing as morale lifts. The song peters out as they catch the sound of rifles firing ahead, then they walk into the Middlesex, blocking every side street. A cavalry patrol gallops past. Money unlimbers his machine guns. The Germans are coming.

Platoons crouch in doorways, waiting, watching. But no Germans come. The order goes out for the battalion to leave Le Cateau and form up with the rest of the 19th Brigade. General Smith-Dorrien, head of the BEF's II Corps, has decided to stop the retreat and fight, with two divisions at his disposal, rather than see it mopped up in pieces by the rolling German juggernaut. A plan to join together with I Corps, under General Haig, just eight miles away at Landrecies, has proved unworkable.

For the Cameronians, it is another day of footslogging. As part of the 19th Brigade, an independent unit to be used as reserve, plugging any holes where the enemy might threaten, they are sent first one way, then the next, and cannot settle. Robertson's war diary for 26th August, written later, expresses every weariness.

"10 am Received orders to move to the left. Did so. 2.30 pm. Received orders to move to Montigny. 5 pm. Received orders to move to Bertry. 9.30 pm. Received orders to act as rear guard towards Maretz. Left Maretz as rear guard. No pursuit by enemy. Marched all night to St Quentin."

But the men, of course, know nothing, just rumours and orders, though they sense the unease of senior officers – no one really knows anything, except that the day is fine again. Mist after rain clears as the sun rises high. So they first move east, then are summoned west. Captain Lee of B Company is given a message by a gunnery officer to pass on to Corps HQ in Bertry. Smith-Dorrien emerges with staff to take the message and tells Lee the battle is so far going "very much in our favour".

The battalion moves on to Montigny and out onto rolling downs, advancing past copses of oak, birch and wild cherry, fields stacked with reaped corn, no sign of the enemy, just the distant rumble of artillery and rattle of gunfire, as stragglers move back behind them. The men now get the first whiff of defeat, sensing their dejection. They rest by a wood, while Robertson briefs the company commanders that they must ready the men to join the battle up ahead. They can already see an advance dressing station up ahead, and a trickle of walking wounded growing in numbers.

The men wait, tense. Fred tries to get more news from the medics at the dressing station – no one knows if they are moving forward or backward. The shelling gets closer. Rain starts. A dispatch rider appears, and the order to fall back is given yet again. Back through Montigny and Bertry. The word

goes round that the 3rd Division, part of II Corps, has been driven out of Caudry, and they must march to retake it. Then that it has already been retaken. Eventually they are told Maretz – their old friend and first billet – is next. And they are the rearguard.

Maretz is a different town now – no bunting, no flags, no choirs of schoolgirls as they move through. Doors tightly locked, no lights showing, it could be deserted. The Cameronians take up position the other side, taking high ground with the Royal Welch, sending pickets up the road to warn stragglers to move faster. And suddenly the troops start pouring through, from every regiment in the Corps, wounded, bedraggled, men riding on limbers sharing cigarettes. Fred stops by his cart to watch.

–It's like a football crowd, mutters Hill, shaking his head. He asks a gunner subaltern, wide-eyed and mud-streaked, what he's seen. Slaughter, comes the reply, on both sides.
–My God, we had targets that a gunner dreams about. They came on at times in mass, and we were firing at them over open sights ...

Hill reassures himself that these men are tired, but not beaten. The morale of the regulars is hard to crack. Fred can see him weighing the logic. Hill is stolid in build, phlegmatic in temperament and observant, already the mess-room lawyer, as befits his Repton and Lincoln's Inn background. And he digs away at issues with an archaeologist's patience – little wonder he carries a fossiling hammer, just in case there is a chance of an expedition. Part of him still thinks this is a holiday, but then, is that worse than toting a camera?

And suddenly, Fred notices, there is quiet. Nothing between the Cameronians and the German Army. They wait.

* * *

As dusk draws in, a grey blur lips the horizon, eyes strain, then a mass of cavalry is suddenly visible, trotting steadily through the rain, onwards, unbreaking, towards them. The Royal Welch open fire. The cavalry scatter, some coming on through the ranks. The cry goes out.

–Cease Fire. Cease Fire. They're ours!

Too late the infantry has realised they are British cavalry, wearing grey

groundsheets to shield them from the rain. The Cameronians send out their stretcher bearers – the pipe band – to bring in the distant wounded. Now it is dark, and somewhere up ahead, the Germans are advancing. Fred counts the bearers out and counts them in, realising half are missing. Then the order to pull back comes. Robertson shakes his head when Fred tells him, and explains he cannot send out more men to look for them, they have to leave.

The Cameronians set off at 9.30 pm, marching through the night, still the rearguard for the whole of the 5th Division. Most are already exhausted from lack of sleep, days on the road, and the anxiety of not knowing what happens next. But they walk on all night, south down long straight country roads towards St Quentin, waiting for the inevitable attack behind, stopping, starting, listening, always ready to deploy. Some march with eyes shut, in a daze of tiredness. Every hour a 10-minute rest is taken, and B Company forms up across the road, facing whatever might come. Each time it takes longer to get started again, as chill attacks the muscles. Fred gees up his orderlies, and rides up and down the column checking on the men.

Officers are off map now and desperately trying to keep their platoons moving. Grim humour sets in.

–How much further to go?
–Just around the bloody corner! comes the chorused reply, echoing the attempts to explain the inexplicable.

Those ahead leave food cases for the stragglers, so they eat on the move, picking biscuits, bully beef and raw bacon from the roadside. The battalion transport has long since been lost. Quartermaster Wood, in charge of supplies, is presumed captured. Officers take packs on their horses to help the men. Oakley – so thin the men call him "Skin"– is seen with two soldiers hanging on each stirrup. Money lays wounded men on his machine-gun limber.

Fred amuses the machine-gun crew by recounting the RAMC recommendations for marching:

Emphasis is placed on:
1. *A light meal before an early start.*
2. *Careful adjustment of pack and equipment.*

3. *In summer, ventilation through the ranks.*
4. *Unbuttoning the jacket, rolling up the sleeves.*
5. *Protecting the back and neck of head.*
6. *Ill effects of alcohol in any form during a march.*
7. *Water discipline.*

–Sir, where's my light meal before the early start?
–Just keep movin'.
–I'm ventilating the ranks, Sir …

So the footsloggers march on.

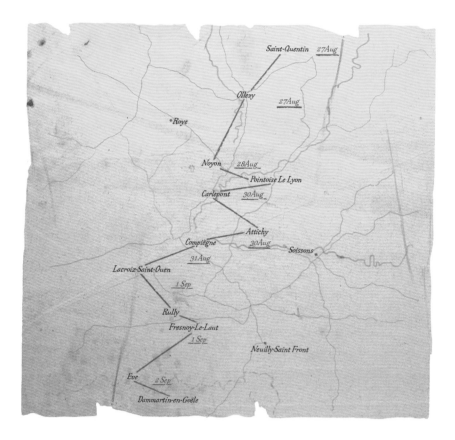

The battalion becomes strung out, then splits in two at Estrées, as a mass of retreating men from other units crush through the village. A, B, and D Companies push on to St Quentin by evening, and find it equally congested with stragglers, yet the shops and cafes are open. C Company, Robertson with his HQ, and Fred with his orderlies and cart straggle in towards dawn,

only to be told: keep pushing south, as German artillery may shortly shell the town. Money hears from Jack that their brigade commander has been kicked by a horse, and is now out of action. His second-in-command has been shot. In effect, no one is in command.

So they walk and walk, 23 miles to Ollezy. The men's wet uniforms now steam in the hot morning sun. The first get there at 3 pm, bivouacking in a field south of the railway. The last men straggle in eight hours later. Others are lost for days, joining other units, waiting to find a way back to the battalion. Sleep is fitful that night. Two villages burn like beacons on the horizon, and the slightest noise wakes the men, conscious that the German Army is only miles away. A few gibber through tiredness. The horses share their unease, pulling their pegs at one point and stampeding, kicking one soldier in the face, another in the ribs, a third has a collarbone snapped.

Fred works on the casualties, one broken nose, two broken ribs, a dangling shoulder. One soldier is breathing hard, his chest kicked in, complaining of pain on a long breath, but no blood, though Fred can feel the grating of snapped bones. He straps on two bandages one above and one below the break, tied off on opposite sides to the injury.

–Get him onto a wagon, as soon as you can find one.

The next soldier is still cradling his arm at the elbow where the shoulder has gone. At this point, on the move, without a Field Ambulance to take in casualties and send on to hospitals, he has to patch and mend and make sure the men can keep going. He gets the orderlies to cut off the man's shirt, and then he gently places a small pad on the axilla of the injured side and bandages around the clavicle. All the while, Fred's pipe never leaves his mouth, clenched in firm concentration.

Finally he checks a third man clutching his jaw. Fred asks him to open his mouth and counts his blackened teeth, wryly, then checks his gums for blood.

–All there. You'll be sore, but you are okay.

The man nods. All around them the battalion is already packing up to move on again. It never stops.

B Company is sent to hold a bridge behind, while the Cameronians tramp south-west to Noyon then south-east to Pontoise-lès-Noyon, another 18 miles of marching. Word spreads that their retreat has been a tactic to draw the Germans south, allowing the French to hit them hard in the flank. Cheered by the thought, they push on, through the congestion, the men, the refugees. At Pontoise-lès-Noyon the first in see fires burning in a field beyond the village and challenge the occupants. To their surprise there stands Tubby with the transport, and a dinner of horsemeat on the go.

–What time do you call this, you bloody rabble? Grub's up! Nag stew! All served with a cup of Rosie Lee ... booms Wood, his round face turning slitty-eyed with pleasure.

Quartermaster Wood, former sergant-major in the 2nd Cameronians, is a portly, hard-drinking, 43-year-old Cockney and a father figure for many, impressed at his ability to rise from the ranks to take a lieutenant's pay. He also has a gift for the gab beyond most dour Scots, and a weakness for the booze that will prove his undoing, but for years he has been a stalwart of the regiment. Even the senior officers, wary of Wood's lip, are pleased to see him, stew in hand.

A quick headcount of the battalion reveals over 200 men missing – lost or straggling. The remainder, piratical and bearded, eat their fill, then strip to their underpants and wash, appreciating the lush grass under their bare feet. Some are cutting their breeches into shorts. Fred and his orderlies bind blisters, apply salve and patch up limbs as best they can. Later Fred briefs Robertson on the men's condition, noting the Colonel's

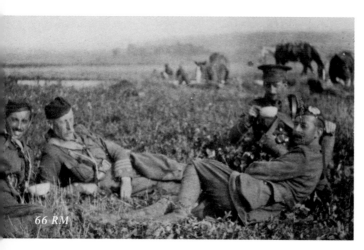

66 RM

steady style – always calm, happy to compliment his officers, diffusing anxiety with his watchful patience. Money hands his camera to Darling to take a photograph as they lie in the field, Fred studying his tea, Robertson wondering, Riddell-Webster lounging, Money grinning cheesily, enjoying his déjeuner sur l'herbe. Behind them horses graze peacefully, no hint of war or chase [66].

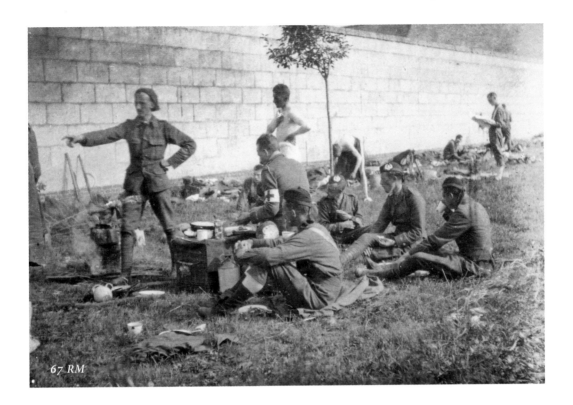

67 RM

The next morning Fred is working again, fixing feet, encouraging men to wash and shave. They cluster round, enjoying his steady good humour. Some stand shirtless reading, others just sit exhausted while Fred works [67]. He has lost eight of his stretcher bearers, and already stories are filtering back of medical staff captured, caught tending wounded too sick to retreat. The British believe the Geneva Convention forces the Germans to repatriate nursing staff immediately. The enemy, it is said later, just laugh when that is put to them.

The strange lull continues as officers return to Noyon to shop for shirts and underwear. Most of their kit has gone missing, cast off in the frantic retreat. Outside the railway station, they see a captured German Hussar officer marched under guard, tracked by a hostile French crowd, baying like dogs. Still no one knows where the enemy is or what will happen next. The Cameronians will entrench, then they will bivouac, then they will move on, all are rumoured. Rose is sent to the village of L'Aigle to reconnoitre billets and finds over 1,000 men already foisted on a hamlet of 50 inhabitants. The Army's thought-out approach to wartime administration, tested in countless colonial wars, has collapsed.

Finally at night the order comes to keep moving south, to Carlepont, then Attichy, 13 miles away. They march through forests, stopping and starting. The squeak of the wheels ahead, the regiments transport, tells the column each time when to start moving again. Outside Carlepont they bivouac in a cornfield, then move on after dawn. The countryside opens out into rolling hills. The battalion marches on, down the Aisne valley, crossing the river south of Attichy. The flood of refugees has to be forcibly held back to let the column through. They camp outside Couloissy, as sappers prepare to blow the bridge behind. Men bathe in the river, their first proper wash for a week. And hot dinner: bully beef, stewed apples, bread and cheese.

Robertson receives orders to parade the men at 5.45 am then wait. Fred assembles his orderlies by the medical cart. At 7.30 the battalion sets off, assigned to the 6th Division in the constant re-allocation that dogs their retreat. They march in stifling heat through the Forest of Compiègne along a ridge that traverses east to west before dropping south on the Paris road, then east along the railway, bivouacking near Lacroix-Saint-Ouen, north of Saintines.

Dawn breaks in thick mist, adding to the fug that now shrouds every command. Robertson walks the battalion into Saintines hoping to find the Brigade HQ. The inhabitants say it has long gone, and earlier that morning, German Uhlans had scouted the village. He notes drily in the battalion war diary: "As we had no maps it was v. difficult to carry out orders."

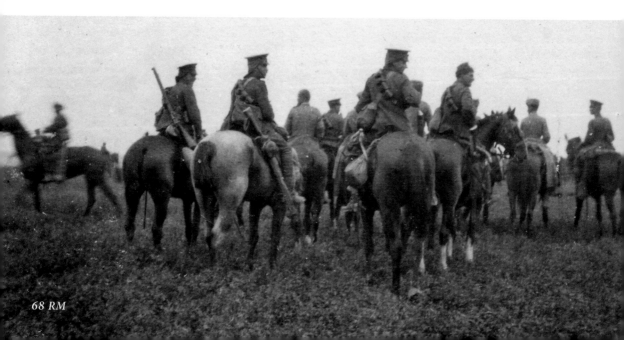

Then they hear gunfire in the distance and an officer from the Royal Horse Artillery gallops in, asking for assistance. The Queen's Bays and Royal Horse Artillery have been ambushed in camp at Néry, two miles to the south, by a German cavalry division plus artillery. The Cameronians advance alongside the Middlesex, and the Germans swiftly withdraw, leaving eleven guns. A scene of carnage greets the rescuers, horses being shot, men stretchered off, bloodtrails on the ground. Fred helps bandage the injured while Money has time to photograph the Queen's Bays marshalling their prisoners [68].

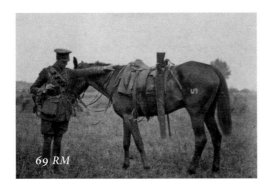

69 RM

Seeing his camera, an old friend rides up on a captured Uhlan horse and badgers him for a shot. Ronnie Brodie, one-time lieutenant in the 1st Cameronians, now with the Middlesex, is enjoying his morning [69]. He had been the talk of the mess three years ago after walking out of the 2nd battalion in Malta to join the French Foreign Legion in Morocco, fighting in colonial campaigns for France and then attempting, and failing, to escape the force. His case had been taken up by the British Foreign Office and, with war pending, he had been released from the Legion only months earlier. Brodie would claim later that PC Wren based his bestselling *Beau Geste* on his adventures. Unsurprisingly, on his return, he had been encouraged by the Cameronians to look elsewhere to regain his commission. But he still has many friends in the regiment. And now he wants a memento of his new acquisition.

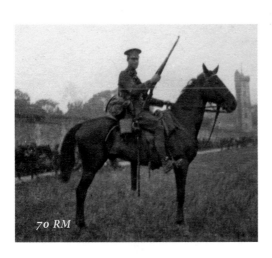

70 RM

–Come on Robin, I can see your camera.
–On your looted horse, Ronnie?
–But of course.

Brodie poses, rifle on hip, as if ready to charge across the Moroccan desert [70]. Money can only laugh.

The retreat continues, zigzagging to Rully then Fresnoy-Le-Luat, the German Cavalry never far behind. The Cameronians march, stop, deploy, waiting to see if the Germans come on, then melt away again, well practised at this disappearing act, and another bivouac. The men on watch that night can see villages in flames just four miles away, a wall of fire creeping slowly towards them. With little water to drink and only dry biscuits to eat they move on next morning, falling back, holding position, then falling back again, marching, halting, shuffling, officers moving up and down the line encouraging the men, carrying rifles, hanging packs on the few horses left.

At one point they halt again and are told to hold them themselves ready. French Dragoons appear over a ridge pursued by German cavalry. Money swings his machine guns round, either side of the road, and orders his team to load, then they open up, driving the enemy back. Fred watches from the column behind, anxious on the outcome, and worried for his friend Money, brave in a way he never could be. He sees the sense now in that suspicion of brains that leaches through this Army – brains that make you think too much, that make you stop and worry then question and run. Brains don't make you brave. Quite the reverse. But they might end this war more quickly.

They move on again. The men are now irritable, mistrusting their orders. They look less like a battalion and more a bunch of marauders, unshaven, blackened equipment in hand, French colours in their caps, knives and spoons held in their puttees.

The villages they pass are squalid and empty. At 7 pm they arrive in the medieval town of Dammartin, and camp in a farm orchard. They have marched 17 miles since Fresnoy, and are now only 20 miles north-east of Paris.

But they get little rest, as these Germans keep coming, keep pushing, an unstoppable force. By 1 am the battalion is moving back again, the orchard already coming under shell-fire. They march through the night, a walking sleep, until at dawn they reach the outer Paris defences, camions of brushwood and barbed wire block the roads, everywhere French soldiers digging trenches, preparing for the Germans. The Cameronians cross the river Marne and march into Lagny at 11 am. There Robertson has been promised a halt. The word goes down the line and every man stops where he is, and slumps to the road. Some sleep leaning against walls. Locals come

out to offer help. An old man moves from officer to officer and offers the contents of his wine cellar. Fred, off his horse and checking the condition of a soldier laid across the medical cart, waves away the offer of bottles.

–If you don't take it, the Germans will, shrugs the townsman.

Women bring out bowls of coffee laced with brandy as the Cameronians engulf the town, so footsore that any step brings a groan, until 7 pm when they rise again and straggle out to the village of Chanteloup to bivouac. Captain Harry Lee, a fusser whom the subalterns have already nicknamed Harriet, runs an inventory among B Company to see what has been lost: 73 greatcoats, 46 packs, 41 canteens, 84 entrenching tools. Lee was previously adjutant in the 1st and 4th battalions, and knows he will have to indent for every missing item. He had thought real war might mean less paperwork, now he sees the reality. Only one man in his company can produce a complete kit. The rest are – literally – ditched.

Robertson does a head count. 186 soldiers unaccounted for, also lost en route. For nearly a fortnight, the battalion has marched day and night, often without proper food, in extreme heat and drenching rain, covering close to 200 miles twisting east and west as the enemy pushed them inexorably south. Money writes in his diary: *"Nous restons ici"*.

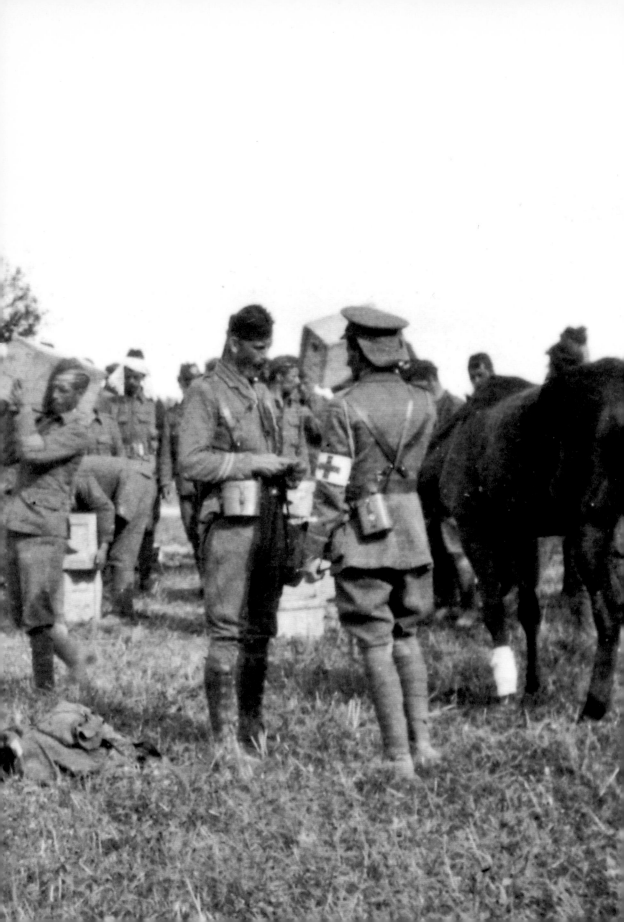

6

MARNE

15th September: Very depressed, hear things are not going so well. Very cold, very damp, cold feet etc. Have to remain very quiet in wood. Fearful battle going on, infantry and artillery. Some shrapnel burst in our wood, also high explosives, but do no harm, frightfully noisy. See our guns retiring. Don't like our position, as duty not clear ... Much rain, soaked, a night of absolute misery. Men digging trenches, stand about all night, superintending, men work in reliefs. Withdraw at dawn ...

– DIARY OF CAPTAIN RHW ROSE, B COMPANY
1ST CAMERONIANS

DO THE soldiers ever know what the generals are planning? For the Cameronians, the days after the retreat were a time to count the missing, check the equipment and bind the blisters. The British high command had other worries – whether to pull the BEF back to the Channel ports for an immediate evacuation, or stay and help the French defend Paris? Eventually General Gallieni, military governor of Paris, persuades Lord Kitchener, British secretary of state for war, to keep the men in position. So the retreat ends, and so begins the Battle of the Marne.

Foot inspection. At Chanteloup, Fred Davidson and his orderlies now work to get the battalion walking again, balming, powdering, bandaging. Flesh is stuck to sock, abraded by boot. Feet are swollen, too tender to touch. At least the men are billeted in barns and outhouses, and can rest, fed from field kitchens, finally feeling release from the pressure of constant retreat.

But at 1 am on 5th September they are on the move again, marching in the cool night air 14 miles south through the forest of Armainvilliers to Grisy-Suisnes. For the men, it is another retreat, and the worries resurface: when will this end?

They arrive in Grisy at 9.30 am. The men bivouac, officers are allocated beds in houses. They sleep and wait, tense for news. The next day they wake and their markers, showing the route to follow, have been reversed. They are to retrace their steps – the retreat is now an advance.

All the officers are briefed: we advance with the 19th Brigade, the French Army to our right and left. The brigade has a new general in charge, new motivation. They relay the orders to the men, who scent a change in fortunes. "I don't mind if I have to march on my stumps so long as I catch up with the bastards." But no one knows the full picture, no officer can answer the inevitable onslaught of questions. They march, half-knowing as ever, and in trust.

At a crossroads south of Jossigny part of the 20th Field Ambulance waits,

doctors and orderlies, assigned to join the 19th's Field Ambulance which now marches behind the battalions, scooping up the wounded which MOs like Fred send back. The new doctors can't miss how dishevelled and weary the men look, trudging past unwashed, uneasy. The men jeer back how fresh the medics and their crew appear, who have dodged the pandemonium of the Mons retreat. The ambulance joins the rear of the 19th Brigade, behind the Middlesex, the Welch, the Argylls, the Cameronians, 16 wagons of ammunition and the battalion's transports. It is a very long line.

For the Cameronians there are new men too, a 2nd Lieutenant, Critchley-Salmonson, and 89 NCOs and men to replace the missing. They march on, through orchards and open countryside, chasing the enemy, but the German rearguard keeps slipping away, the evidence of retreat all around, dead horses, broken equipment, discarded bivouac sites, fireholes dug to prevent any glow visible from the south.

North to Jossigny then east to Villeneuve, butchered sheep to eat. Next day the 19th Brigade turns north again in blazing heat to La Haute Maison, another village, another 11 miles but as ever the Germans are shadows, flitting on encounter. A plane drops messages for Brigade HQ. The men sleep out on straw, and wake scratching, irritable. Money unfolds his Kodak and catches Robertson and Lee sharing soap for a morning shave, determined to set a good example – rather easier for mounted officers. Robertson looks imperturbable, his comforter curled into a Willie Winkie night-cap [71]. Fred can still hear it in his mother's voice.

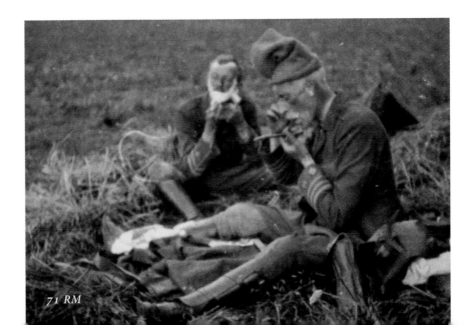

71 RM

Hey Willie Winkie are ye comin'ben?

The cat's singin grey thrums to the sleepin hen,

The dog's speldert on the floor and disna gie a cheep,

But here's a waukrife laddie, that wunna fa'asleep.

Then they are up and off, and the process continues, pushing up, encountering German rearguard, pushing on, French villages passing in a blur. They take shelling, they skirmish, they move east to Pierre-Levée, then across towards La Ferté Sous Jouarre.

Finally the battalions form up to fight, kneeling in bunches, fixing bayonets up, preparing, fearing, knowing this is it, as word passes: the Germans are making a stand. Shells start to fall more regularly. The company commanders walk upright, no ducking, offering encouragement to their men. Fred is soon treating torn flesh, bloodied scalps, the result of the first shrapnel shells bursting above ground, spraying the open fields with fragments. His friend Ferry is hit badly in the shoulder and sent back. Fred runs between the wounded like whippet, head up for a look, head down for a sniff, bolt, stop, lie flat. He could be on the wing again for Edinburgh. *Davidson is playing a good game, though he should try not to give so much advice ...*

Bullets fly past with a *wsssh pttt* as they hit wood, one so near his scalp feels the singe. So this is what it's like to be shot at, thinks Fred, working with unlit pipe gripped between his teeth, his security. He is bandaging, wrapping, filling in the tally tag, tying it on for those neat and tidy Field Ambulance docs down the line, all thought out, all logistically organised.

With no time to build an aid post, Fred stacks his wounded behind a giant haystack, out of sniping sight, working from the medical cart, nodding to his orderlies, put him here, put him there, leave him. In the shouting, he cannot hear the ominous buzzing from inside the stack. Moments later a wasps' nest erupts, forcing all to flee, wounded or not, chased by a stinging swarm. That gets a laugh.

Later Robertson takes Fred aside and warns him to be more careful under fire, and to wait for bearers to bring the work to him. A medical officer is not supposed to expose himself to threat, as a dead MO is no use to his

battalion, and his loss may cause others to lose their lives. Sit tight, let the stretcher bearers pull people in. There will be a lot worse to face soon.

–You are not bullet-proof, says Robertson sternly, then smiles. He can make even a ticking off feel like a compliment.

At Signy Signets, a hamlet with a handful of houses, the battalion waits, lying on the slopes of a high ridge as the shelling continues [72], and British guns race up by horse to return fire [73]. Many of the Middlesex are drawing rations when German shells score a direct hit. The men in the other battalions cheerfully name the spot "Ration Hill".

The chaos of battle sets in. The Field Ambulance has been left behind – it cannot find the Brigade HQ to get an order, and it cannot get casualties back down the line until more transport comes up. It doesn't believe its own horse-drawn field ambulances will find the column again in the advance.

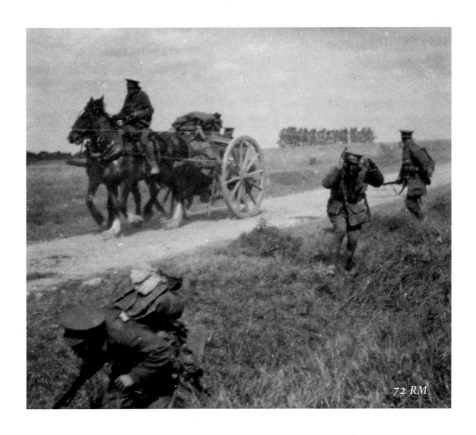

72 RM

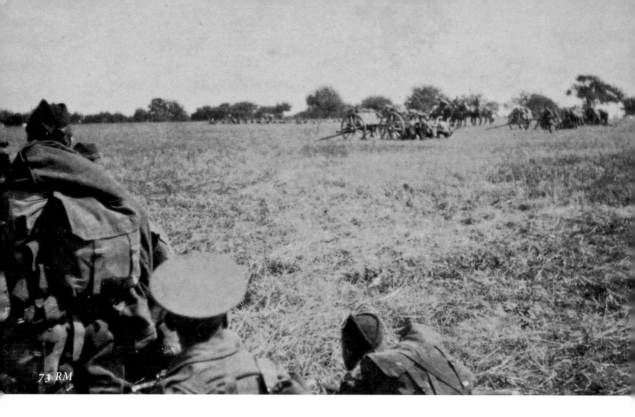

73 RM

Then the Germans melt away and a brief calm descends. The Cameronians take stock, seizing the opportunity for the men to draw rations. Money's camera catches Tubby Wood's team dispensing supplies on the same Ration Hill that earlier had seen many of the Middlesex lose their lives [74].

Cases are split, soldiers hump sacks, Robertson gives orders, Riddell-Webster and Fred are locked in conversation as one of the transport's bandaged horses grazes the grass behind them. Money is already teasing Wood that he has become the battalion's fairy godmother – if only he could stop dispensing so much salted food, the cause of a newly invented condition: bully mouth. Fred, meanwhile, has a handkerchief dangling behind his cap as a sun-guard, a smart addition in a life bent over treating others. Beyond them all, a sole remaining tree bursts incongruously upwards like an explosion.

From the hill, cold at night now, Money then takes a panorama shot of the German line ahead [75]. Innocuous fields undulate gently to the horizon. Only the closest scrutiny shows the smoke billowing in from the right – La Ferté sous Jouarre, once famed for producing France's mile-stones, is now in flames, the victim of ruthless British bombardment. It is a town keen to see the back of the enemy, yet where the Germans will return four years later.

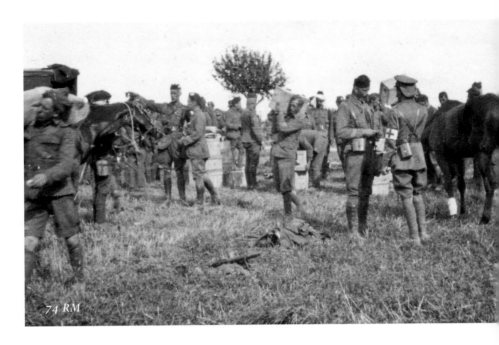

74 RM

On the morning of Thursday 10th September the Cameronians, grateful to get off the ridge, cross the Marne on a hastily built pontoon near La Ferté, in broken step to ease the wear on the swaying bridge. More debris litters the roadside, petrol tins, broken bicycles, discarded shells, high-smelling horse corpses, phone wire curling everywhere. The men are in good humour, sensing they have the Germans on the run. The planes in the sky are all British now, as the enemy's retreat is tracked.

They march a hard 10 miles north to Certigny and bivouac. Then another 11 miles to Marizy Sainte-Geneviève, officers into billets. They are in country previously well held by the Germans, and all are suspicious of the level of collaboration at any well-stocked farm. But the retreating army has also

75 RM

done its best to make all shelter unusable, fouling floors, shitting in basins, onto cooking tools. Fred can see the enemy has made this a science.

Lice, too, are now a constant companion. Fred reports to Robertson that he thinks most of the men are infested. Oakley, whose droll humour has long been a staple of the Cameronians' mess, protests that subalterns may get lice, but field officers never, ever do. His lieutenants force him to strip to his vest for examination by Fred. He, like all the others, has lice everywhere, armpits, head, pubic hair.

Fred makes officers and men strip and sit, running lit cigarettes down the seams of their clothes. He knows that lice bring more than itching, he has sat in classes linking the louse to typhus and relapsing fever. Later it will be implicated in trench fever. But a medical officer on his own can do little – the men need baths, their clothes need steam cleaning. That can be arranged by the Field Ambulance, but not when the chase is on.

The battalion, operating behind the advance guard, is marching north virtually unopposed now, day after day, on the heels of the enemy, mopping up what is left behind. Stragglers are caught, guns, wagons, horses. Air reconnaissance says the Germans are in full retreat, clogging the roads to the river Aisne. And there they stop and turn.

At midnight on 13th September, the Cameronians march into position at Vénizel, a small village south of the river. Three miles to the east, the town of Soissons, an ancient religious centre, with a military history dating back to Agincourt and beyond, is heavily bombarded. The Germans dig in on the Aisne's north bank. Every bridge is torn down. Behind and around them, the province of Picardy, with its wide sugarbeet fields, deep wooded valleys and medieval, buttressed cathedrals, waits and watches.

In a wood under dripping trees the Cameronians sit and count the minutes, soaked by rain, anticipating the order to fight. German shelling is creeping closer. Fires are forbidden, cold bully and biscuits are eaten, the men try to catch a brief sleep under waterproof sheets. Something spooks the horses, they stampede in fright, trampling men again. Five are injured. Fred and his orderlies patch them up – fractures back to the field ambulance, less than a mile behind, flesh wounds stay.

Word comes back that the brigade is over the river now but held up by

fierce German resistance, and entrenching, before another push is made. French divisions on the left and British on the right must move forward first. Always in unison. The Cameronians are held in reserve. So they wait, wrapped in greatcoats, getting shelled, getting wet. In the wood, they string waterproof sheets between branches as shelter. Fred watches ahead as a shell explodes high up one tree, 60 feet tall. With a crack, the top snaps, leans and drops slowly, bouncing through branches, as startled wood pigeons flap away.

Heavy eight-pounder shells are falling now, kicking up spouts of dark smoke on bursting. The men nickname them "Jack Johnsons" after the black heavyweight champion of the world. Behind the Cameronians, villagers have moved into local caves with their livestock, praying the fighting will pass.

At last the battalion crosses the river on a hastily made pontoon and digs in to protect it. From the 15th to the 20th September it waits, same position, same rain, continual shelling, but out of the main battle, which takes place ahead. The 19th Brigade must hold if the 4th Division is pushed back, men are told. But rumours are rife: the British are being pushed back, the French are pushing up, more troops are coming, the German Crown Prince and his family – hoping for a triumphant entry into Paris – were almost caught south of the Aisne.

But the German Army is now holding its line. Both sides dig in more deeply, and assess what must come next. On the 20th September the Cameronians are taken out of trenches and sent back to the village of Septmonts to clean up and prepare for another push. Pay is issued, tobacco too: a two-ounce tin of Capstan – the first time tobacco has been put on ration as a free issue for troops. Only Money and his machine-gun team are left behind, pushed up to the front line at St Marguerite, a mile north of the Aisne, to fight with the 4th Division's King's Own and Essex regiments. The British Army built an Empire with its Maxim machine guns, cumbersome, water-cooled but deadly, and proven in countless colonial wars. Now it doesn't have enough. The Germans have more, and they are more mobile, too.

–Lighter than the heavy ones I have to lug around, says Money glumly.

His pictures show shallow trenches and the flat plain of the Vregny plateau stretching off to the northern horizon [76, 77]. Later he notes in his

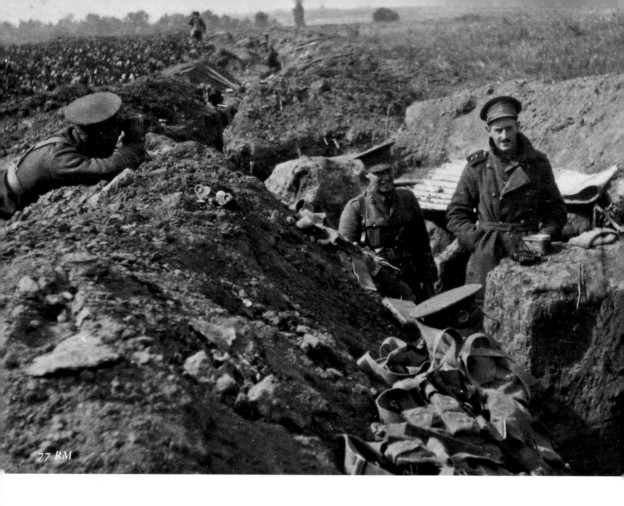

77 RM

diary that the camera brings its own hazards. "I was sniped at a bit while snapping the German trenches in front of us." By this time, presumably, his machine-gun team is used to his eccentricities.

76 RM

Five miles to the south, the Cameronians move into billets, sleeping in houses, four to a room on mattresses and straw, washing, shaving again. After the exhaustion of retreat, and the desolation of a chase across land left devastated by the Germans, the village of Septmonts is a fairytale haven. Embowered in a wooded valley off a treeless ridge, it offers a tranquil sprawl of walled lanes, small cottages and bigger homes, built with the distinctive crow-stepped gable the Cameronians will come to know well.

The centre of the village is dominated by the ruins of a Renaissance palace – once the home of the Bishop of Soissons – and a 14th-century castle whose distinctive, turreted keep pokes up 100 feet above the trees, visible for miles around. Its owner, the Baron, offers a chilly welcome, regarding the invading British much as he regards the Germans.

The villagers are less aloof, helping to wash and darn, in return for rations. These are quiet days for Fred, the Field Ambulance rolls in, just routine cases for sick parade, feet, splinters, bowels. He must check there are baths for all – organised by section, taken in large wooden tubs – clothes handed in, steam-cleaned, replaced. And complete his paperwork. Two centuries of Empire-building has left the Army insistent on ensuring all is accounted for, all is ordered. But he also has time to take his camera out into the countryside south of Septmonts, away from the action, and capture the beauty of his surroundings. In his pictures of the village nothing moves [pics 78, 79]. War is invisible.

79

78

Emboldened by Money's open use of the camera, Fred now starts taking pictures of the men around him, too. Later that week, in the same fields, the officers entertain themselves by organising a shooting party. Riddell-Webster persuades a farmer to dig up a buried shotgun – it wouldn't do to use the ranks' rifles – and Hill corrals beaters to flush out the local partridges across the surrounding land. Taking turns to shoot and beat, they drive the birds towards the gun, a perilous business as the partridges refuse to fly, preferring to run for miles through the crops, or then flapping too low to take a safe shot. In autumn sunshine at the end of the day, the officers pose in a village vegetable garden to show off the "bag" – Hill with partridge in

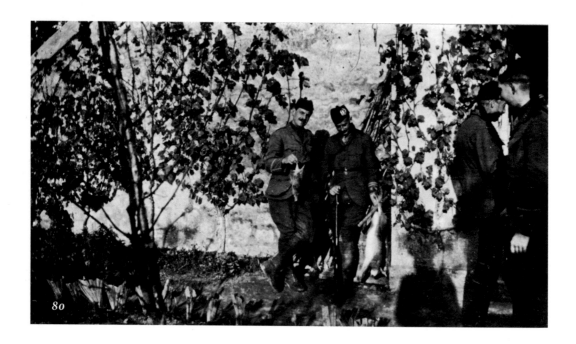

hand, Riddell-Webster dangling a hare, the old shotgun broken on his right arm [pic 80]. Behind them, vines trace the wall and in front, clipped leeks stud the bed as officers enjoy the joke: it's a pitiful bag. They could be on holiday, not half an hour's ride from the front line.

So a new normalcy asserts itself. The men are kept busy with route marches and defence digging – the Army abhors empty time – yet the pace has slowed. Fred photographs the mail and newspapers arriving at

Battalion HQ by cart [81], Hill fossilling in the caves [82] near Soissons – site of a Victorian-era find of teeth from the extinct mammal the Coryphodon – Money posing with his horse Hesperus, both newly returned from the front line [83]. His only comment on greeting Fred again is how fat and sleek the battalion now looks, hidden away in this beautiful French village. Fred can only shrug.

But now at least the Cameronians can replace much of what they have lost. The war diary notes that the battalion is 327 packs short – many of the men found them simply too heavy to carry, stuffed with their own rations.

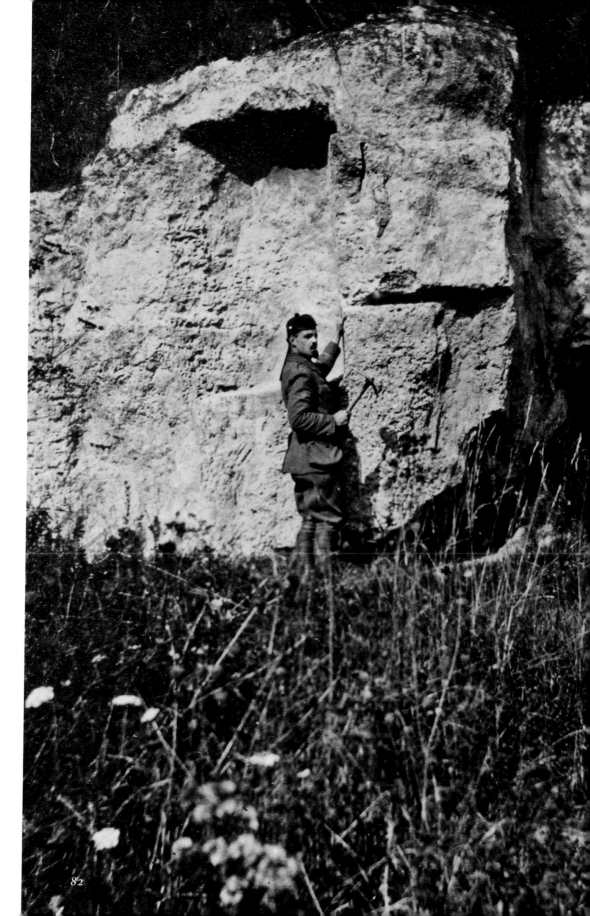

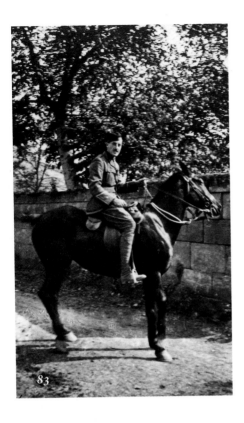

83

Some are also without shirts and greatcoats. For officers, these are items they bought with their own money, and expensive to replace: heavy winter khaki whipcord field service jacket £3 10/- ; knicker breeches £1 12/6 ; Bedford cord riding breeches £2 10/6 ; infantry breeches £2 2/- ; khaki lambswool or heavy serge British warm greatcoat £3 15/-

They head in hope to Soissons to restock, but find most of the shops abandoned, the town's famous 13th-century Gothic cathedral shattered by bombardment. Fred's photographs depict streets as a glassless wreck of rubble, men shovelling, women wheeling bicycles through cleared paths, civilians now living in cellars after the fighting has moved on [84, 85]. The town's distinctive octagonal covered market is pockmarked with shell-holes, witness to the savagery of both sides' shelling [85a].

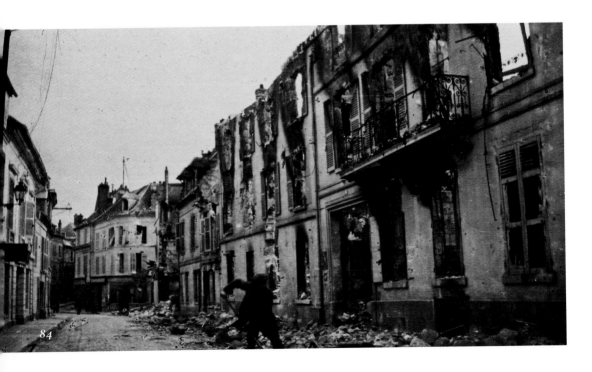

84

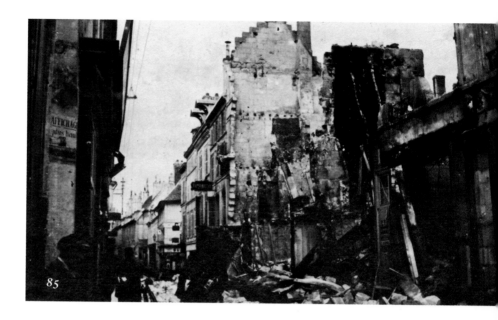

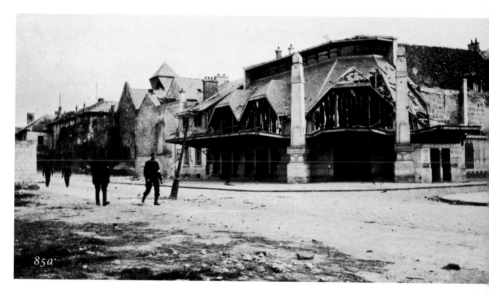

Officers root around the rubble of boulangeries, patisseries and charcuteries for anything worth rescuing.

–Looting or salvage? asks Hill later, ever the lawyer, noting that even those who held it was looting thoroughly enjoyed the salvage.

A hotel provides a meal, the cathedral a final visit before they ride back to Septmonts, passing a large camp of French Algerian soldiers – the bearded

Turcos, reputed to take enemy heads and ears as souvenirs.

–Cut-throats, as one officer describes them later, though not without a certain admiration.

* * *

Fred is conscious that his battalion has not seen a single casualty yet. It has lost Ferry and 12 others to wounds serious enough for treatment down the line. It has lost another 49 sick – bad feet, torn backs, clogged chests. Robertson says a further 40 men are still missing after the retreat, who knows where? They include many of the pipe band, who double as stretcher-bearers. So new bearers are volunteered up. They will work with Fred's own team of orderlies and have to be trained in basic first aid. That is something the MO must address on the move.

–OK, says Fred, listen carefully.

The men stand around him, at ease in a sunny Septmonts garden, though still alert to the occasional, muddled sounds of war that wash over the village.

–I want to talk about fractures. If there is any doubt as to whether the bone is broken, the case must be treated as one of fracture. Handle the limb with gentleness, bear in mind a simple fracture may easily be converted into the much more serious compound or complicated fracture by rough handling.

Common sense, thinks Fred, though he wonders if he's pitching it above their heads.

–If I or my orderlies are busy elsewhere, here's what you do. Remove the clothing gently. In the case of a fractured thigh, or leg, the outside seam of the trousers should be split right up. Braces must be unfastened all round. There must be no dragging on taking off the clothing. The leg of the cut trouser should be drawn very carefully to the inside of the injured limb, and the leg of the trousers of the sound limb can then be pulled off. The sock should be cut off, after the boot has been slit up the backseam, fully unlaced and removed. In fracture of the arm, the coat-seam and shirt must be ripped up ...

By rights they should learn to do this blindfolded, because better splinting

will reduce death-rates. And he would ask them to memorise the training manual, open beside him, but he knows they wouldn't. He continues.

–Apply splints round the limbs, so as to render the fragments immovable...
–Fragments, sir?
–Of leg. Or arm.

Frown. Fred scans their faces for signs of faintness. These are regular soldiers, they should be used to this. Continue.

–You do not need to replace all the fractured parts accurately. Leave that for the dressing station. Reduce the deformity by first fastening the lower bandage round the carefully applied splints, pulling gently and slowly in the line of the limb, and then securely fastening the upper bandage. To support the limb effectually the splint should extend beyond the joints above and below the fracture. Pad the splint with soft material to protect the limb from any hard edges.

–What can we use as splints, sir?

He remembers the old handbook and its choices: "wood, iron, perforated zinc, pasteboard etc." Where should he start?

–Wood or iron. A rifle will do in emergency.

Except, of course, the HQ team won't want all the battalion's rifles disappearing down the line as splints, with the resultant endless indenting for replacements. Never mind. It's in the book.

–Let's look at splinting a thighbone. As drawn in this illustration.

Fred holds up page 177 of the training book. A man lies vertically up the page in full RAMC uniform with arms crossed and a rifle bound down his right leg. To Fred, he looks more Henry III in Westminster Abbey than Private Jock on the Vénizel battlefield. His bearers, he guesses, wouldn't go in for royal tombs.

–I'll show you on Hawes.

Private Hawes, assigned to the team that runs the battalion HQ for its

officers, lies flat on the ground in front, dolefully holding up a rifle and a bundle of bandages. Cue laughter. Fred waits for the group to settle.

–Rules for the application of a rifle-splint are as follows. Remove the bolt and see that the rifle or magazine contains no cartridges. (Pause for more rueful laughter.) Take a narrow-fold bandage, place it over the heel-plate of the butt in such a way that two-thirds of its length are in what will be the outer side, and one on the other side of the butt; take a half-hitch round the butt with the long end, making a half-knot on the outer side above the D for the sling. Tie the ends so as to form a loop about two inches long. This is for the perineal bandage to pass through and is called the butt-loop. Leave the magazine in position, place the rifle along the injured limb, butt towards the arm pit, magazine uppermost. Take a narrow-fold bandage, place its centre over the ankle of the injured limb, pass the ends behind, enclosing muzzle of rifle, cross behind. With the outer end, take a turn round the muzzle in front of the foresight, bring both ends up, cross over instep and tie off on the inside of the foot. Take a narrow-fold bandage ...

* * *

Beyond them, the war rumbles on. Rumours fly of breakthroughs and counter-offensives, espionage and sabotage. But the daily pounding of guns beyond Soissons tells its own story of a fight slowly bogging down. The medics are warned to look out for spies driving a motorised ambulance. Then the battalion is told to parade every morning at 5.30 am in preparation to move. A rumour circulates that the Germans are breaking through at Condé. But still the Cameronians stay put.

On 27th September, Robertson dictates to Darling, still writing the battalion war diary on torn-out signal pad pages, a scratchy list of his officers:

1ST CAMS

HQ

LT.COL. P.R. ROBERTSON

MAJ. C.B. VANDELEUR

CAPT. & ADJT. J.C. STORMONTH DARLING

LT. R.C. MONEY

CAPT. T.S. RIDDELL-WEBSTER

A COY.

MAJ. J.G. CHAPLIN

CAPT. T.R. McLELLAN

LT. J.F. HEWITT

LT. D.G. MONCRIEFF WRIGHT

LT. J.H.C. MINCHIN.

B COY.

CAPT. H.H. LEE

CAPT. R.H.W. ROSE

LT. E.W.P. NEWMAN

2LT. P.R. HARDINGE

2LT. H.S.R. CRITCHLEY-SALMONSON

C COY.

MAJ. R. OAKLEY

CAPT. W. CAULFIELD-STOKER

LT. H.O.D. BECHER

2LT. C.D. ROOKE

2LT. J.D. HILL

D COY.

CAPT. F.A.C. HAMILTON

CAPT. A.R. MACALLAN

LT. E.W.J. HOBKIRK

2LT. R.D. GRAHAM

QM LT. G. WOOD

The following officers are employed or sick:

CAPT. J.L. JACK – Staff Capt. 19th Infy Bde.
appointed 23.8.14.

LT. C.F. DREW – *Sick 5.9.14.*

2LT. E.L. FERRY – *Wounded 9.9.14.*

LT. D.C. FOSTER – *Sick 27.9.14.*

Lt. F.C. Davidson, tellingly, is off the list. He may be battalion medical officer, but he is not quite in the band of brothers yet.

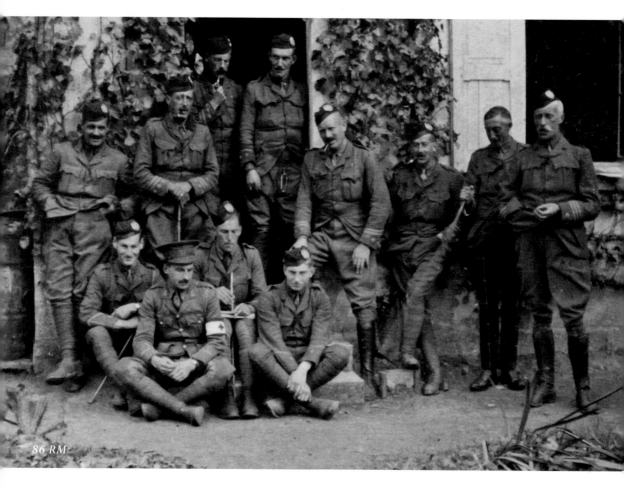

86 RM

in doorway: Hamilton and Becher;
to left of doorway: Hill and Macallan;
to right of doorway: Darling, Riddell-Webster, Oakley, Robertson;
seated: Graham, Davidson, Hobkirk and Rooke

He is always there, however. Money takes a picture at the Cameronians'
HQ billet just days later [86]. It has a men-at-the-back, boys-at-the-front
feel: Robertson, in boots and breeches, flicks cigar ash; Oakley, in tartan
trews, swipes the dirt with his stick; Hill grins, Graham smirks, Rooke is
nervously anxious while Fred, cross-legged at the front, simply looks shyly
away, uncertain what his pose in this group should be.

By the end of the month the newspapers being sent through are full of
jingoistic accounts of the battles being fought. Fred and his fellow officers
can also recognise the names of school friends in the casualty lists that

accompany the stories. And the rumours worsen: French divisions from the south have refused to fight in Alsace, 400 officers and men have been shot by their own side, the Germans are preparing to invade East Anglia, the Russians are sending troops to help defend Britain. Outside Septmonts, spies in ambulances are now seen driving at breakneck speeds through the countryside. Germans left in hiding have been found with phone cables laid back to their front line.

But one story transfixes all: the British Expeditionary Force's senior staff officers have leaked what is purported to be a copy of orders issued by the German Emperor to his generals on 19th August: *"It is my Royal and Imperial command that you concentrate your energies, for the immediate present, upon one single purpose, and that is that you address all your skill and all the valour of my soldiers to exterminate, first, the treacherous English, walk over General French's contemptible little army ..."*

Years later the order is revealed as more likely clever propaganda than truth – the Kaiser claims he never sent it, and his generals say they never received it – but that September it gives the beleaguered BEF a tag. They are the Old Contemptibles, man and boy, and the Kaiser can stuff it.

Others still worry their moment of glory may pass unrecorded. On 30th September, in scratchy ink, Lieutenant Douglas Moncrieff Wright, an only child who writes to his parents every other day, sends the following request in a letter home: "I wonder if you could send me a camera, a folding one. To take photos about the same size as a No 2 Brownie ... and send six rolls of film. Each roll in a round tin ... And send the camera and the films separate not to make too big a parcel ... We had roast mutton for lunch today, it was splendid."

And Wright's parents, living in Kinmonth, near Perth, duly oblige. So the battalion's illicit photography club gains a third member and by the end of October, 21-year-old Wrightie – as he is known to fellow officers – has a camera too.

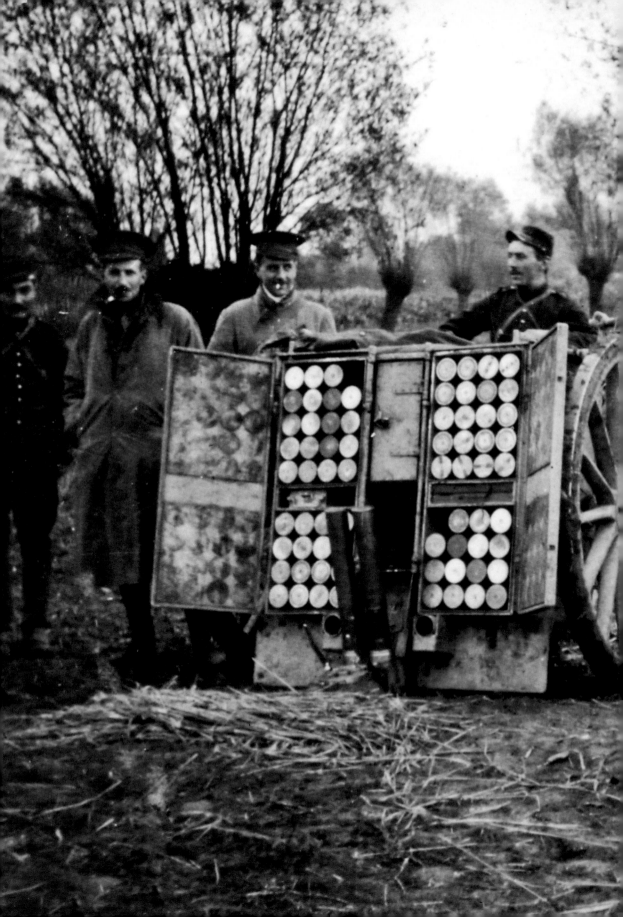

7

TO THE SEA

When I got to Captain Rose, I asked him where he
had got it, he said in the back. As soon as he said that,
he got another that killed him ... And then I got mine
through the thigh, I must have fainted after that,
because when I came to my senses, I was in a ditch and
no-one seemed near me ... I was dragging myself along,
when I caught sight of a house, so I thought if I could
manage to get there I might be alright. So I kept on and
it seemed like hours ... Mr Rooke, a young lieutenant,
came and helped me ...

– MEMOIR OF CORPORAL ARTHUR HONEYBALL,
B COMPANY, 1ST CAMERONIANS

UP AT 5 am, standing to arms, then fatigues, building trenches, practising defence, then the afternoon off – that had been the pattern at Septmonts. The word goes round that the early starts mean only one thing: the Brigade wants to remind them there is a war on. Finally on 5th October they are off. Bags are packed, transports are readied, goodbyes are said. After a last meal at 5 pm the Cameronians move out, marching south, then west. Fred Davidson had his medical cart ready long before the start, his supplies restocked, lost equipment replaced. He will need it. Officers who have spent the week studying any map they can find have an inkling of where they are heading: for the main train-line north. The Germans are trying to outflank their opponents on the Marne, pushing up and round, and the British are now doing the same. All sides rush north to find a gap and a breakthrough.

The 19th Brigade march by night and hide by day, bivouacked in oak woods dappled with wild cherries, leaves just starting to redden. The battalions deploy field kitchens at the roadside and mask their transports with branches and netting every evening, hoping to blur into the pre-autumnal haze for any tracking Taube [87].

They pass French cavalry on the move, the whole sector is in flux as both armies pull troops from the front around Soissons to push north [88]. The British and the Belgians are already engaging one German army around Antwerp, but to the south a large gap remains. The race to fill it has started.

Down to St Rémy-Blanzy, west to Corcy and on to Villers-Cotterêts then
Vez, Béthisy Saint-Pierre and Pont Sainte-Maxence. The Picardy villages
are dark at night, many in ruins, plundered by the Germans a month earlier.
Bridges are blown, replaced by pontoons. The men walk in silence without
songs, without banter, the dark intent of their hidden march weighing
heavily on them. By daytime they try to sleep, but the sun and the guns –
audible to the north – make it a waking doze. Behind the brigade the 19th
Field Ambulance follows. It's already countering the medical orderlies'
love for drinking with Field Punishment No 1, tying men to the carts by
their wrists as a punishment for extreme drunkenness. They stand splayed,
forearms out, for hours at a time, like weary prisoners. This throwback
to Victorian days is not popular with younger doctors, though for some
soldiers, being tied to a cart, especially if you're near an estaminet with
a sympathetic patron, is no hardship. Later in the war, when volunteers
question the whole purpose of the fight, its allusion to crucifixion is lost on
no one.

At 7.30 am on 9th October the Cameronians emerge to march in daylight 10
miles north to Estrées St Denis, a small town bisected by the main railway
to the sea. By 4 pm nearly all have entrained, leaving B Company to follow.
The train runs slowly all night, arriving in St Omer, Pas de Calais, at noon.
The town – no stranger to war, having been fought over by the French,
Dutch, English and Spanish for centuries – sits at the centre of the north's

network of canals, and offers ready access to the Belgian frontier. The battalion has travelled 100 miles, and is now only 20 miles from the coast, and a boat hop to Folkestone.

They march east to the town of Renescure, billet for the night, then march further east through Ebblinghem, Hazebrouck and Borre to bivouac and entrench, the digging hard work in the sodden clay soil. They are in Walloon country now, ever closer to the Belgian border, their pidgin French met with puzzled shrugs from the locals. The Germans have been and gone, leaving wounded for the British to take up, and the soldiers are on edge, waiting for the order to engage, always imminent, but never coming. Rumours reach them that the Germans are reinforcing, and battle is imminent. But when?

The officers are told the 19th Brigade is now joining the 6th Division again, and advancing to clear the Germans from Bailleul, another historic town on the main Calais to Lille train line, nine miles to the east. So up next morning, following the Royal Welch again, ready at last for a full-on fight. They hear bursts of firing ahead, a machine-gun's stutter, then quiet, and enter Bailleul's quaint town centre unopposed. The Germans have again pulled back, wrecking buildings as they go. The inhabitants emerge to cheer them in, "Vive Les Ecossais!" and offer beer and wine. But the Cameronians must march on, to camp in damp fields, to sleep with magazines charged and bayonets on, ready for enemy counter-attacks. The cheerful cynicism of war already infuses them. "Heard we are to move back into billets, so make a bet we won't," writes Rose in his diary that night. The Army at war, he has discovered, is a ponderous, contradictory animal.

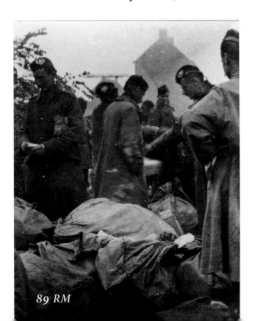

89 RM

But it's still adept at delivery – Money captures Rose the next day at the mail drop outside the village of Steenwerck, vast bags following the battalion, bringing parcels and letters from loved ones [89]. Home to ship, ship to train, train to wagon, wagon to battalion, battalion to company, company to post corporal, the system has been tested by Empire and works.

And the men have already come to depend on parcels for the extras which the Army

doesn't provide: tobacco, chocolate, dried fruit, mittens, spare kit. Soon the other side of war reasserts itself. An order comes at 4 pm to return to Bailleul and go into billets. The ranks, remembering the offers of alcohol, set off in good heart, only for the order to be cancelled three hours later, about turn, back to Steenwerck, set up a defensive perimeter at 1 am and wait in the rain, lying in sodden, flat fields, dreaming of the beer from the breweries they can see studded across the region.

They wake on Sunday and hold a full Church Parade. For the Cameronians, once persecuted by Stuart monarchs, it has its own rituals: sentries posted – a throwback to the open-air prayer meetings under threat from the King's Dragoons – an all-clear given, the commanding officer telling the padre "The service may begin". All ranks attend, Scottish psalms are sung, drowning out the thump of guns now audible from beyond Ypres. The same songs were sung by the same regiment during Marlborough's campaigns in Flanders, not far from this very spot. Lieutenant Rooke leads a small band of Catholics in a separate service later on.

That afternoon the troops look on wide-eyed as a fleet of 33 open-top London buses roll in, part of a new experiment in transport. They arrive uncamouflaged, carrying their London adverts. The ads for Dewar's White Label cause a wistful wince, Pears Soap a soft chuckle. Robertson is ordered to load his men, and off they go as if on a Sunday jaunt, 10 buses per company, for an hour's drive at 10 mph, to check the feasibility of using the transport at the front. The soldiers, happy to put their feet up, and conscious that the buses might mean "less bluidy marching", are impressed.

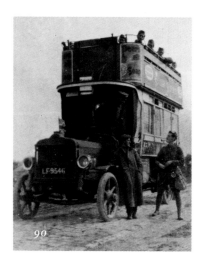

The next day the buses return, led from the front by the Liberal Parliamentary Whip Geoffrey Howard, conscious of the publicity potential, happy to be photographed away from his Rolls Royce. Fred's pictures show the solders gawping from the top of the first bus, while Graham, pipe in teeth, strikes a pose for a driver who looks less than impressed [90]. Another photograph shows Howard, vice-chamberlain of the Royal Household, striding importantly past with Robertson as Cameronians single-file up the stairs [91]. The London and North Western Railway advert plastered on the side – Your

Summer Holiday – draws another wry smile from all.

The battalion boards at 2.30 pm. Destination: Laventie, a small village south of Armentières, back the other side of the French border. Pushing along clogged roads, the buses trundle south through Kemmel and Steenwerk, encountering heavy traffic all the way – supply columns and French cavalry – plus a broken bridge still under repair. It takes them six hours to cover 22 miles. Robertson notes in his war diary, in his now customary dry way, "Going in buses not all 'quite simple'." Even so, the rest of the Brigade marches by foot, and doesn't catch up till the next day.

The men can feel the battle nearing now. News has filtered through that Antwerp has fallen, and the Germans are pouring across Belgium to join those in retreat for a counter-attack. The thump of heavy guns is constant, the way ahead seething with a flux of troops, the landscape dotted with burnt-out houses, yet the battalions have little idea as to when and where the enemy will appear, let alone where other British forces lie – 6th Division to the north and II Corps below them. They simply sense a weighty jigsaw being pushed into place.

Laventie, a sprawling town of farmers and artisans, has been ransacked by the departing enemy, windows smashed, furniture broken, bedding torn and defecated upon. The next morning the 19th Brigade moves out rapidly to support the French front line. First to Fleurbaix two miles east, then to Fromelles, three miles south, where their allies hold a gap between the British forces but are coming under heavy pressure from the Germans. The Welch and the Argylls entrench before the hamlet of Le Maisnil, the Cameronians and the Middlesex are kept in reserve, holding position in a deep drainage ditch. The front line is now half a mile ahead, a low ridge that stretches from Aubers to Radinghem, the vista scattered with farms, orchards and ditches, studded with pollarded willows.

Rose, a fluent French speaker, asks some Cuirassiers returning from the front how the fight is going. Good, they say, they are not retreating, just coming back to make coffee. When Rose relays it to B Company, they

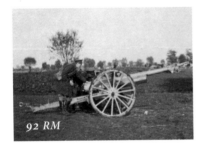

92 RM

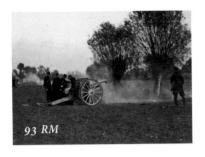

93 RM

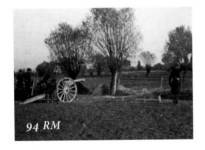

94 RM

can only admire the French nonchalance. It must be going well.

To their left, French guns suddenly start up. Rows of artillery are now lined across adjoining fields, widely spaced to avoid the Germans' return fire. While the battalion waits to move up, Money introduces himself to the French officers, dragging along Fred and Captain Churchill, the signals officer allocated from Brigade. The French seem pleased to show off their famous 75mm guns, the first invented to absorb their own recoil and allow rapid firing without realignment, 15 rounds a minute, at targets up to five miles away.

Fred cannot resist, stepping in to sight a gun, then out of shot so Money can take a photograph [92], before the artillery team resumes firing, clearly enjoying the British admiration, while forward observers signal back their success [93–94]. Later they all pose for a group photo by a limber stuffed with unused shells.

The battery's barrage brings an immediate retort from the Germans' own guns, and shells start to cascade, trying to pick off the French guns. Pfshush! One shrieks past low and loud and buries itself in the mud, just

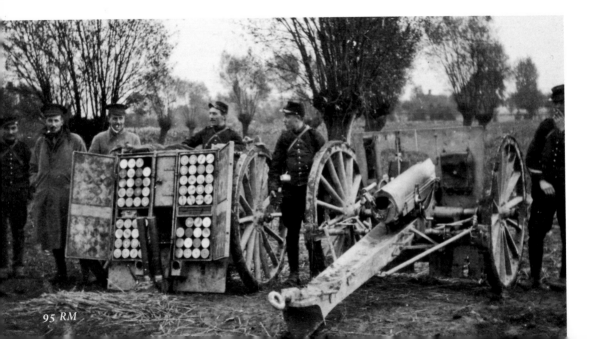

95 RM

yards away, without explosion. They stand looking at each other and the hole, calculating just what they missed. Money then takes a picture of the gouged earth at Fred's feet [96], writing later: "This shell (the fuse can be seen) narrowly missed our heads while taking the above photos, and landed behind us, fortunately it did not burst and turned right over on landing." Had it exploded he, and Fred, would not be around to enjoy the caption.

By the afternoon, fighting on the line from Fromelles to Le Maisnil has intensified. The Argylls, the Middlesex and the Welch are taking the brunt, casualties coming back through the Cameronians, held in reserve. Jack arrives on horseback from the 19th Brigade HQ, wanting a company to help

96 RM

the Middlesex. Lee volunteers, and B Company runs off, heads down, while the rest of the battalion waits, bayonets fixed, in case the Germans come through.

Up ahead the shelling, machine-gun and rifle fire is now intense. The battle escalates, no firm positions, communication fraught with risk. The Brigade's left must close the gap with the 6th Division's right, but where? How? B Company splits into platoons to enter the village of Le Maisnil, crouching low. Some swiftly get lost. The Germans shell the church ferociously, picking the steeple as a targeting point. Staff officers like Jack are now galloping between Brigade, battalion and companies, ascertaining position, passing on commands, relaying news. With a moving fight, the well-practised chain of command threatens to break.

* * *

Fred and his team can only wait to see how the battle moves on. He stays busy helping the wounded stragglers coming back through the lines, working from a table by his cart. He splints fractures, and cleans bullet wounds, checks the dressings, replaces ones badly tied. The packet wrappers lie at his feet. 'S. Maw, Son and Sons, manufacturers of First Field Dressing, Two Dressings in Waterproof Covers, each consisting of a gauze pad stitched to a bandage, and a safety pin.' They must be having a good war, thinks Fred, not to mention whoever is making all the Eusol and iodine. And the morphine? The Germans have it, we have it, the French, the Russians, where is it all coming from? How long will it keep coming if this isn't over by Christmas?

A doctor has his own silent chatter to listen to. It's how Fred likes to work with his hands, asking, answering, while the fingers busy themselves. It's how his carpenter grandfather worked the wood, and how his minister father works his garden. He has heard his father muttering as he hoes, probably practising Sunday's sermon.

Fred can fix anything with his fingers, it's the same skill that makes him good at hockey and golf, the same enjoyment he gets from loading and unloading a camera, putting together, pulling apart, his digits move instinctively, fulfilling purpose. If I get injured, he thinks, don't make it my hands. With these he can sort out any injury. Almost. It's the neck haemorrhages he now dreads. He knows his way round most of the body, but with the neck he still pictures the drawings.

The common carotid artery, lying in the side of the neck, may be compressed against the spine by pressing with the thumb backwards and inwards in the hollow of the neck, formed between the windpipe and the ridge of muscle running behind the ear to the centre of the breast-bone ...

Fred remembers one injured private near the Marne, or was it Vénizel, he can't place it, bearers have the man on a stretcher, not a Cameronian, was he Welch? Middlesex? One orderly is holding the man's neck, blood everywhere. Fred is trying digital compression to stop the flow, bright red, pumping out in jets, he could see the other men reacting, fear spreading. And Fred is fumbling to stop it, hands on wound, on the neck, ignoring every instruction on sepsis and cleanliness, trying to staunch the flow, trying to remember those pictures.

The subclavian artery may be compressed at the base of the neck opposite to the centre of the collar-bone. By drawing forward the shoulder, the artery will be more easily reached by the thumb pressing downwards against the first rib behind the clavicle. Compression can also be effected with the handle of a key wrapped in a soft cloth ...

Who writes these ruddy things? A key? Where's a key when you want one stuck on the road in the north of bloody wet France.

Axillary artery ... Branchial artery ...

He has got it, eventually, holding the flow. He gets a bearer to follow his lead, apply pressure, hold it, while Fred thinks what to do. Forget the key, where's Albert Hustin when you need him? The Belgian pioneer of blood transfusion was, according to the medical journals ... For once Fred can't remember. Let's hope he's somewhere this side of the front. Fred knows his patient is doomed, he has lost too much blood, and without replacing it he will die. But he can do no more, the Field Ambulance will have to sort it out, and he makes a bearer sit, applying pressure to the man's wound till the buses come to pick up what others have collected, the trickle becoming a flood as the fighting intensified. He never finds out the man's fate.

But that was then. It begs another question, though – how can he improve as a doctor if he never knows the outcomes of his treatment?

By dusk the Argylls and Middlesex have been driven back, the enemy

occupies Fromelles and Le Maisnil, and a tense night awaits. The last British troops retreat through the Cameronians, now under order to hold off any enemy advance until trenches can be dug to the rear. Ahead they can see Germans moving in strength between the villages, grey shapes, intent, devious.

Robertson sends forward two platoons from D Company, under Macallan, and two from C, under Rose, as a covering party while the rest of the battalion dig. Macallan and Rose take advance positions to monitor German movements, then move up their men in file. Outside Le Maisnil they are suddenly strafed by machine-gun fire, caught in the open, with enemy revealed on the flank. Rose swiftly drops his platoons back to an irrigation ditch. The machine-gun is stripping the grass 12 inches from their heads. Hill takes men to the corner of the ditch as it turns for the village, to stop any Germans crawling towards them. And there they sit out the night, knees in the mud, holding the line, alert with fear, hoping to crawl back toward the battalion just before dawn.

It is still dark when Rose decides he has to tell Macallan of his plan to pull back and he sets off to find D Company. Hill is left in charge. It is the last he sees of Rose. As he leaves, German shelling starts. Two men are instantly killed – the first Cameronian casualties under fire. Hill remembers the drill, their bloodied corpses must be searched for pay books, papers, identity discs. The men want to carry the bodies back, he forbids it, reluctantly; carrying them would just put others at risk. He covers the corpses with their groundsheets.

Shortly before dawn, following Rose's earlier instruction, he pulls the men back under heavy enemy fire. As they slip away, crawling quickly over the muddy field, the firing intensifies. A private in front of Hill pitches down, shot in the back.

–Where are you hit?

Legs flail, the man looks petrified, saying he feels numb. Then he rises on all fours, grinning.

–There's fuck all wrong with me, sir, he says. The bullet had struck the steel blade of his trenching tool, wedged between the supporting straps of his pack.

–Then get down before there is, retorts Hill.

Behind them, the rest of the battalion is digging in fast along the hamlet of La Boutillerie, a mile south-east of Fleurbaix, trying to create a defendable position. Nothing is linked: no communication trenches, no easy routes back, big gaps between lines that have to be protected by rifle fire, only support troops further back as a final block, sometimes not even that – but it's something to hold against the German push. When it comes.

Over the top, the survivors from C and D straggle back, and it becomes clear what price has been paid. Fifteen men killed, including Rose, the first officer to die. Macallan and 20 men missing, presumed captured. Thirty-seven men wounded. One survivor, Private Honeyball, recounts Rose's death. He had been leading the men back under attack from the Germans, dodging from cover to cover, turning to see where next, then collapsed, shot.

–I asked him where he'd got it, and he said in the back, as soon as he said that, he got another that killed him. I had got hold of him by the feet, and the other chap had got hold of his shoulders by the time he got the second shot. And then I got mine through the thigh. I must have fainted after that, because when I came to my senses I was in a ditch and no one seemed near me, and I did not know which way to go. The shots were whizzing overhead, and then there was a lull in the firing, so I thought I would look and see if I recognised anything. I then knew which way to go ...

Fred works on Honeyball's thigh as he tells the story, lain out on a stretcher bed in the aid post now set up behind a deserted cottage. The soldier is lucky, the bullet through, no fracture, but wounded badly enough to get back to Blighty. He won't walk for a while.

Fred moves from Honeyball to the others as they limp in. Bandaged, injected, wrapped against shock and cold, they must wait till the next nightfall before they can be collected. The German bombardment increases, with each shell a rumbling crash, black smoke, a peppering of brown soil or a clattering of roof slates. One "Jack Johnson" explodes too close, maiming Fred's horse and two ammunition ponies. Clear the mess, keep working, find another horse from transport. Everyone wants the medico to be mobile.

More survivors appear. Suddenly, out of the gloom, news comes that Graham is still alive, wounded in the thigh, carried and pulled to a ditch a few hundred yards ahead by Private May. Others tell Henry May's story, his section decimated by German fire, he has first tried to drag back a wounded lance-corporal, Lawton, then when Lawton is shot again, and dies, he helps Corporal Taylor lift and drag to safety the bleeding Graham, their platoon commander, who orders them to stop and save themselves. Instead, Taylor heaves Graham on his shoulder, and is promptly shot dead. May then laboriously, over 300 yards, under a hail of bullets, pulls the wounded officer back towards a covering ditch, and waits out the night. The next morning a patrol spots them and Graham is stretchered back, unconscious but still alive.

May, a reservist who works as a weaver's assistant at a Glasgow muslin manufacturer, is later awarded the Victoria Cross. Wounded by shrapnel before the award is gazetted, allowed home to recover, he returns to the Cameronians shortly after. When his wife Christina is told the good news about his VC by journalists at her Bridgeton home, she replies there is one thing she would have preferred.

–Him comin' in that door as weel as when he left.

And he does, surviving the war to attend George V's London parade for VC recipients in June 1920.

The elfin Graham recovers in hospital – though he will always have a limp – and goes on to become a Major-General, serving under Montgomery with the Eighth Army in World War Two. His lifelong attachment to the regiment, and his paternal oversight of its men, later earns him the soubriquet Daddy Graham. May says the officer had been so generous buying chocolate and biscuits for his men on the retreat from Mons, when they had lost their rations, that it was unthinkable he would leave him behind.

* * *

Then the first attack starts. German infantry is coming head-on at the Cameronian trenches now, grey greatcoats scuttling like beetles between trees and barns. The trench line seems too stretched to hold – normally a battalion would defend 300 yards not four times that distance – but it does. Both sides are desperate, the Germans to hack through to the French

Channel ports before substantial reinforcements can be brought against them, the British to hold the line, and stop them.

And the line drawn will hold, with a push here and there, for the next three years.

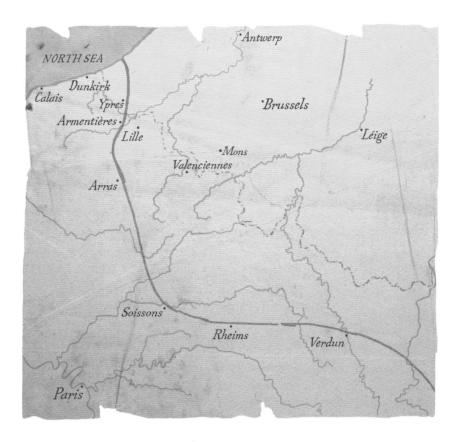

The Western Front in November 1914 - The British side of the line is to the left of Lille.

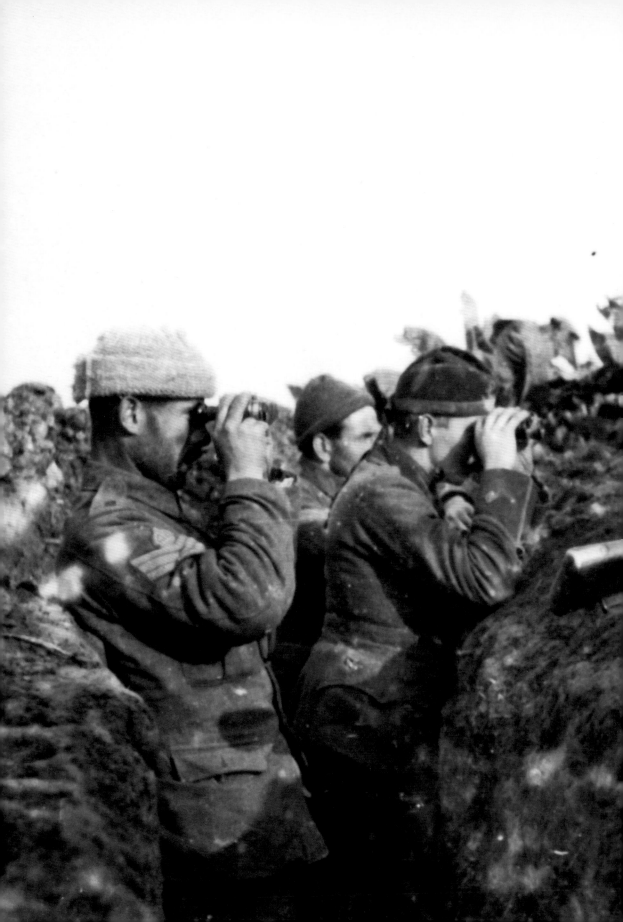

8

LA BOUTILLERIE

25 October: A ghastly night. Pouring rain, clay soil, trench like a huge puddle. One mass of clay from head to foot. Men all wrapped in waterproof sheets. Enemy very venturesome. Our listening posts continually doubling in with wild tales of the enemy advancing in strength. There is no doubt that the Germans are more soldierly than our men in every way. I don't mean better soldiers, but they have a more soldierly spirit. Their patrols work right up to us. We have shot five men of theirs bravely advancing to get information – a thing our men seldom even attempt.

– DIARY OF CAPTAIN AG RITCHIE,
COMMANDER OF C COMPANY, 1ST CAMERONIANS

ELSEWHERE THE front is taking shape. The 19th Brigade has received a battering, the Welch advancing too far without support and pulling back, the Middlesex engaged in hand-to-hand combat, the Argylls losing most of their transport. Lieutenant Dillon, medical officer for the Middlesex, has been shot through the arm and pulled back to the Field Ambulance, which sends another doctor up to replace him.

Under wet-wool skies and autumn drizzle the pattern is set, the Germans attacking each day from their trenches 600 yards away, and the Cameronians pushing them back. C, A and D Companies are stretched across a mile, with B in support. The main road from Le Maisnil runs through the left of C Company – beside it a small farm which forms a salient in the line, jutting out into German territory. Held by C Company, now commanded by Ritchie, it's tagged "Money's Farm" as he places the battalion's two machine-guns there, one in the middle of the company, another further forward to sweep the road. Later, when he's captioning his own photos to hand round at regimental reunions, Money will repay the compliment, and tag the position "Ritchie's Farm".

The photos, invaluable to the enemy if Money had been captured, show the C Company trench curling up to the road, then replaced by a mound of earth to crawl behind, then snaking off again, dug deep [97].

97 RM

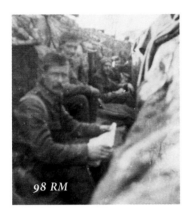

98 RM

99 RM

Later Ritchie is seen in his trench, stern, moustached, orders in hand, with Private Cairns – later to win the DCM for rescuing a colleague in No Man's Land – by his side [98].

And Money's own position in advance of the farm is shown in all its precariousness [99]. A twist of trench and a haystack, a solitary soldier manning the dugout beyond, the trench little more than four feet deep.

A pattern starts, shelling at 4 pm, followed by small, probing attacks each night. The Cameronians have dug small trenches out to create listening posts, 30 yards beyond their defensive line. Each morning the cabbage field beyond is littered with German soldiers who have crept bravely forward only to be picked off.

Then the daytime sniping starts, bullets whistling past, like strange refracted birdsong.

Ritchie, who had only rejoined the Cameronians a fortnight earlier – shipped in from India, where he had been seconded as adjutant to the Indian Volunteers – is proving an aggressive defender. Convinced that a haystack in No Man's Land is being used as cover by enemy sharpshooters, he crawls out one night with Privates Mardell and Childs to burn it down. It is fraught with danger, using a clutch of hay soaked in rifle oil, squirming to the German side of the stack as the wind pushes back towards his own lines. The hay smokes blackly for minutes before bursting into flames and alerting the enemy who fire rapidly on the party, scattering them into the roadside ditch beyond. But they survive unscathed.

Shrapnel shells and enemy attacks are now taking a steady toll of men. Four wounded on 24th October, four again on the 25th, 14 killed on the 26th, and 11 wounded.

101

The combination of rain and shelling turns surrounding fields into a quagmire. Fred Davidson hands his camera to an orderly and wades through the clods behind his aid post to pull out a spent casing. His pose is of a man making a memo to self – knee deep in mud, pipe clenched as always, hair matted from sweat, shell in two hands, flat northern France stretching off to grey horizon [101]. This is how it was. I was there.

Some go no further. Lieutenant Hardinge, newly arrived, shakes Corporal Eady awake in his trench. No response. So he lights a match low only to see blood-matted hair – sniped. Eady had died the previous evening, and slumped, presumed sleeping.

Brigade HQ insists on daytime patrols to probe the German strength and position. This is lieutenants' work – one reason why their lifespan was shortened in trench warfare. Hill,

Erquinghem-Lys

Sailly-sur-la-Lys

Bois-Grenier

Estares

La Gorgue

Lavente

Radinghem-en-Weppes

Fromelles

Aubers

Vielle-Chapelle

Neuve-Chapelle

Sainghin-en-Weppes

La Bassée

X = La Boutillerie

Newman and Rooke are sent out with a platoon each of men, crawling up to the German line. The top brass suspect the enemy is pulling back by day, leaving only snipers to harass the British line. If they are wrong, it could be a suicidal task for the patrols.

Hill expresses his misgivings to Ritchie, who agrees the insistence on a whole platoon jeopardises everyone; just four men would do, not 25. They devise a plan to put most of the men on the flank, to provide covering fire – so as not to disobey the order – while Hill and three others crawl forward.

Eventually 20 men prepare to slip out, removing all unit insignia, ditching their packs, donning balaclavas, stuffing 40 rounds apiece in their pockets. They crawl up a ditch towards the German line, finding a trip-wire of tins

in front of an enemy listening post. Pelt the wire with clods of earth. Tin hit. Nothing happens, so in they go, sliding over the side into the empty listening post, then slowly, softly forward into the enemy trench. It too is empty.

Now they hear rifle fire to their left, so back out of the trench, squirm down the ditch, head home. On their way, they stumble across a wounded Cameronian, lying concealed in a shell hole, who has hidden there since their first night. Hill sends word back for stretcher bearers, they crawl up the ditch, but now the Germans know, and are flooding the trench, firing is continuous, rifle bullets sending up spouts of earth like exhalations of brown air. The bearers roll the wounded man onto a stretcher but cannot move, pinned down with the likelihood of a German patrol now coming after them.

So they must knee-shuffle, nose to the earth, stopping and starting, half dragging, half pushing the stretcher, until they get back safely. Later Hill is summoned to Brigade HQ to report what he saw. The HQ, 400 yards behind the front, is in one of a clutch of devastated cottages strung along La Boutillerie road, and has had every door nailed shut, planks across the top half, bottom panel kicked in for access – so entry to each room can only be accomplished by crawling. It is designed to stop a rushed assault, but as Hill notes, it makes for an undignified way of entering.

* * *

Fred has a shallow dug-out for an aid post. He clears space to work on the man brought in, compound fracture left leg, bone protruding. He never trusts bones. He remembers those drawings of breaks in Thomson's. Or was it Milroy's? Fothergill's? The yards of textbooks a doctor must work through. And all those ways to break a leg. Transverse, oblique, spiral, stellate, wedge, greenstick, impacted ...

The soldier on the table is calm now, opiated, exhausted. The orderly has cut the trouser leg off, and Fred cleans the wound, thinking, remembering, always the words while he works.

It may be known that a bone is broken by the following signs:
1. Pain.
2. Loss of power.
3. Alteration in shape.

4. *Unnatural mobility.*
5. *Crepitus – when handled there is generally a grating sensation.*
6. *Swelling of the limb is generally present.*
7. *The patient may have experienced a sensation of sudden snap or giving-way of the bone.*

Well, he is not up to asking, just deal with it, mutters Fred.

A bone has its blood vessels just as any other portion of the body; it must not be looked on as a hard, bloodless, structure, but as a portion of the living body which is itself alive.

He remembers all that showing off to Dick Fawcitt after lectures, regurgitating whole screeds, instantly learnt by heart.

–You should go on stage.
–How do you think I got into Fettes? grins Fred. It's a blessing.

Or maybe a curse. He has so much now stored away that ransacking his brain is like running down library shelves, looking for the right volume. But for this work, for medicine, where whole encyclopaedias must be memorised, it helps. If he were a minister, it would be the Bible, and all those books of biblical studies that his father pored over. His father who wanted him in the church too – Bertie wouldn't, Jack ran to Canada, Fred ran to Fettes … that was never a school to produce ministers, it didn't even allow ministers to teach there. Maybe that's why he calls me Thomas, too many doubts. Then there's Randall Thomas Davidson, of course. It's not funny any more. And it's not a break that's healing.

In order to allow the process of repair to proceed naturally, it is necessary that the broken ends of the bones remain completely at rest. Nature attempts to ensure this by causing pain when the limb is moved, and to assist Nature, and secure immobility, the surgeon fixes the limb in splints …

Fred always worries when the word Nature comes into textbooks. Whose Nature? The same Nature that makes countries send these men to fight? But if we don't fight, what will the Germans take? And you can't run an Empire without defending it.

He has cleaned the wound, bound it, not too tight, allow for swelling, and is

now strapping on a spare chair leg, wrapped in cloth, tying it in place with old bootlaces – keeping odd bits of furniture, belts, laces, cloth is his new obsession. Saves finding a dirty old rifle for the splint, or a bayonet, or a scabbard, or cutting up perfectly good tables ...

–Let's get him back to the Dressing Station, he tells Hawes, and sits to fill his pipe. Move him carefully, no banging.

Hawes gives him a look as if to say, you think I'm stupid?

* * *

Ritchie is up all night, reassuring his men as they lie uneasily in the trenches, wary about German movement. In his diary, he writes of the toll he is taking.

I am dead tired and beginning to see things – trees suddenly leap into the air and giant men lean over me pointing huge phantom fingers at the enemy and I wake with a start in the act of falling down, terrified lest I have betrayed my trust and been to sleep – but I have only slept a fraction of a minute standing up and with my eyes open ...

He wants to search for Ronnie Macallan, missing since the 22nd, but Darling as adjutant forbids it. Ritchie is building shelters in the trenches now, using doors, furniture and any old planks that can be pulled from the farm. Darling passes on a message of congratulations from Brigade HQ.

Joy, he confides to his diary, *I thought I was much more likely to get a wigging.*

The Germans return at night in vigorous sorties. On the 27th small parties charge the trenches, shouting and bugling, then pull back. Later their rifles blaze away from their own trenches as if convinced a British counter-attack is in progress. Then they stop, make chicken noises and jeer. Ritchie asks Darling for more wire to reinforce his line the next day.

By 30th October the farm is under prolonged bombardment. For two nights previously, enemy patrols had scouted the area, probing the rolls of barbed wire that have been hastily pulled across No Man's Land, trying to pinpoint Cameronian positions. Orders were given not to fire, so nothing is revealed. Money catches the daytime bombardment on camera, a snapped tree to the

102 RM

right, top half dangling, the farm itself already in flames [102].

As darkness falls the men brace themselves for the head-on infantry attack that inevitably follows. Nothing – then after midnight they start to hear something, movement in the distance, men whispering orders, then the bleating of sheep. Ritchie is standing on the parapet of the trench in front of the farm, listening. Behind him, the men of C Company lay out extra clips for their rifles. Ritchie has been up and down the trench, encouraging them, telling them not to fire till given the order, pulling out his revolver and joking he will shoot anyone who fires before the whistle. The men stand nervously listening to the Germans getting closer, visible now, shadowy grey figures crouching behind a flock of sheep driven in front of them. They had all heard the stories of the Germans pushing village women before them at Quévy Le Petit. In the end, there, the British had to fire.

Two hundred and fifty yards, 200 yards, 150 yards.

Finally Ritchie blows his whistle and a cacophony of rifle and machine-gun fire erupts, the dark night suddenly ablaze with flashes, the smell of cordite rising, the bleating squeals of terrified sheep.

–RAPID FIRE!
–KEEP IT LOW!

They can hear bugles blowing and shouted commands in German as the

enemy attempts to rush the trenches. None get nearer than 20 yards away before dying in the onslaught.

The Germans fall back, regroup and attack again. Beaten off, they retreat and then come a third time. Again the Cameronians shoot every German before the trenches are reached. It is a small slaughter, with few British casualties. But they include Ritchie, who is shot near the groin, shattering a leg bone while kneeling on the parapet to see if the Germans will return. His men bundle him into a shelter while the fighting continues. Hill holds his hand while shouting orders. His injury is symptomatic of the lack of equipment the Cameronians have: no trench periscopes, no flares, no hand grenades, no trench mortars. Compared with the Germans, they are ill-prepared for this form of war.

Ritchie is stretchered back to Fred's aid post, there his trouser leg is cut off, wound cleaned. Fred works hard to keep his hands out of the injury, never to touch, never to infect, handle as little as possible – in an aid post, in the mud and blood, he hasn't time constantly to carbolic his hands. He trusts down the line, in the clearing station, they will wash the wound, with hydrogen peroxide, or boric acid, or perchloride of mercury, depending on what's to hand and who is on duty, not his bag. He writes M and T on Ritchie's forehead in indelible pencil to show morphine and a tourniquet have been applied, then fills in the tally, then moves on to the next man. Ritchie will live.

He doesn't. He is sent back to the main dressing station that night, then back further by train to hospital. He dies three weeks later from infected wounds – the medical price paid for the anaerobic organisms bred by the ripe fields in which the war is fought. This is not the dry, desert sand of South Africa. This is freshly fertilised Flanders. A bullet wound can kill you weeks after you thought you had survived.

German casualties now litter the wire in front of the Cameronian trenches. Attempts to bring in the wounded by stretcher bearers are halted after they come under fire from the enemy trenches. Eventually those still alive are brought in at night, including a German medical officer, shot in the stomach, who has advanced with his men. Unlike British MOs he is armed with a revolver – in defiance of the Geneva Convention. Hill lays him on a fire step. The doctor uses sign language to show the bearers how he should be bandaged, then speaks French to ask for a capsule of morphine from his

medical pack. When Hill checks later, the doctor is dead, his morphine vial almost empty. He had made his own choice, and clearly decided his wound was not something he would survive.

Fred is in his aid post when a bearer gives him the present from Hill, a beautiful, cowhide case filled with dressings, drugs and instruments – the German MO's kit. He tells Hill later he has never seen anything so compact, or so well equipped, and he uses it from then on. He adds it to the growing pile of mementos donated by grateful soldiers, or handed on by hoarders like Hill, an obsessive keeper and filer of what is left behind. One item, a tattered pennant from the Prussian Death's Head regiment, Fred sends back to his father in St Cyrus for safe-keeping.

* * *

The Cameronians hold the line for another fortnight – there are simply not enough troops to relieve them. Britain's regular army is being worn away, as it struggles to hold back the Germans at the first battle of Ypres.

Luckily for the men, the enemy does not realise how thinly the line is held here. A captured German officer expresses bewilderment when he is led behind.

–Where are your reserves?
There are none.
–If only we had known, he replies.

A push straight through would have claimed the coast for the Germans, blocked off supplies of troops and ammunition, set in train a second push for Paris and a possible invasion of England too.

Instead, the enemy pounds the trenches with short-barrelled howitzers day after day, but desists from full-on attacks. The Cameronians know, for now, it is a one-sided battle. Robertson allows his emotionless mask to drop in the official war diary: "The infantry in the trenches do not think they have been supported quite adequately by the artillery. If all artillery officers would spend a little time in the trenches, they would realise this too!"

The battalion's tetchy insistence on holding others to account, and questioning some higher up, is starting to reveal itself.

Fred deals with three or four wounded a day, sending casualties back to the advanced dressing station in a two-storey brick schoolhouse in La Boutillerie. Better that than a barn. He had seen what had happened to casualties in a barn on the retreat. Shelled relentlessly, its roof splintering, the injured men lying in straw below watching anxiously, a crash as each shell scatters the slates, wood and lead raining down, then fire catching.

–Get them out! Get them out!

103

Dragging the wounded by their shoulders, men screaming, crawling, squirming on their bellies, oblivious to wounds, just trying to pull themselves out before the beams go. Two die in the final crash, the last shells pounding in.

The schoolhouse is a solid base, for now. Fred photographs the building at dawn, his long shadow advancing towards the still intact front of the school's east-facing side [103]. And he photographs the regiment's musician bearers too, mixed with his orderlies, already a ragamuffin bunch, unshaven, unbuttoned, sharing caps, hats and balaclavas, kilted, trousered, one even carries his bugle. They stand round a hole in the ground behind the school's wall [104, 105]. That is their place of safety.

In the trenches, between shelling, a war of snipers has started. The Germans shoot from old buildings, ditches and haystacks, the Cameronians likewise. Robertson sends Sergeant Blakemore, the battalion's crack shot, into a ditch in No Man's Land to snipe the German line. Blakemore is the Cameronians' secret weapon, a marksman so good he is ranked in the Army's top 20, winning rifle meetings at the ranges in Bisley, Surrey. Day

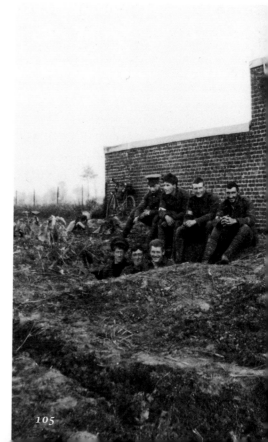

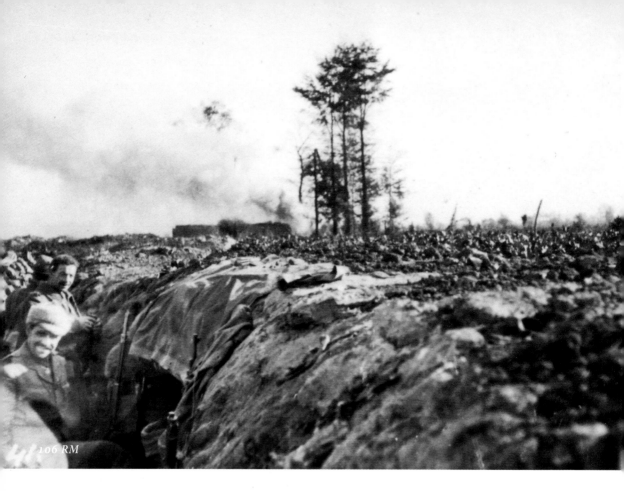

106 RM

after day he now sits out under cover, taking his own food and water, shooting whoever he can see. It is a brutal, dangerous business. Over the near-month the Cameronians hold the line, he claims 30 kills. Within a year, elsewhere in France, he is dead, targeted and blown to pieces by German shelling.

But all this sniping makes the roads lethal to negotiate. The Field Ambulance has to send doctors up at night to clear the aid posts, bringing back casualties to a main dressing station in Rue des Lombards. All are challenged by nervous sentries. Tubby Wood, so handy with the rum ration, nearly shoots Hampson, medical officer with the 19th Field Ambulance, as their paths cross in the dark behind La Boutillerie. Tales of spies and sabotage are rife, of farmers signalling with lights, of Germans hidden in haystacks waiting to make surprise attacks. Farms are burning in every direction.

Money's photographs over the same period become increasingly adventurous. He shows Hill in his trench with an observation post on fire behind [106], German equipment strewn across the foreground [107],

107 RM

soldiers scanning the front with binoculars, trying to see the snipers through the protective curtain of cabbages that still dot the battlefield. [108, 109]. Both sides are now tying bully beef tins to the wire as an early alarm, and strewing cans across No Man's Land to hinder creeping patrols.

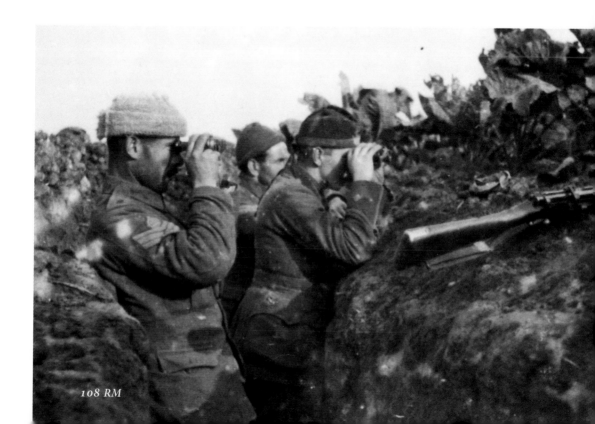

108 RM

The photographs are all detailed enough of the British line and its firing positions to be part of a court martialable offence, but no one is going to take Money to task. For one, he is the most valuable officer on the team, overseeing the machine-guns that have killed more of the enemy than any rifles. He is also well-liked, self-deprecating, and sharp on his feet. He often hands his camera to others – to Fred, to Wright, to Graham – and poses in his own pictures, defying the threat of the enemy's sharpshooters. One taken in his own machine-gun position at Ritchie's farm shows him leaning casually on a blanketed parapet, binoculars dangling from his hands, looking exotically bristled [110], a picture of insouciance. Behind you can see the stocks of rifles ready loaded to repel any surprise attack, to his left the handles of his machine-gun. Years later he captions the photo 'Self and No 1 Machine Gun (Mem. Another must not be photographed again!)'

Does he mean himself, or the gun?

109 RM

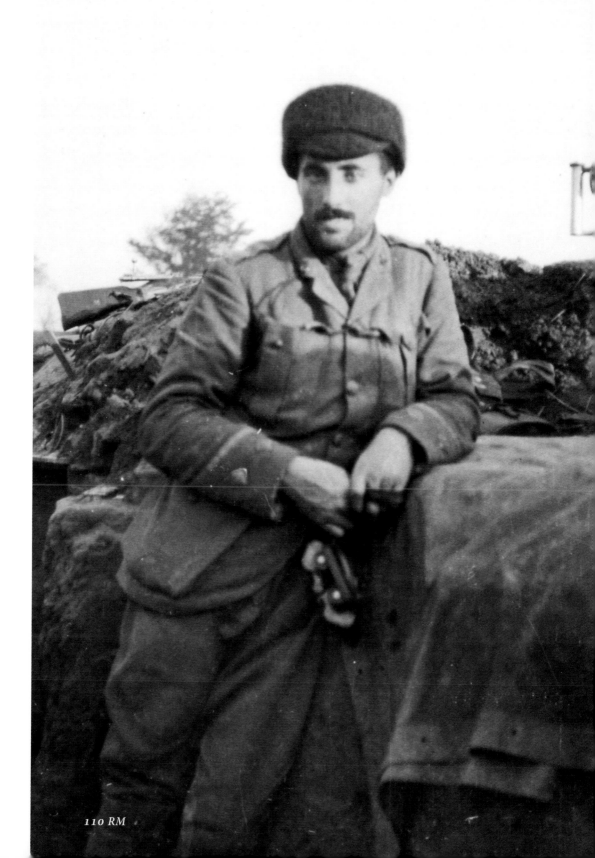

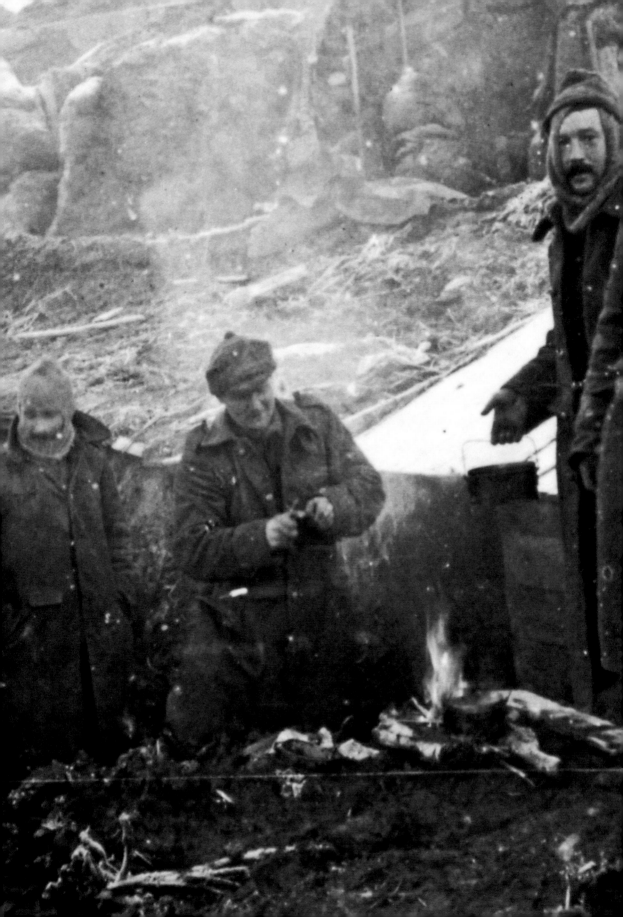

9

HOUPLINES

Then came the snow and sleet. I was so cold at times I could have cried with the actual physical pain. Lice tormented us with their continual biting. To get at them meant undressing, which was not to be considered for one moment. We wore the same clothes day and night. Gaunt, unshaven faces peered through the openings in our balaclava helmets. There was no water for washing or shaving. Dirt caked our hands and faces ... Our latrines consisted at first of long deep slit trenches, above which two round pit props running length ways, lay on trestles ... It required quite an effort to balance yourself across these. If you were caught in a burst of shelling ...

– MEMOIR OF 2ND LIEUTENANT JD HILL, C COMPANY, 1ST CAMERONIANS

THE REVEREND Robert Davidson, sitting at his desk in his upstairs sitting room, looking out over the crescent bay towards Montrose, is writing to his son Jack in Canada, keeping in touch with the boy he never sees. His letters are full of grief for his wife:

A year yesterday she died and it seems to me more like a century. Life is so lonely and the Manse is no longer a home ... She hoped we would all hang together.

He moves on to news of the brothers, picturing where they are, wondering how they cope. Fred, as ever, he calls Thomas.

Your two brothers at the front are having a bad time. The winter is on them now and somehow I fear for Bertie, who is not as strong as Thomas. Both have escaped up to now but been handed many near "squeaks". Thomas has sent home a pennant and flag of a Death Head Hussar – one of the crack German Cavalry Regiments. He does not say how he captured it, as he is reticent as to his own doings. Today I displayed it in Church – had it stuck up above the organ and drew the attention of the (small) congregation to it. It looked rather fearsome – a miniature skinless face – two holes for eyes, one for a nose, another for mouth, underneath the usual crossbones – this in chamois leather on a black background. The owner of it must have fought to the last, as it was riddled with holes and cuts. There is meantime, not the slightest appearance of the war ending and the slaughter is colossal.

* * *

At 6.30 pm on 14th November the battalion moves out of trenches at La Boutillerie and back to the village of Bac St Maur, into billets to rest. The change-over is laborious – positions must be shown, lines of fire explained, and then the march in darkness six miles west. But the men are glad to be out of wet mud, to walk and talk without fear of sniping.

At Bac St Maur, a village near the river Lys, dotted with textile works, the troops stay dirty; there are few facilities for communal washing – "appliances not v. good" notes Robertson mournfully in the war diary. The mood is lifted by a batch of mail from home, including parcels of comforts from a grateful public. "Friends in Scotland" as Robertson puts

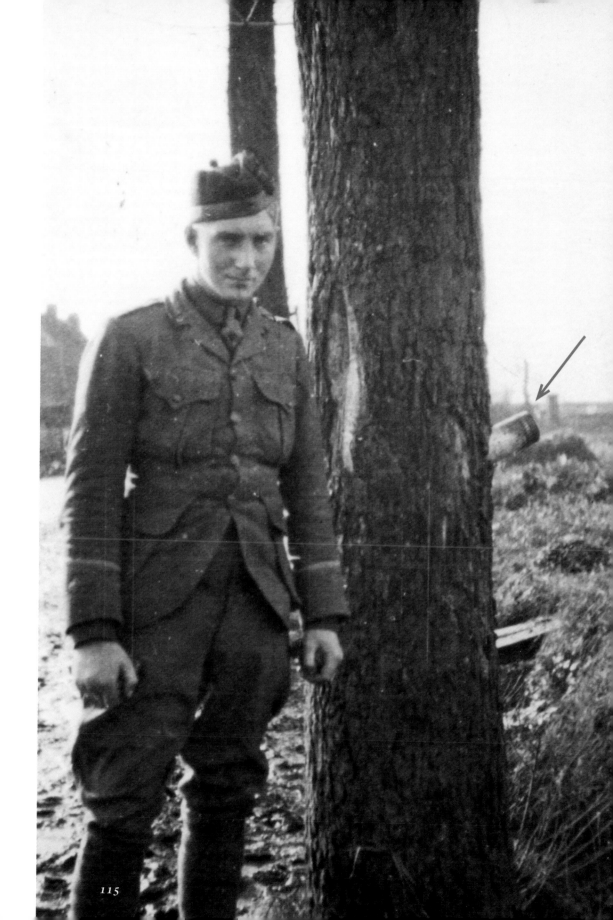

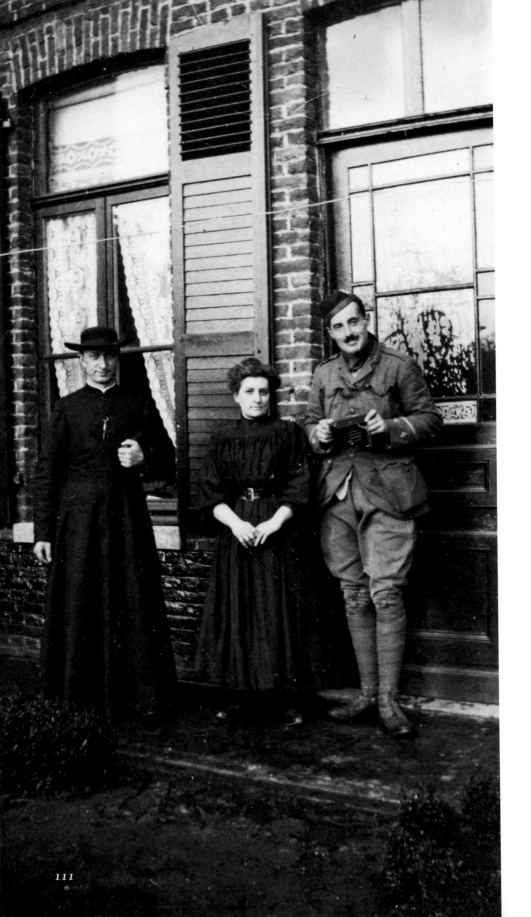

it. Mittens, tobacco, cake, soap – the latter raises a smile.

Fred Davidson has a letter from his father, telling him Bertie is now in France, working with the Field Ambulance assigned to the Indian Army's Meerut Division. All help is welcome, mulls Fred, but the cold, wet fields of northern France are a long way from the Asian subcontinent. Bringing Indian troops into this war of attrition will not be easy. At least Bertie shouldn't be too hard to spot – the RAMC's paper trail of bureaucracy will bring them together.

He folds the letter and drums his fingers, anxious to get out and about. Across the room Robertson and Darling pore over paperwork, spread across the dining table in the Curé's house allocated as Cameronians HQ. Next to the mayor, the local priest is a figure of status in these villages, and an alien figure to a Presbyterian battalion where Rooke is the only Roman Catholic officer. But such Curés have already earned notoriety for their anti-German stance – some have been shot by the enemy. And Fred likes this one, with his quizzical face and eager-to-help manner. When he sees Fred's Ansco and suggests a photograph, all the officers pitch in.

A series of informal photos follow of officers freshly washed and shaved – no shortage of warm water for them in the Curé's house – while the priest and his housekeeper stand proudly by. Money dominates the first, feet splayed, clutching his own camera, as if to say "this is what we do" [111].

112

Fred then hands his camera to Money to take another as he joins the HQ team. Oakley towers over all, while "Bull" Chaplin, A Company commander, looks on, gently amused, wrapped in a battered Burberry. The Curé stares wistfully into middle distance; his housekeeper, hand on hip, impatiently confronts the lens. Fred tries to strike a pose, pipe in hand, leg bent, medical

bag at his feet, while Wright shares a joke with himself, just a hint of a smile [112]. The soldiers hold the mien of confident victors, proven in battle, safe from danger for a moment.

113

In a third, Oakley and Chaplin are joined by Hamilton and Hobkirk, moustached and determined, from D Company. Only Darling, the battalion adjutant, second from right, looks uneasy, keen to get back to his admin, or maybe nervous that all this picture taking, forbidden in Army rules, will lead to trouble [113]. The modern world starts here – in its informality, in its insistence on memorialising, in its prostration before technology – and his discomfort is tangible.

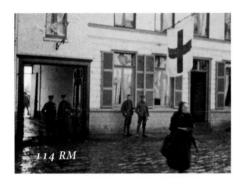
114 RM

Later Money takes his camera around the village. The 19th Field Ambulance has a base in a large linen factory on the river, the last one left intact in the German retreat. Its windows are smashed but the yard provides cover for the horses, its offices a base for the doctors, its warehouse with its bales of linen an easy sleeping quarters. Money's photos show the shattered windows round the yard [114].

115 RM

Outside Bac St Maur he spots a shell embedded in a tree and poses "Frankie" Rooke beside it [115]. The young lieutenant's face tells it own story: lugubrious, amused, but always uneasy. The shell sticks up and out at an angle, like a discarded beer bottle flung away after a good night out.

The respite is short. By 16th November Robertson has received orders to take the battalion to Houplines, relieving the Seaforths and Royal Irish in trenches beyond

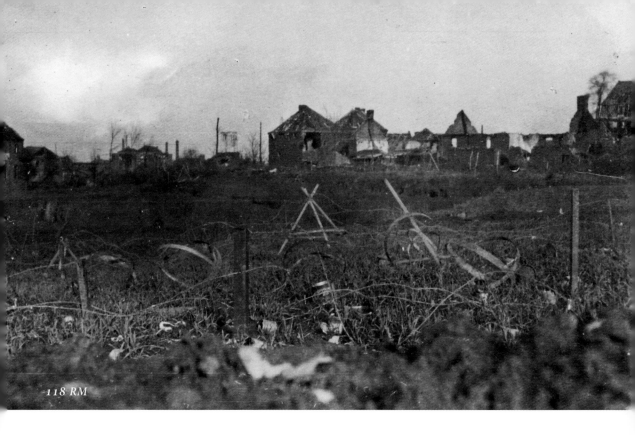

118 RM

Armentières. The shortage of troops in the regular Army, which has taken heavy casualties from the German push around Ypres, means resources are thin. No rest for the hard pressed.

The battalion marches on 17th November, leaving Bac St Maur at 2.30 pm, and arrives at Houplines three hours later, stopping to eat en route. In four hours the exchange is complete and the Cameronians can survey their new territory, on the eastern suburbs of Armentières, a town most officers know from their childhood reading of Alexandre Dumas's *The Three Musketeers*. Facing them is a German line that runs south around occupied Lille, eight miles distant.

It is a bleak prospect. In front are ploughed winter fields crossed by bare roads, dotted with factories and houses. Enemy snipers watch every move from the tall industrial chimneys that punctuate the landscape. Money later takes three photographs [116–118] that capture the pragmatism with which the Germans have chosen their line: plenty of cover, then a clear, flat field of fire. Cords are visible running back from the British wire to the German position just in front of one old brewery. This landscape, for the next four months, is Fred's home.

116 RM

117 RM

Inside Armentières, life goes on, despite the war on its doorstep. The town centre has seen street fighting, but remains little damaged so far. The Germans, after occupying it briefly, seem content to leave Armentières be – a position that changes radically four years later, when they bombard it with mustard gas, and in return the British shell it remorsely to halt their advance. For now, however, just as the French appear unwilling to turn their guns on German-held Lille, an uneasy stalemate ensues.

So in October 1914 Armentières, long wealthy from its linen-bleaching factories that stretch along the Lys, goes about its normal business, and its 20,000 residents stay put – the rich in their fine, Flemish-style houses, the workers in their cottages, manning the warehouses on the outskirts that supply the French Army, disappearing into cellars when sporadic shelling starts. Shops are open, restaurants serve omelettes and beer, brothels down cobbled sidestreets do brisk business. The latter will be a problem for MOs like Fred, as the first VD cases start showing in what will later become an epidemic among the Army.

Out in the industrial suburb of Houplines, with its bomb-damaged breweries adjoining churned potato fields, the Cameronians are taking stock. They had heard from the troops they replaced that this is a safer front than any near Ypres. The Germans, in places just 100 yards away, seem intent to sit and hold, now conscious of the hazards of a full-on attack over such clear ground. Yet the constant sniping keeps everyone twitchy. Up ahead, the village of Fremlinghem, now just a clutch of ruined buildings occupied by the enemy, provides perfect protection for sharp-shooters.

And the trenches the Cameronians inherit are barely habitable, drainage

ditches swiftly fortified in the early fighting, now sodden from the high water table, too near the river Lys. Some were held by the Germans, then abandoned as the water rose. The enemy move back to a higher, drier line – and make sure to channel any drainage downhill. The upshot is a foot or more of water in the Cameronian trenches on rainy days, and most days it pours.

Fred sets up an aid post beside the battalion HQ, part hut, part dugout, built into a support trench with mounded soil as protective breastwork. After a few days he sees his first cases of trench foot, dead-white, doughy feet that will later go black, with spongey, swollen soles. The men need waders which, like most necessary equipment, patiently indented for, are slow in arriving. Fred asks the Field Ambulance medics for advice, yet no one knows what works, so every MO tries his own remedies: gun oil, whale oil, coal braziers in the trenches, anything to see what helps. Meanwhile the number of men having to recover high and dry, out of trenches, begins to grow. And as temperatures dip below freezing at night another problem emerges: frostbite. Do you wrap frostbite injuries to keep them warm, or allow them to breathe in plain air? Both remedies are advocated.

Fred soon realises that prevention is better than cure: keeping feet clean and dry, restricting time in the trenches, ensuring washed socks are

repeatedly issued, finding those waders and gumboots. He also advises Robertson that the morning rum ration, a quarter gill per man on the coldest days, should become a permanent order. The men take it in their tea, and make the usual jokes about Tubby's earthenware jars marked SRD – Special Rations Department. Or in the ranks' experience: Seldom Reaches Destination.

Fred tags and clears his injured by wheeled stretcher to an advanced dressing station on the main road to Houplines, deep in the cellar of an old brewery by the river Lys. It, in turn, clears its wounded back to the main dressing station by the old Jesuit school in Amentières, if shelling and collapsing streets allow. The brick-built brewery has its function painted in capitals across the courtyard wall – BRASSERIE – and is already partly ruined, owners long gone, though one old brewer remains to work the stills. The doctors ask Robertson for guards to be posted, if only to discourage the soldiers with buckets asking:

–Canna hae a fill-up?

Houplines itself, a working-class suburb of Armentières, is in pieces, shattered by German shelling, its red-brick, terraced streets blocked by bomb damage and its workers' cottages now empty, factories and warehouses wrecked. No lorries can drive by daylight, and at night the cratered streets are impassable without headlights – impossible so close to the Germans. The town hall is glassless, its empty windows offering a fine view over rooftops to the front line. Behind, over the river Lys, lies the Belgian border.

* * *

In the trenches a routine is established. The battalion holds 1,200 yards of the front. Each company controls a stretch. C, under Oakley, takes the left. D, under Hamilton, and B, under Lee, are in the middle. A, under Chaplin, holds the right. Each day, as dawn breaks, the companies stand to arms, rifles ready on the fire step, until the opposition trenches are fully visible – in case the enemy plans an attack in the early morning murk. Then the order to stand down is given, and the sick are sent to Fred's aid post beside the HQ mess hut, an iron-roofed room partially dug in behind a six-feet-high breastwork of mounded soil, one solution to the rising water table: pile up, rather than dig down.

Then equipment cleaned, uniform brushed, breakfast taken – bacon if you're lucky – followed by inspection and a list of repairs to be done. Those who have been on duty all night crawl into dugouts in the trench – sometimes just small alcoves carved out of the earth – or if those are too wet, under beam and plank parapets, or just a cape, to sleep. For the rest, working parties are detailed. Like a Russian doll, everything is broken down into smaller units. So each platoon within each company is responsible for its own area. Pile more earth on the breastwork, dig more sumps in the trench to drain water. Divvy up the sentry duty. Work out who is on the wiring party that night, replacing defences damaged in shelling; and who is carrying, trudging carefully to the quartermaster's store to haul up provisions.

At each company HQ – plank-roofed shelters in the support trenches running behind the main line – an orderly room is held: misdemeanours listed, culprits punished. Then lunch, bully and biscuits, pork and beans. Then more tasks. At dusk the companies stand to again. Then stand down. And when dark, the wiring parties go out into No Man's Land. The British have no flares, but the Germans do. If caught in a flare, the advice is to stand very still, as the enemy shoots at movement. But it's hard to do in full glare. Even without flares, or without the gaze of the giant spotlight which the Germans use to sweep the area, there is often a random burst of machine-gun fire, just in hope of catching someone unawares.

As well as the trench foot, the coughs, the fevers that trickle into sick parade, Fred has to oversee sanitation: where to get clean water, where to build toilets. The river, he is sure, is contaminated with sewage – a problem as the same water is still being used by the local brewers. For lavatories, he supervises more trenches, then planks on trestles above to sit on. Use the trench, fill it in, dig another. But you don't want to be caught in a shelling with your trousers down. And the men increasingly take to using buckets, preferring the safety of their own trenches. The filth, as the days march on towards December, will become another problem.

* * *

On 18th November Money takes a series of photos showing the bedraggled reality of life in the line. Hobkirk and Chaplin, cigarettes dangling, document case in one hand, stand outside the Battalion HQ prior to a dawn conference with Robertson [119]. Chaplin is one of the toughest officers in the Cameronians, an old hand who joined in 1894 and fought through

119 RM

Indian campaigns, earning his nickname "Bull" for his indomitable strength of character. It brings him into conflict with his seniors later in the war when, commanding the battalion, he refuses to send his men into an attack he believes is pointless.

For now, he is Robertson's favourite, always first in the discussions as to how to take the fight to the enemy. Elsewhere Hamilton, a walrus in his muddied

120 RM

121 RM

Burberry, eyes the camera while his men, swaddled in balaclavas, scarves and cap comforters, make morning tea in D Company's line [120]. They look like lost refugees, the breastwork behind a random jumble of earth, sandbags, crates and ration boxes.

Rooms are carved out of mudbanks, boots dry on roofs; straw, tarpaulin, planks, crates and tables are scattered around. In the floor a drainage channel is bridged by two beams [121, 122].

The HQ mess hut doubles as admin centre and dining room, bedroom at night, one side built into the bank, the other

122 RM

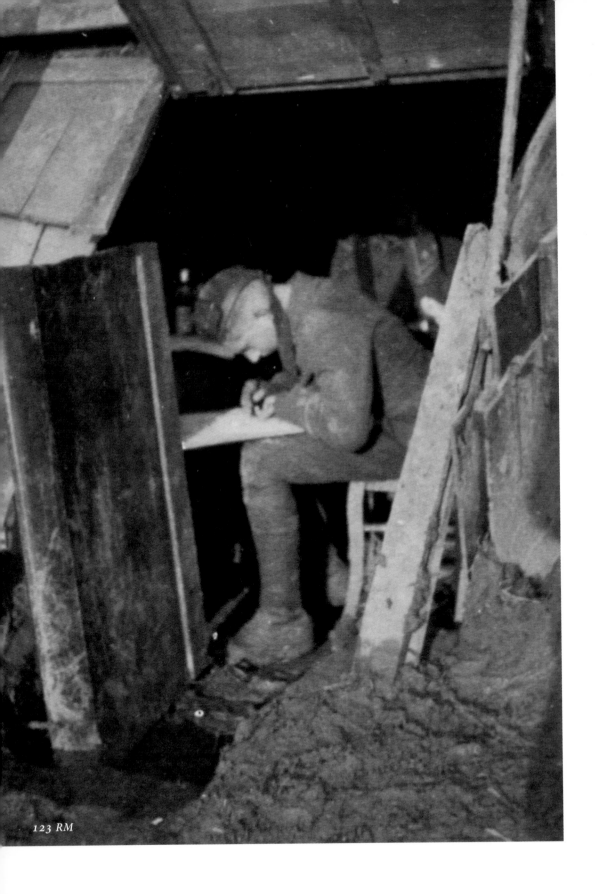

123 RM

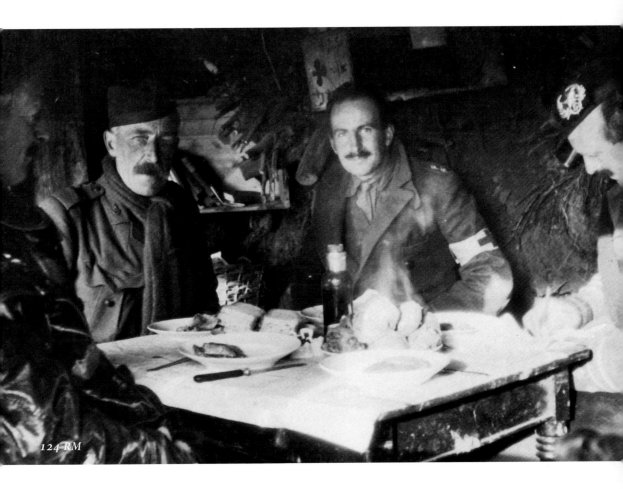

124 RM

constructed with material torn from shell-blown Houplines homes –
planks, doors, window frames. Rooke uses the table to copy a trench map
diligently, half the wall removed, letting light in from the south [123].

Later the HQ team take lunch, newspaper doubling for tablecloth on the
rickety table, bully beef on the plates, a bottle of sauce offering a defiant
touch of home [124]. Darling the adjutant writes, Oakley sits stiffly in his
waterproofs. Only Robertson and Fred stare into Money's camera, the
commanding officer inscrutable, the medic, a young man now used to
eating with his elders, calmly at ease. If he is a junior officer trespassing
on their territory, it is not palpable.

Both men know they are posing for posterity, holding themselves alert,
part of something remarkable that is unfolding as Europe rolls up its
sleeves and slugs it out – for empire, for access, for economic prowess, for

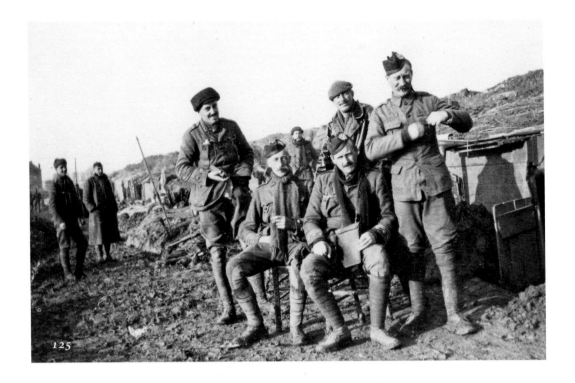

125

ways of life threatened by the success of others. Fred is just two years out of university.

Afterwards he takes his own photos of the HQ team: Robertson, Oakley, Darling and Money with D Company's Lieutenant Duncan. Scarved and mud-spattered, they pose outside the HQ mess hut. Fred tries two shots, one wide [125], the other tall [126]. In the second he catches Money in the process of unfolding his camera, ready to take his own pictures.

How many will survive this war? Fred knows his *Ivanhoe*.

The knights are dust
Their swords are rust
Their souls are with the saints,
we trust...

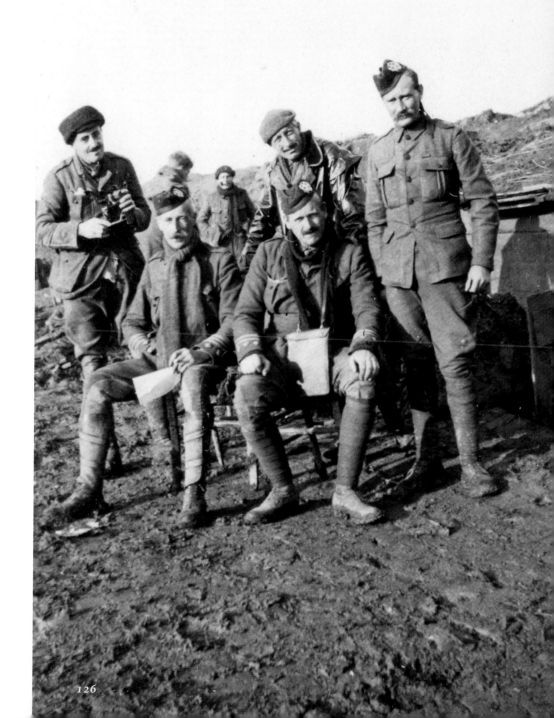

10

HOW'S MARYHILL?

28th November: Paraded the men at 10 am and told
them a thing or two about drink. The pot calling the
kettle black – however discipline must be maintained!!
Messed about and watched Frélinghien being shelled.
Took some photos. My camera, a Vest Pocket Kodak,
arrived a little time ago. This, the same as keeping a
diary, is not really allowed, though there are quite a few
about. One has to be careful not to advertise it ...

– MEMOIR OF LIEUTENANT TRAVIS HAMPSON
19TH FIELD AMBULANCE

THE FIRST snow falls on 19th November, followed by hard frosts. Fred Davidson shuffles paper in his aid post. The Army always has more directives, more forms, more clerking for him to do. He pulls out the latest bumf on sanitation, wondering what the freeze means. He loves the certainty of tone in his paperwork.

Prior to a unit taking over a section of the line, the MO of the unit together with Battery or Company sanitary representatives will proceed to the line and meet representatives of the unit to be relieved who will show them around the area for which they are responsible.

Provided they are not being shot at ...

They will make themselves thoroughly acquainted with the sanitary arrangements, positions of latrines, refuse pits etc.

In an ideal world ...

A refuse pit four feet deep will be dug under supervision of the MO, for disposal of refuse by the Sanitary Squad of each Brigade and battalion, and each company of each infantry battalion ... These pits will be marked with a board showing the letter of the company and will be filled in under the personal supervision of the MO before the unit is relieved.

Nothing he enjoys more than watching a hole being filled. Luckily his war is full of holes.

Each latrine will be provided with at least two urine pails. These will be emptied nightly in soakage pits four feet deep dug near refuse pits and labelled "Urine Pit". Cresol solution will be placed in the latrine pails and urine buckets after emptying.

Which reminds him: ask Tubby to get more Cresol, before it all disappears somewhere.

* * *

Fred is off and out, looking for tea at the HQ kitchen. Men eye his camera mistrustfully, breath steaming the air. The kettle is on the brazier, their grimed hands held above for warmth [127]. They stamp their feet and wait for the cry of "Char up".

Behind them, Robertson prepares to sweep snow off the HQ Mess roof – wise move given its planked porosity. The photographer's shadow, a Fred motif, creeps again into shot [128]. Money takes the same shot minutes later as Robertson climbs to clear the roof. There are two shadows in shot now, as Davidson and Money stand side by side [129]. What are they

128

129 RM

memorialising? A much-liked commanding officer not afraid to do his own work. Many years later, Fred sends his three sons to Charterhouse, Robertson's alma mater.

And beyond the HQ Mess, at the dugout which Money shares with Fred, more soldiers stand, apprehensive and cold. Lumber lies in the foreground, a telephone line sags on bent poles only inches above head height. The lines are broken continually under shelling. The fog of missing information will hamper every attack and every defence as the war proceeds.

Moments later Fred is the other side of the camera again, as Money photographs the same scene at the mouth of his dugout [131]. Fred is stamping his feet too, hands deep in reefer jacket pocket, a strip of face visible between balaclava and moustache. Becher, scarf-wrapped, stained and pistoled, stands grumpily by a Maxim machine-gun. They could be attending a winter junk sale. He hands the camera to Wright who takes a picture of the MO, emerging from the dugout with a grin, like a snowy Jack-in-the-box [132]. Money just smirks shyly, adjusting his Christmas Tree belts. He has a copy of Kipling's story collection *The Day's Work* with

him, and is threatening to read
Fred *The Maltese Cat*.

–A polo match in India, told
from the horse's perspective,
explains Money, straightfaced.
Fred is not a horse lover.
Later, captioning his own
photographs, Money describes
the "bivvy" they share as
"a nasty wet hole". To the
uninformed viewer, however,
the war looks a long way away.

It's back every night. Patrolling
No Man's Land has now
become a regular activity.
Some wonder if it is too much
an obsession of the divisional
command, which is starved of
reconnaissance and constantly
wants more maps, more
prisoners, more material.
"Showing an aggressive spirit"

is good for morale, say staff officers, based a mile from the front. And in
some ways they are right. For the professional soldiers around Fred, in
these early stages of war, patrolling is not a chore, some even enjoy it – a
dangerous game of cat and mouse that relieves the monotony of trench life.
For junior officers and men, it is also an effective team-building exercise.
Scuttle out on all fours, grab a prisoner, find a machine-gun post, tie rope
to the enemy wire. This is what they joined up for. On 26th November they
find the Germans have done likewise, tying a long cord to C Company's
wire. What are they planning?

Just more psychological warfare. Admiration for the efficiency and
playfulness of the enemy is growing. They are opposite a Saxon regiment
which seems to know as much about them as they know about the
Germans.

–How's Maryhill? comes the shout from one of the forward enemy

trenches, every morning. The implication is that the Germans will be there soon ...

And the Cameronians are still painfully ill-equipped: no hand grenades nor mortars. No one seems to have planned for trench warfare. Instructions come down that they must make their own bombs in old jam jars, packing in stones and empty cartridge cases with mud, gun cotton, a detonator and a four-inch fuse. Fred is already treating minor injuries from the ad hoc bomb factory, and the bomb throwers are quickly tagged "suicide squad" by their mates.

Then the rifle grenades arrive – rodded projectiles fired by a specially modified rifle, slotted into a wooden stand. Hill works with a team, setting the rifles up, launching the grenades over the parapet. At the highest trajectory setting, they fall 50 yards short of the nearest German trenches.

So out they go at night, setting up the grenades again, another 50 yards nearer. Four rifles, 10 yards apart. On a crisp, clear night, they can hear the clanking of a wheelbarrow down the German trench ahead – supplies being brought in.

–Fire! shouts Hill, and the grenades plunge over the breastwork and set off four, percussive explosions. There is a moment's silence and then the clatter of feet on duckboards and the rapid trundling of a wheelbarrow being pushed away at haste. Hill's diary recounts the proud response of one of his men.
–You've put the fucking wind up them, Sir.

* * *

Fred's daylight pictures show the dangers. Barbed wire strung at neck and groin height hung from tripods running across flat fields to shattered Frélinghien [134, 135]. To get caught in plain sight on those was certain death.

Even shooting the photographs – the same view snapped twice, one tall, one wide, another Fred motif – is to take your life in your hands. To look over a parapet, or through an observation loophole, was to court the sniper's attention. The Germans have superb telescopic sights, the legacy of a world-leading optics industry and a decade of preparation for their war. The edge of earth, in the bottom right of one picture, suggests Fred

was smart enough to hold his camera up and simply click.

Later that week the Assistant Director of Medical Services calls a meeting of MOs in Armentières. The discussion, again, is sanitation, and what can be done to improve it. Dig, bury or burn? Then directives on prevention of dysentery are read.

General measures:
- *Proper disposal of excreta.*
- *Food protection.*
- *Pure water supply.*
- *Search for carriers.*

Use fly-proof pail latrines and burn. If burning impossible, bury in deep pits.
If possible, shell-holes should not be used.
Deep-pit fly-proof latrines must be fly-proof.
Shallow trench latrines should never be used

Water:
—should be properly chlorinated and carried up in stoppered petrol tins.
—boil, use in tea etc.
—use with sodium sulphate tablets, never drink from shell holes.

Hampson, a doctor with the 19th Field Ambulance, takes aside Fred to show him his Vest Pocket Kodak, just sent from England. Chandler, MO for the Argylls, promptly pulls out his own. Fred pulls his Ansco out of his bag. They are all chroniclers of the conditions now.

* * *

The snow melts to mud and slush, the days are grey and bleak. Robertson's war diary lists a string of visits by top brass, anxious to maintain every battalion's fighting spirit: the Brigadier from the 19th Brigade one day, the General in charge of the 6th Division the next. It also lists the steady toll exacted by snipers. Private Brady killed. Lance Corporal Wiseman killed. Dead before Fred even gets to them. Head wounds.

The battalion has one piece of good news. A message comes in via an Argyll officer that Macallan, lost since La Boutillerie, has been seen, a wounded prisoner of war in a Lille hospital. The "missing, presumed dead" tag blows away. Ronnie Macallan, the golf nut, the man who won two cups at the Royal and Ancient Golf Club in 1904 and 1908 while on leave as a subaltern, an officer already married, with a daughter ... He will go on to have a long, distinguished military career, but he won't see his battalion again until repatriated in 1917.

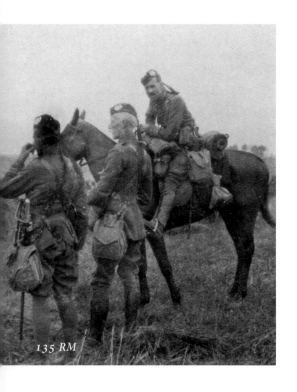

135 RM

That night, they raise Ronnie a glass.

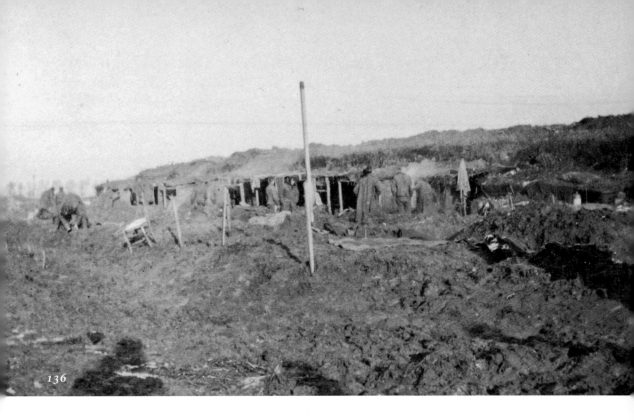

136

They have little inkling that Macallan's immortality is already ensured in
the film Money has sent back to Scotland to be developed. His photograph
of Ronnie on horseback advising Robertson during the retreat from Mons
[135] will become a staple in books covering the early war for decades.

* * *

Over a month in trenches, with just a three-day break in the middle, now
takes its toll. Fred is seeing men with feet so swollen that marching is
out of the question. Nearly every solider is infested with lice. Rats are
feasting on the waste left everywhere. Fresh water is hard to find, with
suspicions that the Germans are now deliberately polluting the Lys.
The men using buckets for lavatories throw the waste where they can.
Fred's photographs show dugouts from a distance – earth ramparts,
dangling wires, even an umbrella. They are living a shanty-town existence,
surrounded by rubbish [136].

The battalion finally gets respite on 3rd December, going back into billets in
battered Houplines, opposite the brewery dressing station. The men are in
good cheer – newspapers carry reports of a Russian victory at Lodz, on the
Eastern Front. Surely the Germans can't hold both fronts indefinitely?

* * *

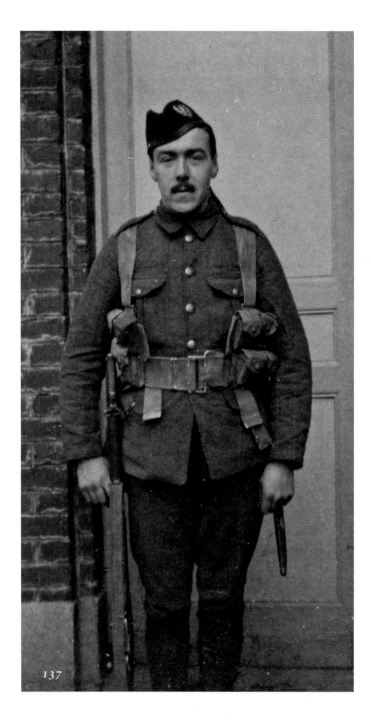

137

The order goes out that officers will now be allowed home on eight-day leave at staggered intervals. Robertson, Hobkirk and Chaplin – whose wife is eight months pregnant – are first to go. Oakley, the pernickety joker, is left in command. The King visits the front, trying to boost morale. He gives out medals at nearby Croix du Bac. Frankie Rooke takes eight NCOs over to represent the battalion while Private Cairns is awarded the Distinguished Conduct Medal for his role as one of the covering party at La Boutillerie, the night Macallan was captured. Money later photographs him in Houplines, in a doorway, scrubbed clean after a stint in the 6th Divisional Baths, looking every inch the newly-washed soldier, his ribbon only faintly visible above his top pocket [137].

The baths at Pont de Nieppe are the first of their kind – a giant factory for washing men and clothes built at a riverside bleach works rented by the Army, and overseen by its Field Ambulances. Huge vats, hydraulic presses and plentiful hot water supplied by boilers means a whole battalion can bathe at once,

handing in clothes to be washed, picking them up again after ironing.

Fred supervises the Cameronians, one Company at a time, stripping, washing, bantering as they sit 50 to a vat, short, wiry and naked. Many carry the scars and bruising built up over two months of fighting. All, now, are unselfconscious in their nudity, happy to have survived, happy to be warm and clean, throwing soap across the carbolic fug, hoping to score a direct hit on a mate's head.

While they bathe Fred walks back into the cold and across to another warehouse where 200 women wash and press the men's clothes – attacking the seams with wire brushes to shift the lice, steaming the material repeatedly with heavy irons to de-infestate. Underclothes are boiled. Woollen socks, if irreparable, are unravelled to use for darning. At least the army is now taking this seriously.

Fred knows from his lectures at Edinburgh that these vermin are not just a wartime phenomenon or exclusive to Flanders. He has seen pediculosis – infestation by lice – in the Gorbals slums. The men probably brought it with them. Then close proximity, lack of washing, the sweat of continual marching and the damp of trench life provide the ideal conditions for re-infestation.

At least, muses Fred, the louse knows no discrimination. The officers have as many as the men, another factor that binds them in the trenches. He can see that the old ways are breaking down in the squalor of shared life: shared dugouts, shared buckets. Previously only the MO floated between ranks and officers, as happy dining with the Colonel as borrowing tobacco off a private. But the good officers have always known they have to look after their men, now they are all honorary MOs. The world is starting to change in these muddy slits of ground.

A week later Robertson returns from leave with Chaplin and Hobkirk. The battalion route marches to maintain fitness and takes in 135 new men, including two new officers, Captain Stirling and Lieutenant Bannerman. Scrubbed up and clean the soldiers look refreshed. Money photographs men and officers milling outside the Orderly Room in Houplines. Oakley, always with stick, looks balefully at the lens while McLellan, Hobkirk and Darling turn and face, [138] mid-smoke.

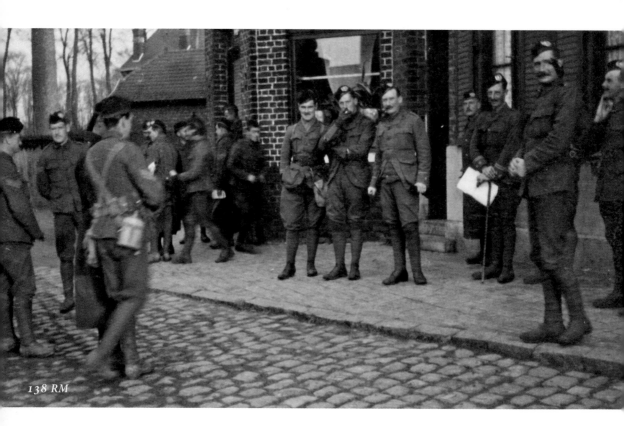

138 RM

139 RM

Elsewhere a machine-gun class is conducted in a disused spinning mill [139], the base for billets, sleeping between looms. No point in wasting good space.

And everywhere the guns keep up a sporadic bombardment. Money and Fred tour the outskirts, photographing the artillery. Men happily pose for them, some pretending to load, aping real action [140, 141].

Others are larking for the camera, already used to these amateur cameramen, or just sitting around looking bored. Boredom is four fifths of an artilleryman's day.

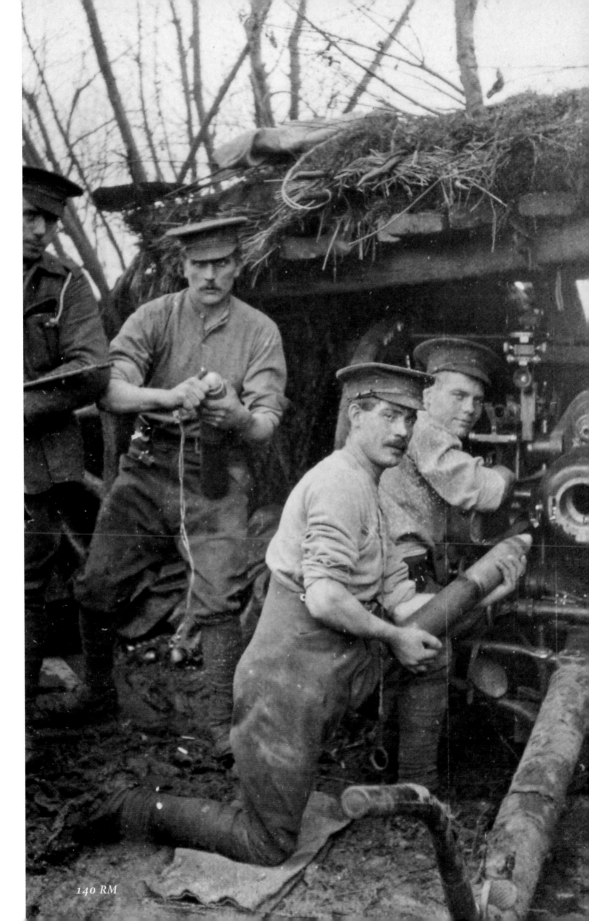

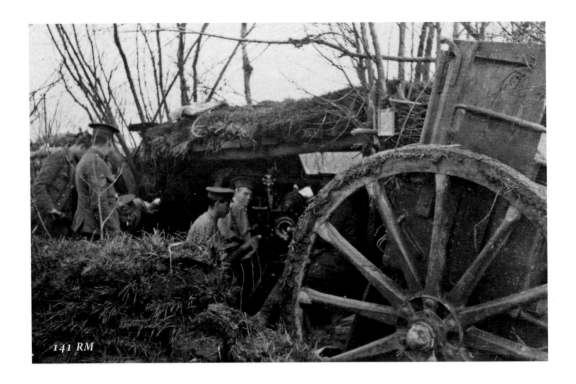

141 RM

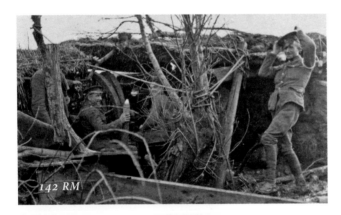

142 RM

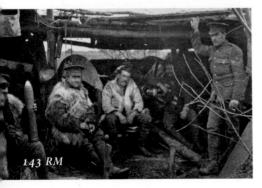

143 RM

In a final shot of murky devastation Fred in his Red Cross armband pokes the muddy ground behind an artillery dugout, the sacks and clods disguising an 18-pounder gun. Houplines's chimneys punctuate the horizon, testimony to what was, before this war arrived [144]. All around, the winter desolation seems tangible. No birds.

–Only the magpies and hawks will survive, nods one artillery man. Plenty to feed on.

* * *

Next day Fred is chatting in a Houplines street, breaking his vow never to stop, always to keep moving till he gets under shelter, when it happens.

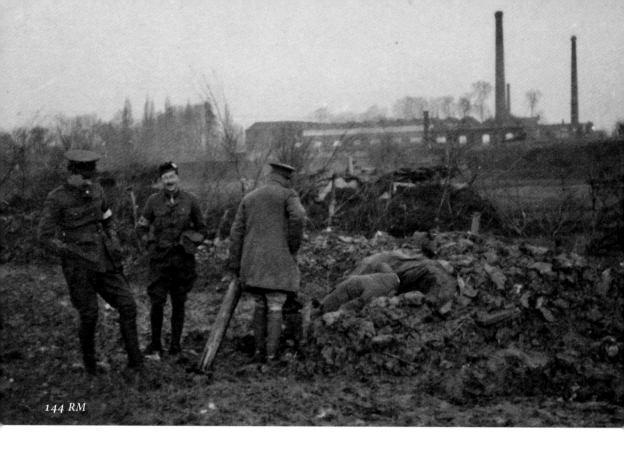

144 RM

A distant scream gets louder. Then a sudden, concussive bang shatters the wall of the terraced house behind them, wind momentarily whipping their cheeks. Then quiet. Brick dust, rubble clattering. A black and jagged shard of shrapnel spins by Fred's foot. He reaches to touch – it singes the leather of his gloved hand.

You cannot keep dodging forever. The law of averages trips you in the end. Down the street, beyond the dressing station, stepping over rubble, Fred hears another scream and stops, it gets louder, it gets louder. He just stands still. Bang. The shell smashes into a house 10 yards up the road. He has been under fire before, but you don't want to get caught in a street under a prolonged hate. He remembers the newspaper's description of the artilleryman's trade:

The effect of high explosive detonating among buildings is tremendous and does not depend upon the damage caused by the actual splinters of the shell, which is comparatively small, but upon the fact that every brick and stone, in fact, all solid objects within a considerable radius, become death-dealing missiles which are hurled for hundreds of yards in every direction ...

Fred moves quickly this time, heading back. These Houplines streets are narrow, bricked, slated, two rooms up, two rooms down, shattered windows turn eyes to the danger. They remind him of the mining towns he's seen, hunkered rows of human-hewn solidity. Another whistle. He keeps moving. Womph. This one catches him, hot, wet, in the shoulder, spinning him round, hat flying, thumped off his feet. Out.

Coming round he sees, dust, sky, a face over him, moving lips. He hears nothing, just a ringing and the dull ache in his arm, as he watches blood seeping down.

–It's your shoulder, a man is mouthing, pulling him up by his good side, support-walking him back to the dressing station. Fred's wounds are treatable, lacerated flesh, no bones broken, but he can't stand, can't move his arm, can't hear and he certainly can't scuttle along wet trenches, but they can wait. Slowly sounds are returning. He will recover. His turn for a week's leave is coming, a long trek back to Scotland and a long trek back. Another doctor from the field ambulance will take his place temporarily with the Cameronians. He wants to keep going for that.

He gets patched up at the dressing station in Houplines. While Fred is lying there, dazed but relieved, Bertie appears, as if sensing his younger brother's weakness. He looks washed-out, exhausted, in a worse state than Fred, his nerves frayed. His division has fought at La Bassée and Messines, and lost too many. Bertie has also done a stint as MO in the 2nd Leicesters, part of Meerut's Gharwal Brigade, and undergone heavy front-line shelling, before being withdrawn to hospital himself, exhausted. After precious few pleasantries, he sits and tells how it has been in the trenches, and how the poorly equipped Indians fare.

–They simply can't cope with the conditions, the stretcher bearers ... they're in sandals, for pity's sake. The ambulances have no orderlies, the hospitals no blankets, wrong food, wrong burials, the retired medics they've brought in don't know what they are doing ...

Bertie is down to a whisper now, not wanting his complaints to be heard. Momentarily he seems devoid of hope.

–They'll sort it out, reassures Fred.
–You're right, nods Bertie, smiling. His eyes still betray a bleakness.

Later, as he leaves, he asks: What will you take Father? Fred just sighs. The pennant might have been enough. He knows his father sees him as indomitable.

Death is everywhere now, the end on everyone's mind, but avoided, as if each man convinces himself he, not others, will be the lucky one. Fred knows his father tells everyone his third son will be fine, he will work through France "with his usual luck". Maybe Reverend Davidson feels he lost his third son long ago, once his wife sent him to Fettes, to an English education, where the Church of Scotland was pushed beyond the gates.

Just as he lost his second son to Canada. And his first to medicine.

Bertie a doctor, Jack an accountant, Fred a doctor, where are the ministers? Sons four and five will be ministers, whether they like it or not. Such are families. Such is his father. But it was his mother who decided on Fettes, he is sure of that. Ambitious for her boys. Just as she sent Jack to Canada, to live a better life. What would she feel now? Two boys in the war, the others itching to come over.

Fred remembers a conversation with another medic he met in the push after the Mons retreat. The doctor was young, bullish, confident, a Cambridge rower, captured by the Germans for a week, liberated by the advancing French. He had spent captivity overseeing a house full of wounded prisoners, foraging for food, begging for medical supplies – the enemy just let him get on with it.

On some cold grey morning, in some fuggy estaminet, in some small town with another flowery name, they take brandy and coffee together again and again, and Fred asks his new friend how he deals with shirkers in his battalion. The man smiles and speaks, clipped and determined.

–In the early days I was brutal. I sent all before the CO who I thought fell out needlessly. I heard myself described as a bloody bully but we reaped the benefit.

Fred understands. He asks him if he ever gets scared. The man turns to wave his hand at the girl with the brandy bottle.

–Plus encore, mademoiselle.

Then shakes his head.

–I make a point of disregarding fire, and take no precautions beyond not exposing myself more than I need. If one is killed doing one's duty, one can't help it and it is the best way of coming to an end, and I repeat that to myself when I am getting plugged at. Somehow I don't feel that God means me to get killed yet.

Fred pulls on his pipe and wonders. The best way of coming to an end. He knows most of his soldiers think they will dodge it. That's human nature. Once they think otherwise, the Army will cease to function.

Then the medic opposite leans forward and adds casually:

–Though before I came out, I had a conviction that I shouldn't come back alive.

All of that was in October. Weeks later Fred hears the doctor has died, shot through the head while kneeling to treat a wounded man in the push south of Ypres, despite constant warnings from his commanding officer that he should stay in his aid post and let others bring the wounded in.

–Use your bloody bearers!

He wouldn't. He would work the trenches while the men fight. He would treat the soldiers where they fell. *Tous pour un, et un pour tous.*

* * *

Fred had watched Bull Chaplin reading a telegram days before. Chaplin, 41, is a driver of men, no-nonsense but well-liked, a regular in the battalion polo team. He has been home on leave to attend his pregnant wife. Now he has the news: she has given birth to a son. In the officers' mess they toast the baby's head with vin rouge, and let Bull know that the boy must have a name embracing Houplines or Armentières. They hold a drunken vote.

First choice: Richard Armentières Chaplin.
Second: John Houplines Chaplin.

–Thank you, grins Chaplin. But no thank you.

Fred, whose own middle name Churchill was a corruption of his grandfather's place of work, can only sympathise. Who would want to be named after a place of death?

One wag has a copy of Dumas's *Three Musketeers* out, and is already quoting.

–And say you will wait for me at Armentières?
–Write that name on a bit of paper, lest I should forget it. There is nothing compromising in the name of a town. Is it not so?

* * *

By 11 December the Cameronians are in new trenches without Fred, replacing the Argylls at Pont Ballot, east of Armentières, where the line makes an awkward right-angle turn. On a pitch-black night in a deluge of rain, guides march them up to the trenches as the retiring battalion files out. In the dark any layout is confusing, zigzagging this way and that, officers squabble over dugouts as others realise that, at some points, they have lost sense of which side faces the Germans trenches. Had there been an attack that night, the enemy would have slaughtered them.

But there isn't, and the Cameronians settle to sorting out the problems – principally, water. Thirty yards of trench are under a permanent 18 inches. When the Brigadier-General in charge of the 19th Brigade visits the trenches on 14th December, his boots are sucked off his feet by the voracious pull of the mud. He carries on walking in his socks. Or that's the story told.

Captain Jack returns, after a month's sick leave for pneumonia. An ambitious but likable disciplinarian, who writes a daily diary in code, he has spent three months as staff captain at the 19th Brigade, and is full of insight into the HQ's problems: three changes of commander, three changes of Brigade Major, the continual switches between divisions. Inside the Cameronians duties are reshuffled. Oakley is now the battalion's No 2 – Vandeleur having been transferred to command the 1st Cheshires, decimated at Mons. Riddell-Webster has already left to replace Jack at Brigade headquarters.

On the front line order is imposed. Trenches are split into a series of section posts, manned by an NCO and six soldiers, 25 yards apart, separated

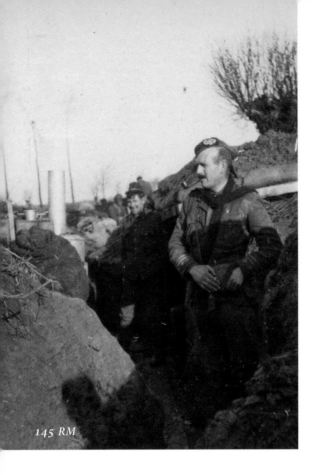

145 RM

by waterlogged trenches. Saps – smaller trenches – lead back to where the bulk of the men wait in support, taking turns at the front on watch. Three companies man the trenches, one rests in Houplines, fetching, carrying, helping at night with repairs.

By 16th December Fred is back from leave, no comment to make about home. He has been in St Cyrus for only a day, reassuring his father but telling little. He spends as long shopping in Edinburgh, bringing back VAT69 whisky and fruitcake, and more films for himself and Money. Then he slips back easily into his MO's routine, visiting each company daily, with Robertson, Darling and Money, usually at first light, as any movement from the back can be spotted from the German lines, who will then shoot or shell. The visits allow company commanders to feed problems back to the HQ team and discuss supplies needed. Darling as adjutant dutifully takes note. On just such a visit Money photographs Darling, notepad in hand, by a company field kitchen [145].

Everyone senses bigger battles being fought elsewhere: the pounding of guns at Messines, to the north, gunfire and searchlights at La Boutillerie, their old battlefield, to the south. Yet the sector around Armentières remains quiet. Just the relentless sniping that wears away at men's confidence. Move your head, pshht, and the earth behind sprays up a small cloud of brown dust. Or just a pllp as the bullet burrows into soft mud. One second later and you would have bought one.

Elsewhere they hear staff officers are amusing themselves beagling at Croix du Bac. How they would like to swap.

* * *

Fred keeps taking pictures. He photographs Pont Ballot's muddy bleakness one grey morning, a tin of boiled sweets – Nuttall's Mintoes – abandoned on a pallet almost as a taunt [146]. These were farmers' fields just the year

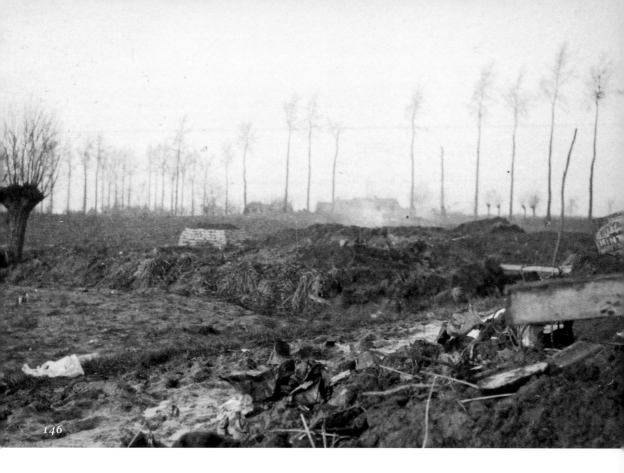

before, stretching flat and fertile to
the horizon, brimming with beets and
potatoes. Now they are a gouged, dead
landscape. No one is visible. That's
the commonplace sight. Whole days
can go by without a German seen, so
severe is the sniping, so scrupulous the
cover taken.

Fred is welcome to roam, all owe him
favours. Even when not being shot
by the enemy, the men are perfectly
capable of injuring themselves, sitting
on bayonets, shooting their arms
when cleaning their rifles, firing
at neighbours by mistake, or just
drinking themselves to a standstill,
if they can find the alcohol. It is the
Glasgow way. Fred patches them up,

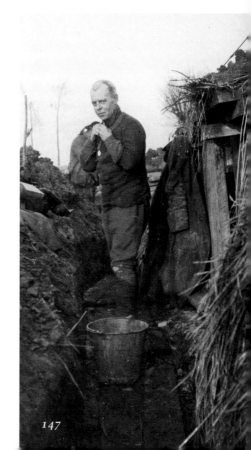

such accidents a constant undertow to sick parade. No one suggests it is deliberate. Yet.

Fred photographs A Company's support trench close up, where the men are more confident moving around. Bull Chaplin is getting dressed in the morning, duckboards at his feet, the mud of the trench wall as his sideboard [147].

In a second picture, a dirt-encrusted McLellan stands perilously tall by the same spot, hands clasped, bemused but indefatigable [148]. Just eight months later McLellan, 31, is arrested in trenches near Bois Grenier, a mile to the south, for "certain inaction" – code for refusing to commit his men to an attack – then tried and acquitted days later. Blind obedience is not the Cameronian way.

Bull gets his men shovelling mud, and his improvements to drainage win him admirers. Money takes his Kodak round A Company too. More Chaplin, more Wright, hands deep in pockets, more McLellan [149–153]. Wright has reason to smile. He has persuaded Money to give him films to develop via his amenable parents, who make prints at McCullum, "photographic dealer and Kodak supply stores" in Scott Street, Perth. Mr and Mrs Moncrieff Wright are already posting the pictures back to their boy at the front, under plain cover.

For the rest of the Cameronians, the monotony has become deadly. Digging, draining, sniping. Digging, draining, sniping. The footsloggers have become the trenchrats. They wait for Christmas, thinking of Glasgow, 500 miles away.

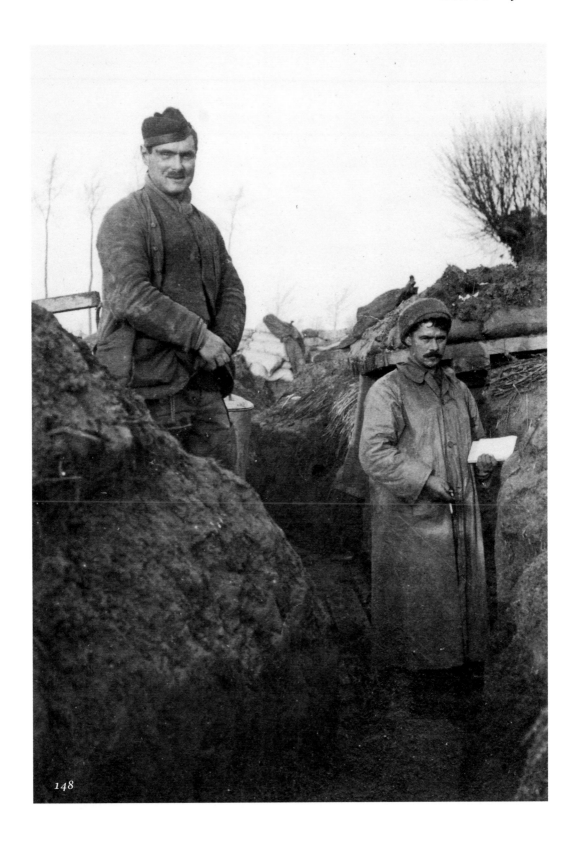

148

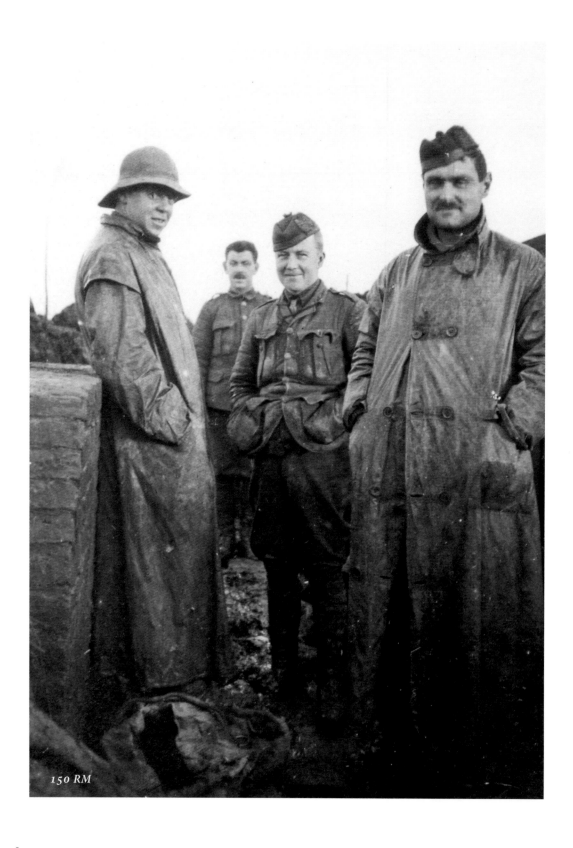

150 RM

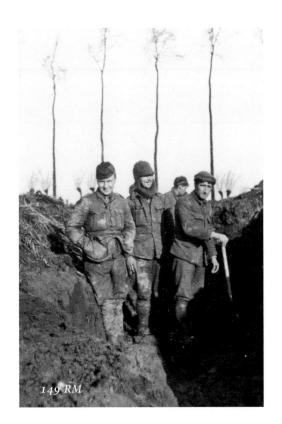

149 RM

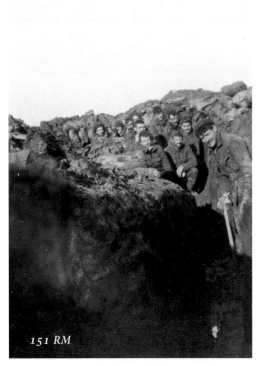

151 RM

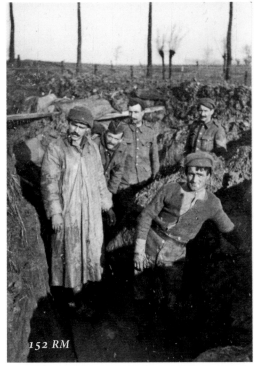

152 RM

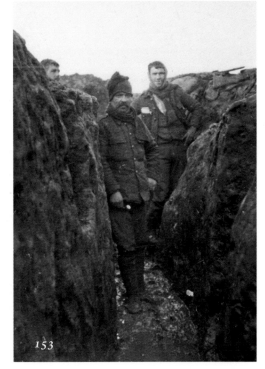

153

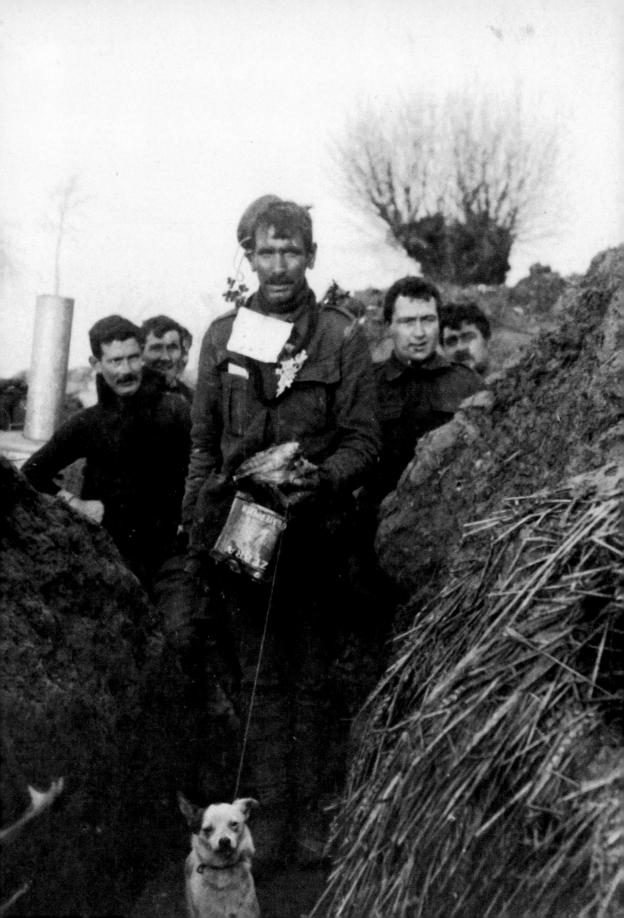

11

CHRISTMAS

15th December: Another typical trench day; but
luckily the rain has more or less held off. Had it pretty
hot "observing" this morning. A sniper near the three
gabled house, I think, put in 12 shots all round. I kept
moving along the trench and back again, which was
just as well as he put in a couple just into the spot
where my head had been and about half-a-dozen made
the earth fly in front of me. Finally one whizzed by
about a couple of inches from my ear. At this timely
moment, Salmonson arrived to relieve me Xmas is
only ten days off. Won't it seem queer to spend it in
the trenches?

— DIARY OF 2ND LIEUTENANT PR HARDINGE,
B COMPANY, 1ST CAMERONIANS

SO MUCH for the war being over. Fred Davidson finds the men are resigned to seeing out Christmas in the trenches, far from home, far from the fugged pubs and beery punch-ups that punctuate a Glasgow winter. Here, at least, they are with their friends and their regiment, which for many from the tough slums is a better family than that they knew, growing up. And with this family, discipline is loyalty and sacrifice is expected; following orders is something you do, not to let the group down. Right now, with these men, malingering is rarely a problem. Fred is trained to spot shirkers – it's part of the MO's job, and he would have no qualm about sending anyone back to the trench who reports in sick with a make-believe condition: you owe it to others not to swing the lead when your mates are caught in a hate. It will, of course, change.

Fred is thinking of home, too. In St Cyrus his father will be overseeing the school Christmas tree, supervising its decoration with his kindly sighs. Outside, the North Sea winds will be cutting down the street to the Post Office, blowing stray bun bags up and away, while the rail station stands bleak under steely cold skies. Is that what he is fighting for? Those grey-green fields rolling off to the Garvock hills, the chuntering train ride into watery Montrose, the churches standing like unlit beacons, Carnoustie's sea-swept links, Dundee's teetering Tay bridge, Edinburgh's palatial George Street. He is always trying to get away, though he wouldn't want Hun boots on his Carnoustie greens.

His father knows everyone in St Cyrus, ministering to the high and the low. Fred does likewise here, with his community, so that's his purpose. He pulls on the same resources, drawing on memories of how his father would listen, advise, admonish, cajole, console and celebrate. Fred can imagine doctors replacing ministers in a new secular world, changed by technology, changed by war. There is already talk of a state-funded national health service, though few believe it will ever emerge. But looking at this army's system of process – triage, ambulances, concentration of expertise – he can see how it might work. But what medico would want its concomitant bureaucracy?

Fred is spending too much time filling in forms, requesting supplies, writing up notes, accounting for this and that as his orderlies work the stretchers – the paperwork dogs him, that legacy of the Empire's committed grasp of logistics. For every man at the front, there are three clerks behind, organising their files. He can believe it, and he doesn't question it, because labour is cheap. At times, though, he wonders whether he is just a glorified postman, wrapping up Eusol'd patients, labelled for delivery to dressing station, clearing station, hospital.

But he knows his men – he already thinks of the Cameronians as "his men" – need him. There is a sense that something bigger is coming, battles that will create more work than the doctors can cope with. He could see that at La Boutillerie. He shudders to think what he would do if his men were hit by a prolonged, intensive bombardment of their trenches. One long amputation of torn flesh and crushed bone. The dugouts need to be deeper. And if it gets worse, where will the Army find the doctors to cope? They are already pulling old medics out of retirement to cover for young doctors sent to the front. Every barrage on every front sends back a ripple that washes over the old country.

So it continues: the British artillery step up their shelling of the Germans on the 16th. Something is up. Robertson receives confidential orders that the Divisional staff need more information, and want the Cameronians to attack the German line head-on, capturing prisoners and equipment for analysis,

154 RM

presumably as a prelude to an even bigger assault. The top brass are obsessed with straightening lines and removing salients – the right-angle kink in the Cameronian trenches must be pushed out. The Germans also have a searchlight on higher ground overlooking the trenches that sweeps the sector at night, making patrolling a more perilous activity than usual [154]. That is on the must-go list too.

Robertson protests that the German field of fire is too good, his men will

be decimated, and little information will be gleaned. His complaints are ignored. On 19th December the Cameronians are ordered to man the front trenches and fire rapidly on the German line at 11 am, 1 pm and 3 pm, simulating the preamble to an all-out assault. The plan is to fool the enemy into bringing up supporting troops, and reveal their communication trenches to British artillery.

Instead, the Germans opposite sit tight, wait, and when no attack emerges, send up a derisive jeer, throwing turnips and rubbish out of their trenches towards the Cameronian line. Point made. They are too smart to fall for that ruse.

By 22nd December Darling is telling Jack, whose C Company is in support, to "test all wire cutters" – the sure sign that an attack is imminent. Jack asks his quartermaster-sergeant, who replies that he would, but most of the wire-cutters were lost in the retreat from Mons. The Army is still playing catch-up.

Perhaps this is the final evidence Robertson needs. By the next day the attack has been cancelled. No one is quite sure why. Lack of shells, lack of equipment, lack of men – the list could be long. Jack hears that eventually Brigadier-General Gordon, in charge of the 19th Brigade, had backed Robertson up, and agreed that little would be gained by sending the battalion over the top. It is a rare gesture of common sense in a war that will shortly become nonsensical.

Nine months later Robertson, promoted to head the 19th, shows the same courage in countermanding divisional orders, and cancels an infantry attack at Loos when officers of the Cameronians and Royal Welch tell him it would cause huge loss of life for little gain. For now, it is seen by many as a blow for sanity. Even Money, usually gung-ho, can sit in the HQ mess when Robertson is absent and mock the staff command's intentions.

–So, after three rounds rapid from our tame battery at three in the afternoon we are to step out of our trenches and go quickly across 300 yards of ploughed field – best-quality mud – and two quickset hedges, where, so the staff assure us, we shall find only a few demoralised Saxons, remove any machine-guns, mortars or other dangerous toys which might be lying about, and then return to our own lines being careful to leave no wounded behind. All souvenirs to be handed to Brigade HQ the same evening.

He sighs. Who says the Saxons are demoralised? And what about the machine-guns in the farms behind? Perhaps they should come and look for themselves.

The night patrols are taking a toll. Fred will sit in the trenches now, far from his aid post, carrying just a surgical haversack. He waits in case his men take a beating. He has time for tea, a nip of rum, the lads' stories. Sit in the mud, with your breath turning to steam, keeping your head down, ducking the breastworks where the bullets whistle through. And wait. On a cold night, you hear more than see.

The trip wire trips. A can is kicked. Then the sporadic patter of machine-gun bullets. It only takes one man down hurt as night turns to dawn, and light leaches in, threatening to expose him.

Fred is up and over, half running, crouching, then crawl, squirm over to the man down, never frightened, exhilarated, inviolable. One can work faster than two, less of a target. Fred hears the *ffft* of bullets hitting mud beyond him. His soldier is shot in both legs, shaking, immovable. Fred talks low, calms, soothes, ties two tourniquets, offers morphine, squeezes his arm in reassurance, then heaves the big Jock round, keeping low, pulling him by the shoulders.

From the trenches the men are firing round him now, offering cover, showing support. He's into a shell-hole, he's out again, into another, a bearer belly-wiggles out and helps Fred pull, 20 yards takes 20 minutes, the German machine-gun starts up again, almost lazily raking the ground to their left, *plew plew plew plew plew plew plew plew*, as if nonchalantly unsure whether it might cut you in half or not, pushing up little spouts of brown earth. And they pull, crouch, pull.

When they tip the man over the wet lip of the sodden trench, a ripple of applause goes up from the platoon lining the firestep. Fred slides down after and sits in a crouch, panting, grinning.

–Ye stayin' for breakfast, sir?

Not just a doctor, but a brother.

Despite the steady trickle of replacements the battalion is still not up to
strength and on the front line, incessant rain is now pulling in the sides of
the trenches, sometimes trapping men in their "funk-holes". They dig, they
pump, they pray for colder weather so the mud will freeze again and stop
sucking at their heels.

Christmas Day falls on a Friday. No one is quite sure what will happen.
Business as usual, says Divisional HQ, but the men are wondering. Orders
have been passed down that there will be no ceasefire, no fraternisation,
and the officers suspect their dour Cameronians, pinned down by constant
sniping, will hardly want to shake German hands. In the support trenches,
they remain ready to fight. Fred takes photographs of his stretcher bearers
wrapped up in their "teddy bears" – goatskin jerkins issued to combat the
bitter winds [155].

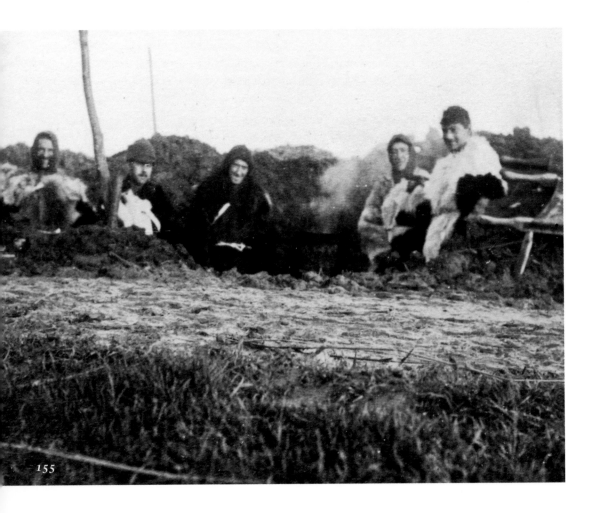

155

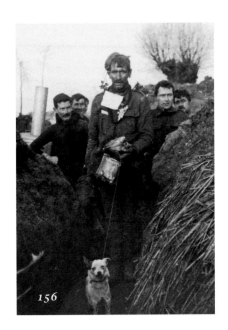

156

In another, HQ servant Hawes grins behind a soldier bedecked in tinsel. He holds a mongrel on the lead, and an indecipherable sign is pinned to his tunic [156]. Years later, Fred captions this "Xmas 1914. Father Xmas in trenches". The dog, adopted for the duration, is the first of many to appear as the soldiers look for help to fight the rats that now feed off corpses and waste. Soon the Cameronians will have a band of strays to support, much loved. Fred cannot live without dogs, and promises himself a suitable terrier or two.

But on Christmas Eve a strange quiet descends. The sniping on both sides stops and the peace bewitches the men. At midnight they can hear the enemy singing Stille Nacht. Then the shouts begin.

–Tommy Tommy why you not come across?
–'Cause we don't trust you, and ye hae bin four months shooting at us, reply the Jocks.
–Hoch Der Kaiser, shout the Germans.
–Fuck the Kaiser, yell the Cameronians in response.
–Gott strafe England!

Some of the Cameronian officers are shouting out "Waiter! Waiter!" The ranks use "Fritz".

–You didn't have to know her long, to find the reason men went wrong. On her bed she sure was fun, moving her arse like a Maxim Gun. Inky pinky parlez vous …

The singing continues all night, but no one dares enter No Man's Land except one Cameronian, drunk on rum, who ignores the warnings of his fellow soldiers and staggers off down the line, visible to all. Later, it is said, he tells an officer of another battalion to "fuck off" when ordered to return to the trenches. He is arrested and faces a court martial.

The next day Fred hears more stories at the dressing station in Houplines. The Argylls and the Royal Welch have dropped weapons and met the enemy midway. The Germans roll out barrels of lager and hand round

cigars. Hampson is still smoking his, passed on by the Argylls' MO.

The Germans say they are Saxons and sorry to be fighting. Other stories circulate. The 6th Cheshires share a cooked pig, the Lancashire Fusiliers lose a football match with the Saxons 3-2. Two men from the North Staffs regiment kicking a ball around No Man's Land enter the German trenches and don't return. Jugglers and barbers setting up, a sergeant performing in drag. More balls kicked across.

The French are always fascinated by the British obsession with football, asking why so many soldiers carry balls strapped to their packs. Here is the answer – they are waiting for Christmas.

The Royal Welch, holding trenches previously manned by the Cameronians, negotiate a full day-long truce, captain to captain, meeting in No Man's Land. When the two officers shake hands, and toast each other with beer, both sides applaud and cheer. But the truce is just an agreement to cease sniping, no more. The next day the Royal Welch captain symbolically fires three shots in the air, and then climbs on the parapet holding a flag saying Merry Christmas. The German captain opposite climbs up, bows and salutes, then returns to his trench, and fires two shots in the air. The war is on again.

Other doctors tut-tut the story, such fraternisation being in clear contradiction of Army orders. But when you are patching up the wounded, dealing with the product of relentless barbarity, you pause. Fred is a patriot. He has read his GA Henty and other tales of derring-do, like every Edwardian boy, and he believes in the British Empire, the greatest the world has ever known, and he understands the ideal of sacrifice within a group. But he has seen enough hurt and pain now to know: be careful what you wish for.

* * *

On Boxing Day the Cameronians are relieved by the East Yorkshire regiment, and go into billets in Armentières, away from the front line. The men sing as they march the cobbled streets, jaunty with expectation, the town's many distractions now close at hand. In the mess, each receives an engraved brass tin filled with tobacco, cigarettes and chocolate, plus a card stating it is a Christmas Gift from Princess Mary, George V's 17-year-old daughter, "and the Ladies of the Empire". Cue much ribald chuckling.

But first, there is the battalion Christmas dinner, organised by Tubby Wood, where by tradition the officers and NCOs serve the men, and all bet on whether anyone can outdrink the incorrigible Cockney quartermaster. Then there is New Year to celebrate, seen in with suitable enthusiasm and haggis. Plus the mountain of cakes, sweets and chocolate sent from home – more for the Scottish regiments, seemingly, than anyone else. Then the necessity for each company's officers to visit the mess of other companies, and drink their and everyone else's health. In barracks the toasts are made with decantered port; in war it's whatever they can find – whisky or vin rouge – in battered enamel cups.

–Mr Vice the King, shouts the company commander, at one end of the table.
–Gentlemen, the King, replies his deputy, firmly seated, at the other.

Hill, Jack's No 2 in C Company, later confides to his diary that junior officers find the seated toast rather affected. But he keeps it going, because, like the goat that the Royal Welch habitually drag along with them, it differentiates and binds. Chaplin's A Company even draw up a ceremonial New Year menu:

> *Soup – Haricot or Thick Shrapnel*
> *Fish – Lobster Salad or Filleted Von Kluck*
> *Entrée – Bread & Butter Pudding or Peaches*
> *a la Souvenir*
> *Entremets – Boiled Rabbit or Roasted Kron Prinz*
> *Savories – Sardines on Toast or Remnants*
> *of the Huns*
> *Café – Desert – La Guerre Fini*
> *A Happy New Year To You All is the sincere wish of*
> *all the Knuts Konnected with the company.*

Overall, of course, Christmas and New Year become – in the best Scottish tradition – a prolonged, alcoholic party.

Perhaps because of this, or perhaps because Robertson has already marked his card by arguing against the Division's strategy, Major-General Keir demands to see the battalion marching past his HQ, four miles outside

Armentières, on the first Monday after Christmas. So the Cameronians parade at 8.15 am on 28th December. Robertson, in the battalion's war diary, holds his contempt at a gentle simmer.

"The Maj. Gen. Comdg. VI Division wished to see the Battn. Marching. The Battn passed him at his HQ at CROIX DU BAC at 10 am. TOTAL DISTANCE marched about 9 miles. The men are rather groggy, which is not to be wondered at. 8 men fell out."

By the 30th December, the same divisional HQ is holding another meet for its beagles.

* * *

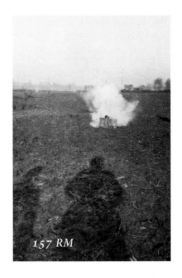

157 RM

Amid the haze of strong drink, Fred supervises more baths for the men. In Armentières, most are billeted in another large factory, sleeping between defunct machinery. Companies take turns in route marching or playing football, the usual Army tactics to keep the men out of the estaminets and brothels. March, fatigues, sport. The matches between the Cameronians and the Argylls will later be played with the passion of local derbies.

Some officers have other worries. Money has read new orders emphasising that cameras are banned and that there must be absolutely no photography. He notes in his diary on the 24th: "Dreadful blow – orders saying 'Taking of photography is prohibited'." Wright is rather more nervous. He has spent the last month passing prints around the battalion, sending photographs to Graham and Ferry as they recuperate, and arranging even for disapproving officers such as Darling to have copies. McCallum, his developer in Perth, has also passed some of the Cameronian photographs to the local press. The young lieutenant can suddenly see his Army career ending ignominiously. He writes anxiously to his parents: "Remember do not let any of my photos be published or exhibited. All these photos ... were Mr Money's, not mine ... Do not let any of mine appear, please be sure of this."

From McCALLUM,
OPTICIAN & PHOTOGRAPHIC DEALER,
KODAK SUPPLY STORES
8, SCOTT STREET, PERTH.
'NEXT G.P.O. Phone 326

Photographic materials

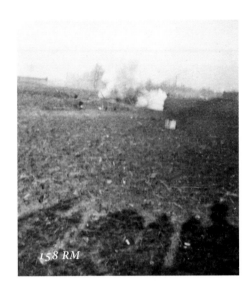

158 RM

Yet by the 26th, Money – perhaps buoyed by Robertson's nonchalance – is taking pictures again, this time behind the front line, at the Royal Engineers' base on the outskirts of Armentières. Here his machine-gun team is inspecting new equipment: trench mortars, grenade bombs [157, 158], more machine-guns.

Poignantly his photographs depict a test set up to show the effect of machine-guns on barbed wire strung 200 yards away across a ploughed field [159]. Before, the wires are intact [160]. After, they are shredded [161].

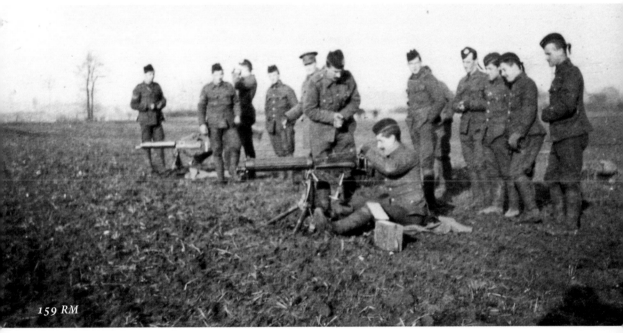

159 RM

160 RM

161 RM

No one can say the strategy of shredding-before-advancing – which so singularly fails to work over the next three years – hasn't been tried and tested. Money's machine-gun crews can be seen bantering behind the guns, spirits buoyed.

By 2nd January the Cameronians are in trenches again, up to their calves in water again, in a new sector, Bois Grenier, south of Armentières, again. Flat, wet mud awaits them, dotted with pollarded willows, as before. Winter's bareness lies like a thin blanket over this sodden land, consoling no one. Just over 100 yards away, the Cameronians can see the Germans bailing out their trenches with mess tins. That makes them laugh. Unfortunately, as the enemy occupies higher ground, there is only one way the water is going.

That night Stirling is shot through the head by a sniper while walking C Company's trench. One minute talking, the next slumped speechless, the back of his head a tangle of brains and blood. He is a boisterous adventurer, the son of a Brigadier-General, part of a family that will be pulled apart by this war – one brother has already died on HMS *Monmouth*, sunk off the coast of Chile in the battle of Coronel just two months earlier.

Fred is working on another soldier, another bullet wound, a mess of tendons and crushed bone splinters, when they bring Stirling in, dead before anyone can help. He keeps working, keeps thinking, pulling out the bone fragments he can see. Jock Stirling they called him, his old Wellington nickname, as stupid a soubriquet in a battalion of Jocks as you can get, but he loved it, and everyone loved his spirit, always wanting to have a go at the enemy. Another head wound, another victim to the Army's insistence that soft caps are all the protection a soldier needs. The men must wait until October before the "Brodie" steel helmet arrives, resistant – at a distance – to shrapnel and bullets.

The loss of Stirling so soon after his arrival at the front makes many in the battalion pause. If the war starts chewing up new recruits so fast, how will they cope? Kitchener's volunteers, the new army recruited since September, the citizens' army predicted by Lord Roberts, will number over a million, but the Germans have millions already. In the HQ mess, the mood is sombre.

Later in the week the battalion buries Stirling in the orchard behind Bois Grenier's brewery, whose cellar now accommodates a dressing

station. Stirling's grave is the second in the orchard, lying just yards from John Oldham, a private in the Leicestershire's killed two months earlier. Stirling's plot is timber-fenced, wired against rabbits, and laid out with a small, formal garden. Box hedging surrounds clipped irises and a wintersweet bush, in flower beside a cross inscribed "Who makes a sacrifice lives". It is testament to how each man would like to lie in rest. Both Fred and Money take repeated pictures of the assembly [162, 163, 164], the first grave either has photographed since the war began. Death is now

162

163

164

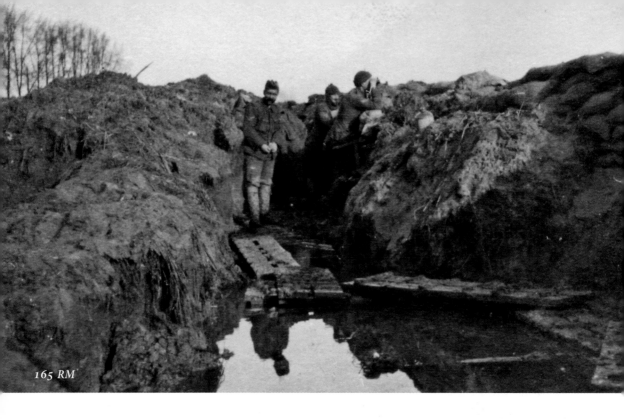

165 RM

too all-encompassing to sidestep. By the end of the war Bois Grenier's orchard cemetery will hold over 300 graves.

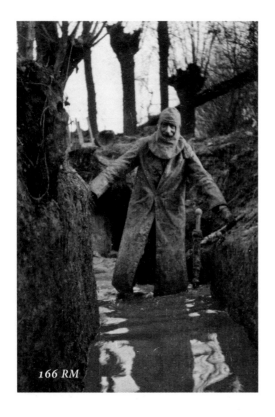

166 RM

On the morning of 5th January Money joins Robertson's daily inspection of the battalion's trenches. Part of D Company's trenches is a lake of floating duckboards [165].

Behind, he photographs Robertson wading stiff-legged down the communication trench between HQ in Bois Grenier and C Company [166]. Robertson returns the compliment, taking a shot of Money in the same position, this time holding the handle of the trench pump [167] for effect.

Money is already offering copies of his photographs to Glasgow newspapers – anonymously – and assembling his pictures with an eye to publication. The poses seem more casual than ever, the officers conscious of putting up a good front. He

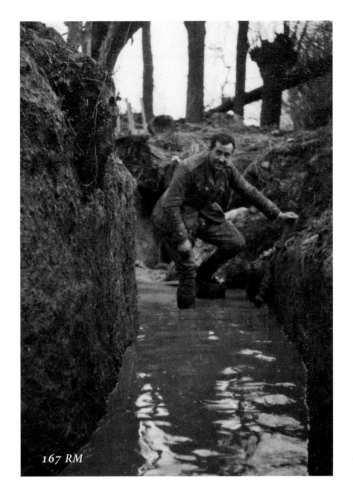

167 RM

photographs Becher and Jack looking mud-spattered but determinedly nonchalant in the C Company trench, just days after Stirling is sniped there [168]. Only a battalion stalwart would notice that Jack, 34, is already hunched, pale and drawn, his health again declining fast just a month after recovering from pneumonia.

Money is moving beyond the people, places and destruction that most soldier photographers depict. Now he is showing the detail of how they live and fight, yet still he avoids the more awkward truths. These cannot be shown in a family newspaper, and for the men involved, the truths are not what they want to remember.

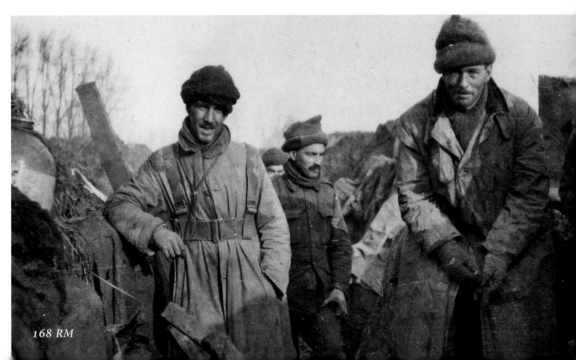

168 RM

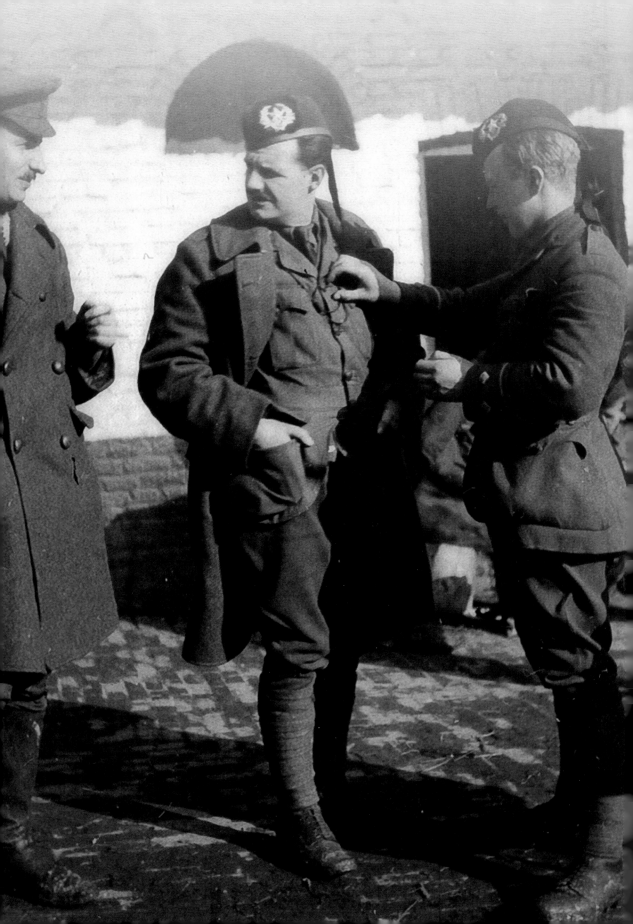

12

BOIS GRENIER

10th January 1915: We had a visit from Bertie ... He is
quite well, but was a woeful ticket ... with a patched-up
uniform too big for him, riding boot spurs, a waterproof
coat, carrying a German rifle and bayonet ... His own
uniform had got worn out and he had just picked up
a bit here and there ... He seems rather fed up with the
war and thinks it will go all summer. His squad has
suffered greatly – only 300 left out of 1000 – of course
that is killed, wounded and missing. Thomas was
having his usual good luck when I heard last.

– LETTER FROM REVEREND ROBERT DAVIDSON TO HIS
SON JACK DAVIDSON IN CANADA

MORE RAIN. It never stops, flooding trenches, drenching men, soaking their woollen uniforms so each step is a labour. The front at Bois Grenier is now a muddy weave of outposts, loopholes and submerged supply channels, the sniping continuous, the trenches still in parts disconnected. Frankie Rooke takes one in the hip slithering over one trench to another shortly after dawn. Stretcher bearers drag him to the company HQ, and lay him on a table, staunching the wound with a field dressing. They wait for the MO. Fred Davidson runs crouched through the water up the communication trench from his aid post, then plunges into the dugout. He undoes the dressing, checks the pressure being held. Cleans with Eusol, checks for bone fragments, if he's lucky it will be straight through both buttocks. Everyone has an eye on his work, everyone likes Frankie, no one wants to lose him.

–You're OK, all intact, reassures Fred, holding Rooke by the shoulder.
The lieutenant is starting to shake again. Men are clustered at the shelter entrance, watching.
–Give me room.

Fred works coolly, remembering, always remembering, check and recheck ...
The bullet has passed straight through, but the bleeding must be stopped.
Fred has run through the drill for a bullet-wound haemorrhage with his stretcher bearers again and again – if he hadn't known it by heart before, he certainly does now ... *arterial haemorrhage may be known by*

1. the blood escaping in jets or spurts, because it is pumped out by the heart.
–Come on Frankie.

2. its bright red colour.
–Hold it, hold it.

3. that it may be stopped by pressing on the artery between the wound and the heart.

–OK it's slowing.

Venous haemorrhage may be known by

1. the blood being of a dark, purplish-red colour.
2. its flowing in a continual stream and not escaping in parts.
3. that pressure applied on the side of the wound furthest from the heart stops
it, while pressure applied between the wound and the heart does not do so.
A dependent position, muscular exertion or straining, or any obstruction to
the veins above a wound, greatly increases venous bleeding. Hence it is much
greater after accidents than at operations.

Prof Thomson, his old surgery teacher, barely touched on bullet wounds,
but why would he? No one used guns in a Glasgow punch-up – bottles,
razors, chair-legs but not guns.

Whatever the nature of the weapon concerned, the wound is of the punctured,
contused and lacerated variety.

It certainly is. Fine and dandy in the operating theatre, try sorting it out in a
muddy trench, two lanterns for light, rum jar on the hook, bet that's empty.

Fred is clamping and unclamping his unlit pipe as he works, willing
Frankie better, worrying about infection, keep it clean, *pus bonum et
laudabile*, which ancient doctor was it who thought it necessary for pus
to form in wounds? Galen. He was wrong. Cauterising with boiling oil?
Giovanni da Vigo. Wrong. That's medicine, always wrong later. The
profession's motto: how times have changed.

Frankie's shaking again now, going into shock.

–Will he be alright, sir?
–He'll be standing at communion with the best of them, though sitting may
be a problem, mutters Fred, working, pressing. There is a fine bead of sweat
working its way down his aquiline nose.

Captain Jack squeezes past the men outside the shelter, looking in, always a
stickler for all things in order, but he too loves Frankie, the worry is written
on his drawn face. Fred notes Jack is wheezing as he breathes.

–We can't take him back in daylight...
–I know, he'll be alright, says Fred, just give me time.

He has to stay confident, remain assured; he learned that even before medical school. God Almighty Davidson. He's lost Stirling. He's lost Ritchie. And he thought he had saved him, too. He's lost countless young men already in this war, what is he doing to help? But Frankie's different, too bloody young, what is he, 20, 21? Too bloody funny. Has a temper too. He remembers Frankie at Barry Camp. Frankie in Maryhill. This is what it is going to be like, losing friend after friend, till who is left? God save us. What God indeed. He knows what his father would say, up in that fine pine pulpit under that blue ceiling, angry and resolute.

We commend them to the God of all comfort, whose consolations never fail. In wiping the tears of others, our own will cease to fall.

–You are muttering, says Jack.

Fred grimaces. Frankie will be alright, he will be all right. Certainty is the great redeemer. *The earlier the wound is disinfected, the greater the possibility of diminishing the risk of septic infection.* That is his God. Break another ampoule, *apply dressing loosely to allow for swelling*, but he needs to get Frankie back to a hospital, no laparotomy for lacerated intestine, but repair torn blood vessels, nerves, tendons. Paraffin paste ...

–We'll carry him back at dusk, says Jack.
–Get a bloody brazier in here and keep him warm.
–What about the smoke?
–By the door.

Fred is wrapping Frankie now, blanket after blanket, keep him hot, still thinking of his father's kirk, a report of a soldier's funeral. *The Dead March is played by the organ while the congregation remained upstanding and the National Anthem was joined in by all.*

Not with Frankie, mutters Fred. He squeezes his hand. The bearers will be late taking him back, that delay could be fatal. But he will live. No funeral just yet. Step down from that pulpit.

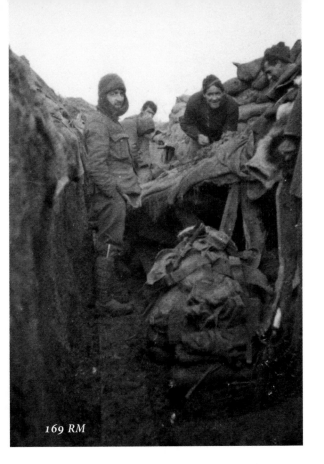

169 RM

The next day the water in the trenches is worse, and rising further the day after. The men try to build up the parapets and stand over the flow, but the sliding soil makes it difficult. By Friday 8th January dugouts are falling in, boards, papers, tins a mess on the floor, the earth spilling over the ramshackle beds and benches. Money later photographs a similar collapse in a forward trench [169]. If you're lucky, you get out in time. "Rotten if one happens to be inside."

Robertson gets his men to start a clear-up – the battalion is being relieved by the Royal Welch that evening, and trudging back to billets behind Bois Grenier, so it wouldn't do to leave it piled and tangled for others. Or they will leave it thus for you.

Fred sits with Rooke, back in 19th Field Ambulance's base in Armentières's Jesuit College. He is responding well. Patched up to return to the front with a bullet through and through – it seems nonsensical to Fred, but he knows Rookie would have it no other way. These are his congregation too.

Fred wonders if Bertie is back from Scotland yet, back to his Indian boys who feel this cold so much more than his Scots. He knows his brother took a German rifle and bayonet home for the Reverend to admire. Perhaps they will end up above the organ too? What fear will that put into the proud Presbyterian congregation as the distant war starts taking their sons from them, one by one? Every winter they lose fishermen to the sea. Battered by the east wind, frozen by the Arctic currents, they know every hardship. The women will understand, for now.

* * *

Out of line, the battalion is billeted in small brick cottages and farms around Gris Pot – GreasePot to the Jocks – a hamlet less than a mile from the trenched front line south of Bois Grenier village. The hazard of shelling is constant. In Bois Grenier, near the battalion HQ in Moat Farm, all the officers go to the back garden of one home to view an unexploded

"Jack Johnson". It has, they are told, flown through two windows without detonating, before landing with a soft plap in the mud outside. Money puts a box of matches atop before both he and Fred photograph the beast [170]. It looks innocuous in its inertness.

170

* * *

The war is stalling now, both sides depleted, restocking, reassessing how to restart in the spring. Britain is sending that new army to flesh out the old sweats and calling in troops from its colonies. Germany is digging in and pondering where to strike next, after missing Paris, its main goal. France and Belgium are counting the cost.

For the Cameronians, routine is now established. They spend five days out, five days in the trenches parallel to Rue des Bois Blancs beyond Bois Grenier, alternating with the Royal Welch. Relations are tetchy between Robertson and the Welch commanding officer, with both sides accusing the other of poor standards. Fred hears from HQ servants that the row started

over an enamelled potty which one Colonel insists on using, and the other throws away on taking his rooms. From such a tiny spark can a feud be kindled under pressure: leaving not a pot to piss in.

Underpinning the tension is a fight for supplies. With shortages now apparent along the front, the wiliness of the battalion quartermaster becomes key. Wood is emperor of all he can hoard, king of the rum jar, known to be partial to a tipple himself, he is also a target for other battalions' filching, as he keeps more than he needs. Their tactic is simple: get Tubby roaring drunk, wait till he falls asleep, load up and leave.

Behind the lines, a muddy wilderness of ruined farms and shell-blasted billets is filled with men resting between work and play. Fred has time to follow the routines, camera ready. In Wood's supply yard, he catches the paunchy Cockney standing proudly, proprietarily, hands in pockets, chest puffed like a pigeon [171]. Around him, his team gather about a single rum jar placed in honour on a crate. They know the joke – they look like they have won the Scottish Cup.

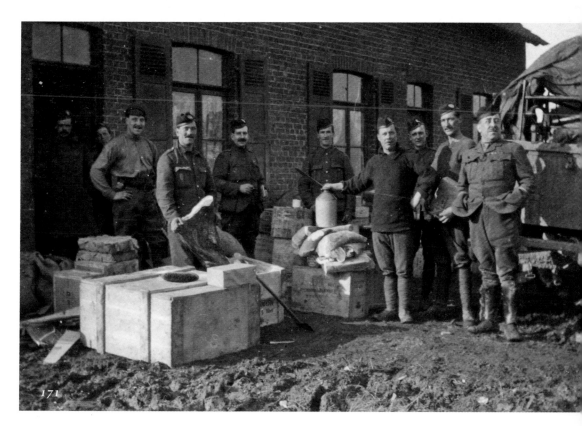

171

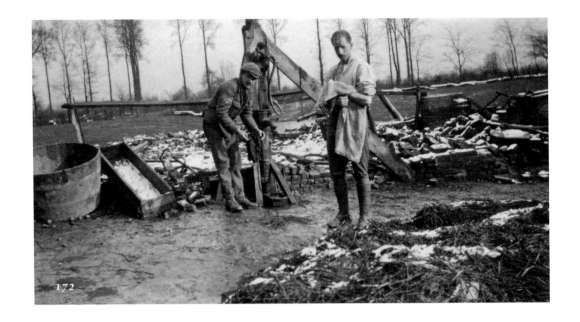

172

At New Farm, where the Royal Engineers store equipment, Fred greets an officer washing up before Robertson visits, standing with towel in shirtsleeves, snow still spattering the ground around him, an NCO working the yard pump [172].

173

Later Robertson arrives to inspect new frames for dugouts and defences [173]. The winter rise in the river Lys and the continual sodden state of the trenches means the Army has decided to build up, rather than dig down. The breastworks that the RE have devised seem too flimsy for purpose. The battalion war diary notes tersely that they prove to be "not bullet proof".

Robertson also lists the daily demands of constantly rebuilding the trenches: 2,000 sandbags, 50 fascines, 30 footboards, 25 palisades ...

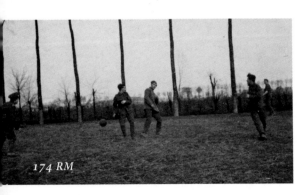

174 RM

Out of the line there is football for the ranks [174], practising for what will

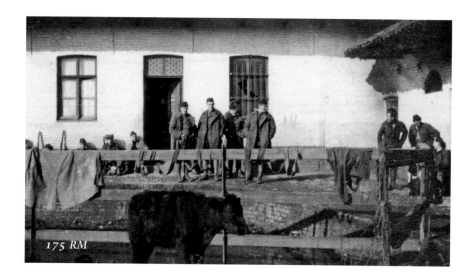

175 RM

become a monthly grudge match with the Argylls, and a riding school
for officers, marked out behind the Brigade HQ on Rue de L'Estrée, a
mile north of Bois Grenier. The men take one look at the smallholding's
red and white brick walls and dub it Streaky Bacon Farm – what else so
near GreasePot? Money photographs Hill, Becher, Wright and McLellan
standing in the yard, three posing, one in conversation with another group
lolling in the rare February sun [175]. Along the walls, below the windows,
soldiers sit with rifles propped, resting, soaking up the pale heat.

Fred can be seen moving, just the peak of cap and shoulder, behind a
jocular Wright, on his way to take his own picture, not of his fellow officers,
but of the ranks, increasingly his preoccupation [176].

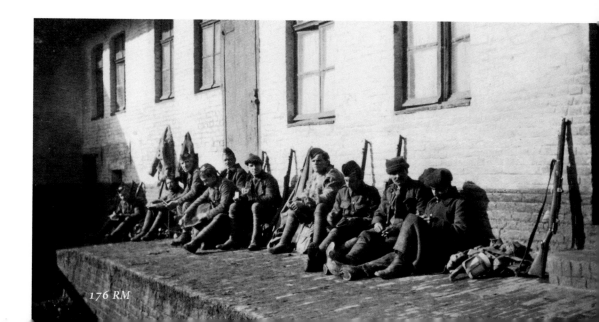

176 RM

The officers have reason to be upbeat. The first awards for gallantry have been confirmed. Robertson, Ritchie, Rose, Darling, Money, Corporal Taylor and Corporal McCann are all mentioned in dispatches – as is Fred. Robertson is also awarded the CMG (Companion of the Order of St Michael and St George), Darling and Riddell-Webster the DSO (Distinguished Service Order), Money the Military Cross.

177 RM

Fred, too, wins the Military Cross, for his feats under fire – one of the first doctors to win the new award. The impish Wright can't resist, and makes a fake Iron Cross to pin on Hill's stout chest in the Streaky Bacon yard. Money, enjoying the joke, captures the duo on film, making the mock award in front of Fred. The good doctor, perhaps, is advising them where to put it.

He has other victories to celebrate, too. He has badgered Robertson into giving him a commandeered cottage in Bois Grenier as a temporary 'rest house', where ranks can spend a day or two out of line recuperating, in the dry, away from war, though still very much under threat of shelling. Fred has a stockpile of cakes, cocoa, shortbread and jam sent from home, plus a gramophone, to sooth his charges. He is already seeing too many frayed nerves, too many men emerging from a night under shellfire with wide, staring eyes. Then the chills, temperatures and racking coughs. These wet and cold conditions, these broken nights, fetching and carrying across rivers of liquid mud under threat of sniper-fire ...

B Company has sought a distraction. Its trenches have adopted a black cat, Flamanderie Susan, named after the flooded farm facing the German lines at Rue des Bois Blancs [178]. A fierce ratter, Susan stalks her territory with proprietorial pride, walking the parapet without fear, her tail a taunt to enemy snipers. But no German shoots. And then she presents Harry Lee with three kittens. With no sign of a father – no tom cat for miles has ever been seen – Lee is the subject of ribald jokes from fellow officers. He doesn't know whether to be flattered or angry.

Fred's photographs continue to detail the destruction. Bois Grenier's church is now a battered ruin, its steeple having long been an easy sighter for artillery [179]. Windows are blown out, bricks lie in muddy puddles on the street.

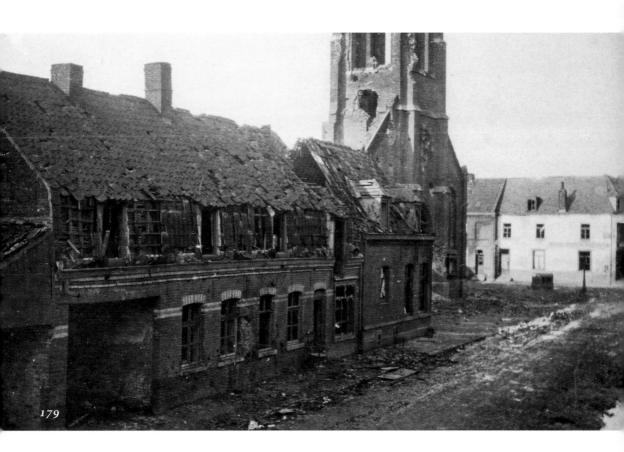

180

–Kultur in Bois Grenier, mutters Fred, echoing the now habitual British jibe at the land of Beethoven, Bach and Goethe.

Elsewhere Water Farm, just behind the front line, stands desolate, its trees snapped by shells [180], useful only as a lair for observation.

And Bois Grenier itself empties fast, its wash-house, dressing station and support facilities making it a continual target. The last inhabitants load carts, heading south, wondering what offence they can have given anyone to deserve two foreign nations pulling apart their homes and their livelihoods [181]. Perhaps those old enough to remember the Franco-Prussian War know they must simply move and wait. But for how long?

Around them, the war is becoming a slow slide into inevitability – inevitable wounding, maiming, death, destruction. With the whole genius of industrial technology unleashed in its cause, it will find the worst solutions to this stalemate. The unthinkable will become thought. The unteachable will become taught. But no preparation will prepare man for the scale of what becomes possible.

The refugees make the right choice. Within six months Bois Grenier is flattened.

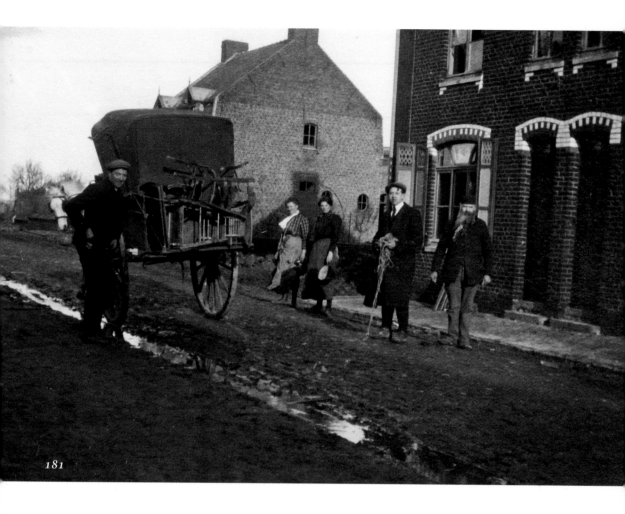

181

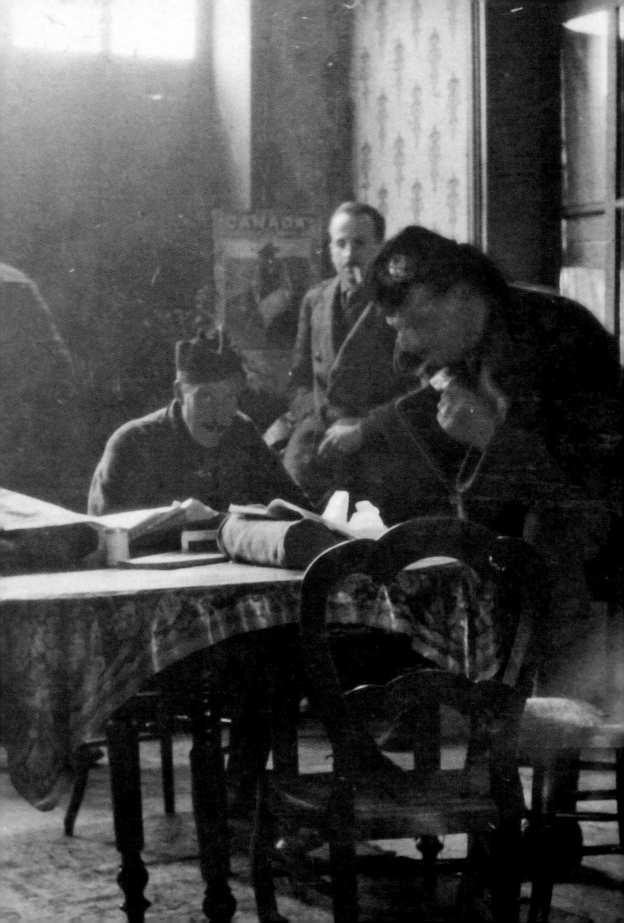

13

THEY THAT
ARE SICK

7th February: I cannot throw off a chill caught
some days ago, and have therefore stayed in bed since
the conclusion of yesterday's parades, with a slight
temperature and some pain in my chest. Davidson
has advised me to report sick but I declined to do so.
He then sent a message saying that the Commanding
Officer concurs with his opinion, and asking what hour
will suit for the mess cart to take me to hospital on
handing over my company ... How often I wish that my
duties were all finished!

– DIARY OF CAPTAIN JL JACK, COMMANDER OF
C COMPANY, 1ST CAMERONIANS

THE KAISER'S birthday falls on a bright, clear night, moonlight bouncing up off the puddled landscape like a silver knife. The British Army waits, wondering if the Germans will mark the 27th January with an all-out offensive. So the Cameronians, in billets at Gris Pot – officers in cottages, men in their dark barns – must stand to arms, boots on, rifles loaded, ready to support the Royal Welch in their trenches. The British guns briefly bombard the German lines, just in case the enemy is massing its men to attack.

Nothing happens. Later Fred hears the stories of German discord filtering across No Man's Land. Some had cheered the shells falling on their fellow soldiers down the line. The Saxons holding trenches opposite the Middlesex shout across that they are being replaced soon by Bavarians.

–Give us time to get out and then shoot the fuckers!

And they laugh at their own callousness. This is what the war will become, hating your own army as much as the enemy's. Hating your officers more. Fred Davidson can see that the average officer has more in common with his German counterpart than his own ranks – books, food, music, hunting. So how long till those ranks, drawn from the same working class agitating for change at home, find their own officers a more worthy enemy than the Hun? Or will the squalor of the trenches, suffered by officers and men alike, bring a new unity? We will see.

Fred's sick parades start to lengthen. Some seek treatment too readily, most steer clear, refusing to accept they are ill. Captain Jack, heavy-set and lined, looks wan, shivers, has pain in the chest, and is halfway to his second bout of pneumonia but won't leave his command. Fred likes him. Jack never shows his feelings, but is not without compassion. He sees the war is rarely about glory, and he worries about the entrenching, and the cost in lives to be paid with any breakthrough. He fought the Boer War with the Argylls, and was adjutant before Darling, he has no illusions about what is coming.

They all wonder what Jack is scribbling in his coded diary – coded because

diaries are forbidden, coded in case the Germans get hold of it. That makes Fred smile. If the Germans get hold of it, you are probably dead, but still Jack cares about the cause. Though perhaps not enough to obey the rule. Every doctor is an amateur psychologist.

Jack is probably the most able of the battalion's officers but a sick officer clinging on will eventually endanger lives. Fred has to make a decision. He talks to Robertson discreetly, away from others, and the commanding officer agrees. Arrange a supply cart to bring Jack back to the main dressing station in Armentières, and send him a message.

–What time would suit? runs Fred's message.
–No time would suit, is the curt reply from Jack, buried under two cardigans, two Burberrys, a muffler, and self-dosed with quinine, running C Company from its habitual quagmire.

Fred returns to Robertson. This is what a good MO does, treading carefully. He understands Robertson well enough now, and knows he values his officers and their determination to see out the worst. The commanding officer sighs then next morning walks to C Company at dawn to see for himself. Jack brazens it out, insisting his symptoms are easing, he is feeling much better. So he stays, and so his condition deteriorates. A week later Robertson, pestered by Fred, orders him out. Jack is sent back to England with severe influenza. Robertson himself is back in Armentières with the same condition just days later.

* * *

The waiting, the watching, has strange consequences. For some, fear stokes hunger. Money photographs a lone soldier digging for potatoes in the vast, empty fields behind Streaky Bacon, an armoured train rumbling down the line from Calais to Armentières behind [182]. Mile-long trains of ammunition and men now come and go, but still there are shortages.

Just two batteries of 12 field guns support the entire 19th Brigade. One shell per gun per day is their rumoured allowance, except in emergencies. That does not reassure. Money, with his technologist's yen, pictures the guns by his billets. Look. It's loaded then it's fired, at full recoil [183, 184]. The newspapers will like the before and after.

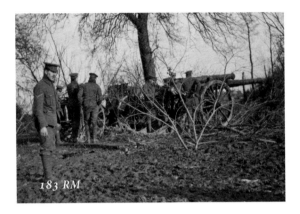

183 RM

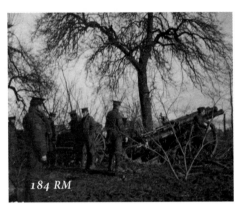

184 RM

185 RM

Fred tries to keep the peace in HQ's Gris Pot billet, s sturdy brick house with blown-in windows and an owner still determinedly in residence. She gets paid for the scrum of officers in her house, but it is never easy, always another occupation. Both Fred and Money photograph the "madame of the billet", in the fields behind her home. Money has already decided he dislikes her, nicknaming her "the Obus", after the French word for explosive shell. "A dreadful old woman" he bluntly captions his picture of her, plus sons [185].

Fred is always more careful, holding his counsel and photographing her with the men that flood her home and outbuildings, the HQ servants – the ranks that run Robertson's comforts. In a gesture that is redolent with his own yearning, "Grimsby" Hawes holds her baby on his left hip [186].

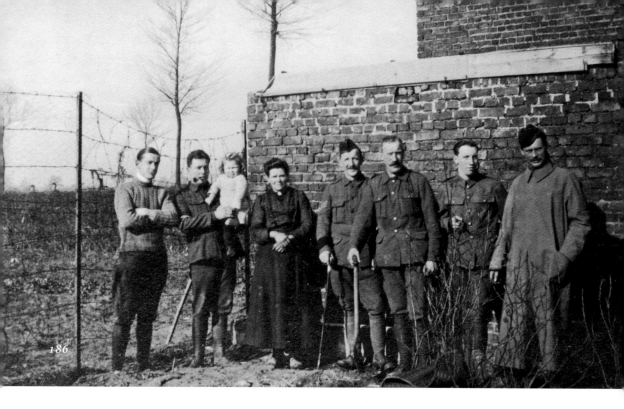

Fred takes another picture of the cheery Hawes, later, in the trenches – this time gently cradling a rum flagon, as counterpoint [187].

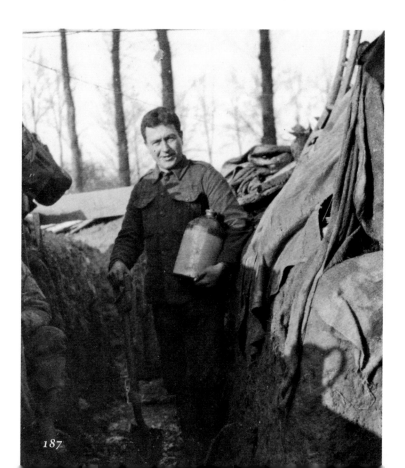

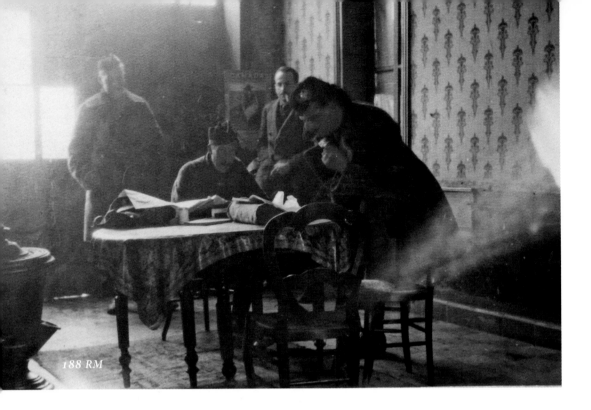

188 RM

Inside the Obus's home the officers have a bare room for planning, sifting the commands that come in from Brigade and beyond. Money's photograph shows Oakley and Hill poring over maps, Chaplin waiting impatiently and Fred, as ever, slightly apart, watching on [188]. Behind his shoulder hangs a calendar titled CANADA – an indication that the first Colonial troops are now arriving to bolster the British war effort. Add that to Kitchener's recruits, and the old sweats sense that momentum might shift their way. If the new troops are up to scratch, of course. And if there are enough.

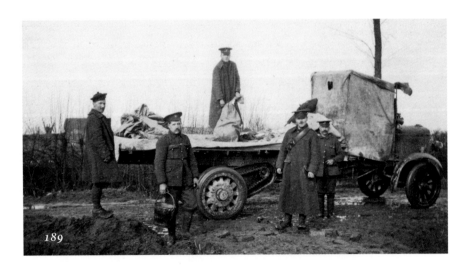

189

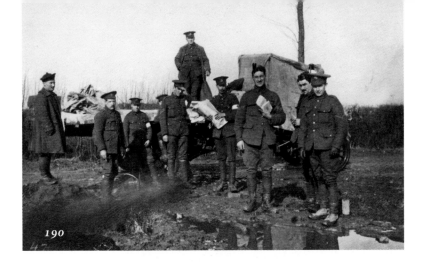

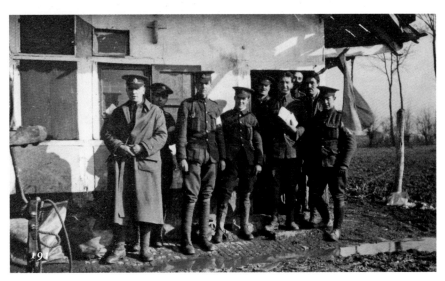

The routine for billets continues, sick parade in the morning, fatigues in the afternoon, censoring the men's letters, always more of those when out of the front line, always more to read: touching, upbeat, never telling the true story. Then supplying the trenches at night, soaking up the bickering from the Royal Welch who call them late and sloppy and dirty Jocks. The Cameronians, in their turn, do the same. With the war held in stalemate, little things count, the mail, the baths, the treats, the baccy – pipe tobacco for the officers, cigarettes for the ranks – the slow trickle of new equipment and clothing.

Fred photographs the weekly drop, the scene before and after his orderlies arrive at the mail lorry [189–191]. Comforts from home, far from home. The post corporal will walk the letters round the companies, calling out names, dispensing his cures for loneliness. Those who receive share with those who don't. In that way the brotherhood is upheld.

Many are busy with fatigues, singing while they work. The ranks now have a new tune, a great tune, adapted from a French marching song, but embroidered with their own lyrics. It starts with the story of a young French widow waitressing at the Egmont café, across from the rail yard in Armentières. Fred asks a private on sick parade to tell him the rest.

–So she catches the eye of an officer who cannae stop 'imself grabbing her behind. And she slaps him! Then …

Male fantasy writes the rest. Now the ranks are yelling it gustily on fatigues.

–*I had more fun than I can tell, beneath the sheets with mademoiselle. Inky-pinky parlez-vous ….*

Fred asks him how long the new song has been doing the rounds.

–Ooh months, sir.
–And how many verses are there?
–As many as you wan' sir. Thas the beauty o'eet.

* * *

Fred is walking Armentières's Rue Nationale, heading for the town's Jesuit College, base of the 19th Field Ambulance, but just taking his time, whistling, trying to remember the latest words, hooked on that long, ascendant first syllable of the initial *parlez*, redolent with hope.

–*Mademoiselle from Armentières, paaaarlez-vous ….*

It is almost sunny, almost quiet, just the gentle chatter of house sparrows audible above the pom-pom of guns blown in on a cold east wind that reminds him of home.

–*You didn't have to know her long, to find the reason men went wrong …*

He could close his eyes and be in Grassmarket, or climbing up to his rooms in Ramsey Lodge. Only the smells are different, coffee and cinnamon, as against old Edinburgh's faecal waft. Little wonder they built New Town.

–*On her bed she was so much fun, moving her arse like a Maxim Gun, inky pinky parlez-vous.*

A verse for Robin and his machine-gun crew, with his camera and his jokes and his banter. Money's father was virtually running Le Havre now, processing the waves of troops entering the war. No wonder Robin can get just about anything in and out, including so much film for his camera.

Fred passes No. 37, the plain-fronted house rented by 19th Brigade for officers to recover from the chest colds now sweeping the front line. No point popping in, he'll never get out. But now at least he and other medics have somewhere to put the growing number of mild flu cases. The sick need to rest. What did the Army expect if it immerses 100 men in a wet trench for five days at a time?

And the younger officers are the worst – they have something to prove, spending longer than the ranks in the filthy conditions, standing longer when others want to hide, offering an example, just to show they can. It ain't cushy, as the old India hands put it. And right now they all want cushy.

Money argues that maybe the ranks are better used to the harsh conditions. Sharing one room in a Glasgow tenement slum with eight siblings, a midden for a lavatory in the courtyard used by nine other families, while your father knocks seven bells out of your mother every night ... a wet trench with your mates is not the horror it seems to others. A wet trench is an escape from the Poor House. And you are with your mates. Your mates is all this war will leave you with.

But everyone needs somewhere to recover, so the estaminets help the men forget. The Cheval in L'Armée above Bois Grenier was a regular – champagne, beer, vin rouge, omelettes, whatever you want, whatever they can get. The war is on their doorstep and the need to make money is urgent. Fred has even seen their girls sloshing down communication trenches to the front, selling chocolate and the continental *Daily Mail*. Not the front held by the Cameronians, mind you. Out by the Rue des Bois Blancs, the Rue des bloody white poplars, nothing moves without being shot. Unless it's Flamendrie Susan.

–She'd grab your prick and give it a squeeze, until it hung down below your knees ...

Poor Lee, he does fuss. Then again the officer class, with their Spartan educations – cold baths, corporal punishment, brutal fagging, engrained

stoicism – should be perfectly prepared for this war. He can still remember cracking the ice in the tin bath provided for his Fettes cube.

Hence a stroll down the still tree-lined streets of Armentières to the Café d'Egmont on a rare warm day is recommended. A tip of the cap to the ladies. An eye out for any senior medics who must be saluted. Across the street, the first French posters warning of spies are being plastered. *Taisez-vous! Méfiez-vous! Les oreilles ennemies vous écoutent!* You don't need high-grade French to understand that.

Passing one estaminet rammed with desperately cheery soldiers, determined to make the most of their few hours out of the line, Fred can hear that song again – more popular than a Charlie Chaplin film in this town. A jar of beer, a plate of chips, a song on the piano, always a volunteer to play. Every rank is catered for. He can see the electric lights flickering. Rumour has it that electricity is still supplied from Lille, under German occupation. The enemy hasn't found the line to cut it yet. Oops.

There is even a Follies concert at the theatre this afternoon, put on by the 4th Division, with – he has heard – real girls from Paris to sing. Two, to be precise, nicknamed Vaseline and Lanoline. Or was it Vaseline and Glycerine? It seems to change.

–She sold her kisses for two francs each, soft and juicy – as sweet as a peach …

Fred thinks two francs might be a bit steep, he has heard you can get a lot more for less. He stops outside the theatre and decides he'll watch the show, joins the queue, takes his seat, and enjoys it all, wrapped in the warm guffaws of his fellow men. Vaseline sings "I'm Gilbert zee filbert, zee king of zee nuts". Innocent stuff, but the audience roars. The show's producer, a captain from the Army Service Corps, the body that runs the war effort's logistics, tells lewd jokes.

–An Englishman and a Yank in a railway compartment. The Englishman took down his suitcase, and on opening it some mothballs rolled out onto the floor.
–Say, stranger, what are those? asks the Yank.
–Mothballs, replies the Englishman
–Gee, some moth …

Fred wonders what a Scotsman would have said.

Before long every division will be putting on Follies to allow the men "to let off steam". But now, of course, sex in the Army's womanless world is suddenly an issue. Out here, by the fleshpots of Armentières, in the paroxysms of war, the men only know tarts, mothers and Madonnas.

But mainly tarts. By 5 pm Fred is walking past the queues already forming outside the "maisons tolérées", waiting for the lamps to be lit, blue for officers, red for ranks. Beery, joshing bunches of boys, like a crowd at the turnstile, push for the best position at kickoff. One franc for the madame, one franc for the girl, nine or ten on offer, arrayed in silk skimpies, a staircase, a doorway, a bed, if you're lucky. Fred had heard stories of Army stretchers being used, but he didn't credit that. Nor does he blame the men. They don't want to die virgins. And the married men have their needs.

–It is of course unhealthy for husbands to be denied regular intercourse.

Fred had heard that in the 19th Ambulance mess. Yet it's not so long ago that the battalion frowned upon officers getting married. The regiment was all.

And Fred understands more about women than anyone else in his battalion wants to know – he's assisted in all those Dundee births, for starters. As a medical student, he has dissected women too.

Then he was brought up with a small army of five brothers, headed by a genial patriarch fond of speechifying but run by a mother-adjutant who dictated all. The director of medical services says Fred must coach the ranks in abstinence. What would his mother think of that?

Probably agree, but it is as much use as a puttee in a bog for a man getting regularly shot at. The Army hopes that restraint and exercise – inter-battalion football matches, route marches, constant fatigues – will encourage virtue. Sexually transmitted diseases are not even mentioned in any RAMC handbook. Despite the fact that the Army and prostitution have long had a cosy relationship, back beyond the Duke of Wellington's "camp followers" ...

But the French have a real expertise at prostitution and exercise it vigorously, with legally regulated – but medically unchecked – brothels operating in most major towns in northern France. So the number of admissions to hospital for British soldiers with VD on the Western front will jump from 3,291 in 1914 to 24,108 in 1916, then to 60,099 in 1918. Beyond that many are treated covertly within their regiments. It is Britain's dirty little secret.

Such treatment is against Army regulation. Sufferers are supposed to be named and shamed, and have their pay docked. Nor are medical officers allowed to offer out condoms in the early stages of the war, despite RAMC arguments that to ignore such sensible precautions was to add thousands to the sicklists.

–She'd give a wink and cry oui-oui! Let's see what you can do with me ... Inky pinky parlez-vous.

Word comes down, instead, that medical officers will have to give more talks, and hold regular inspections of soldiers' penises for lesions. Such "dangle parades" – soldiers in line, dropping trousers for a walk-past perusal – are an innovation introduced by the medics servicing the New Zealand armed forces and eventually taken up by all. Those with symptoms face having their genitals painted blue with potassium permanganate and then irrigated with the same chemical, an antiseptic later used by women as an abortifacient. Fred has all that to look forward to.

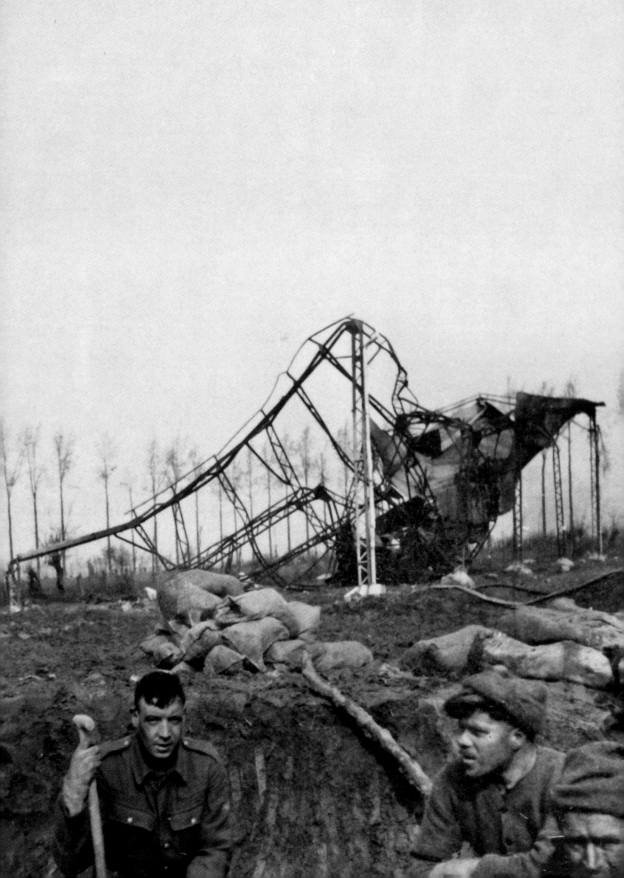

14

WORLD
WITHOUT END

12th March: They were ready for us when we started
bombing. There was nothing for it but to get back as
best we could ... It was everyone for themselves and the
one who could lay flattest on the ground stood the best
chance. While trying to transform myself into a worm
a bullet parted my hair, and a Verey light fell and burnt
itself out a few inches from my head. When the fire
died down I skimused back ... Some of us left pieces of
clothing and flesh on the wire.

– REGIMENTAL SERGEANT-MAJOR PB RODERICK,
ROYAL WELCH FUSILIERS, QUOTED BY JC DUNN IN
THE WAR THE INFANTRY KNEW

IN THE trenches the work of constant repair continues. Money returns from eight days leave in Scotland with a clear – and illegal – agenda for journalism in his photographs. Wright is already remarking to friends in Scotland how much extra income the machine-gun officer is making from his hobby, selling discreetly to newspapers, the ban on photography brushed off with ease again. Wright is also asking his parents for more supplies, which he appears to be distributing among his fellow photographers. "Please could you get me six more films sent out," he writes on 1st March. "Do not have anything to do with the shop written on the parcel or anything about photographic material."

Money tours the Royal Engineers yard in Erquinghem, a mile above Gris Pot, photographing the growing stockpile of dugout frames for the trenches [193]. Then the finished article in use – his machine-gun team rebuilding their position with one of the new dugout frames [194]. He also devours the gadgets now arriving at the front, so popular as a morale booster for home audiences [195, 196, 197]: the range finder, the trench periscope, the

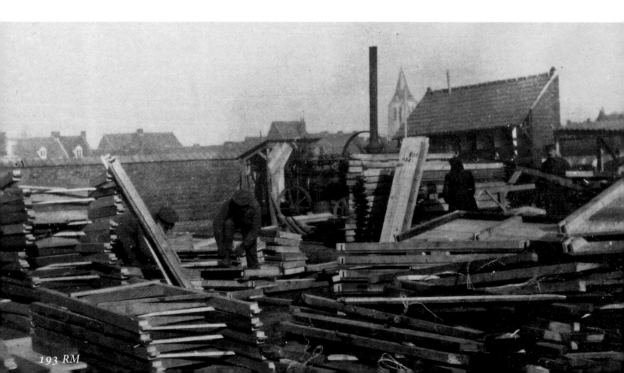

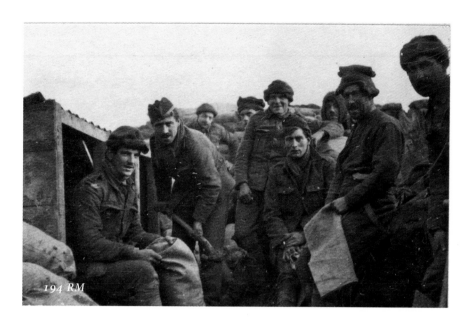

194 RM

hopelessly gimcrack rifle grenade (stick gun through triangular frame of 4″
by 2″, stick grenade on rod into barrel with special cartridge, hope for best).
The latter, of course, still doesn't offer enough distance.

And the repelling of water becomes the new obsession, brick-flooring a
wet trench [198], pumping the flooded shell-holes [199], chuckling at the
Royal Engineers' attempts to help. Laughing at others is another way to

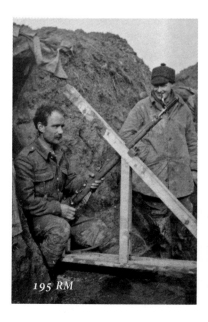

195 RM

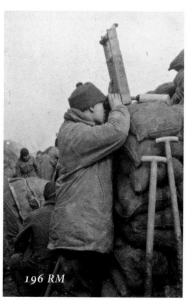

196 RM

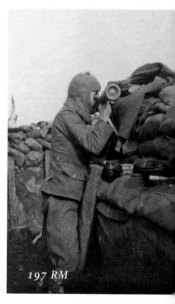

197 RM

198 RM

lift spirits. Money has already given Fred Davidson his description of one pool.

–Cox's Corner, where the RE made futile attempts to make the water run uphill, and only succeeded in making it run round and into the trenches at the other end!

The front line beyond Grand Flamendrie Farm is now a killing ground of pocked willows, tin-strewn fields, and barbed wire running to above head height [200–201]. An elegant line of poplars offers only a frail defensive curtain to the small-holding behind, the stubby pollards in front already dented with bullet holes above the scattered cans.

Money later captions the scene "A study in empty tins". Such rubbish strewing is deliberate, as any obstacle into No Man's Land provides a hindrance to enemy patrolling. It works both ways, of course, making the Cameronians' own excursions doubly hazardous. Divisional HQ, as ever, wants frequent patrolling, not just to map the area and exercise control of space, but

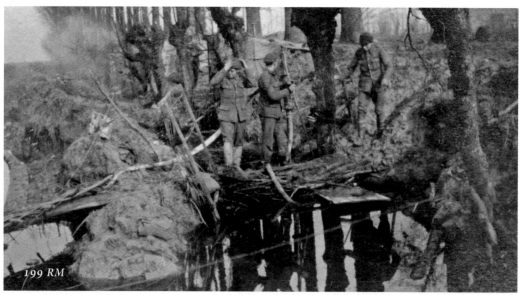

199 RM

200 RM

201 RM

also because, in its view, such excursions would lift spirits – just in case the sitting, waiting, bantering saps the soldiers' courage.

C Company keeps its HQ in Grand Flamendrie's cellars. The buckling floor joists provide an illusion of cover. Yet water seeps round the cellar, rain drips through the ceiling, rats agitated by the blasts scuttle over puddles. The men sleep amid straw on raised platforms, knowing a direct hit would bury them all. They hear the shells that miss plop into the wet ground outside, mud diffusing their explosions.

Money is looking for newspaper shots now, climbing Grand Flamendrie's ruins up into its wrecked roof to take photographs of the German line – so threatening to the combatants, yet invisible to the eye of the viewer. Only the blasted stumps of barns and buildings can be seen, a thin pile of earth signifying the rampart behind which the Cameronians hold their ground [202, 203].

On the ground he shows his machine-gun team working round the Maxim, the same pockmarked pollards and soaring poplars behind, an opened tin

202 RM

203 RM

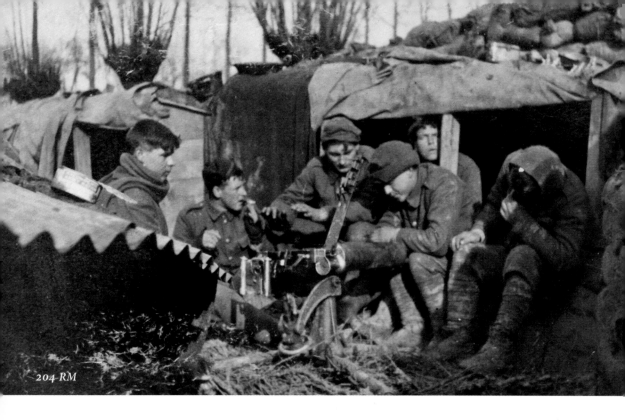

204 RM

of Maconochie Army Ration stew balanced on the corrugated iron roof of one dugout while the men crouch around [204].

Money is touring all the companies now, he wants to capture on film everyone who has fought with him so far, as if to say "this is the gang". He knows this stalemate cannot last. A big push will come, with the inevitable loss that must bring. They are already half of what they were. Of the 1,050 soldiers who sailed to France with the battalion in August, only 507 remain. Of the 28 officers, only 14 are left.

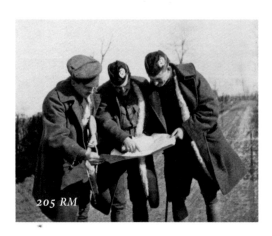

205 RM

He poses Fred with Hill and Becher poring over a map on Rue du Biez above Gris Pot, looking like a trio of lost hikers [205]. Becher's good-natured grin gives the game away, their very presence standing upright showing how unlost they must be. Anything moving on the short road from Bois Grenier to Rue des Bois Blancs is shot dead in daylight. They are far from the front line.

The corner of Fred's camera can be seen clutched under his left arm. In the same spot he poses Hobkirk and Money celebrating another new arrival, sheepskin linings for officers' coats. Hobkirk inspects his with pride [206]. Money, sporting his habitual knavish grin and dangling cigarette, looks like he is offering something for sale.

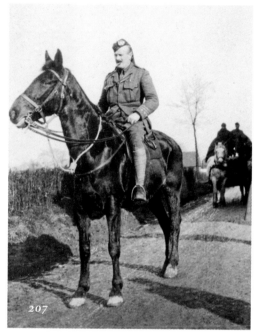

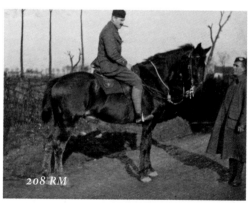

Then down the same road comes Sam Darling, the Cameronians' adjutant, on Hesperus, his new charger, a horse that clearly impresses everyone, as both Fred and Money photograph it.

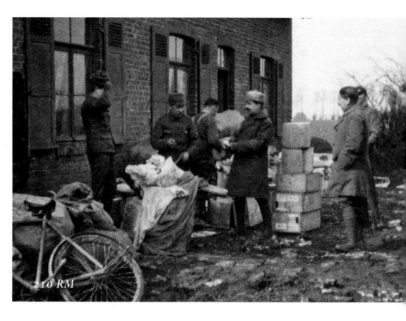

At the Quartermaster's depot Tubby Wood still presides with jolly equanimity, still making jokes about the rum ration, hands deep in pockets, slit-eyed and grinning [209. 210]. Years later, long after Tubby's fall from grace – court-martialled and dismissed for drunkenness in 1919 – Money dubs the scene "Vin Pang and his minions", an affectionate reference to the Chinese Emperor's majordomo in Puccini's *Turandot*. Thirteen years after the war, Tubby dies penniless in a Glasgow mental asylum, with Robertson, Vandeleur and Hamilton begging the War Office to help him financially. But that is another story.

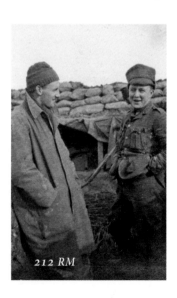

Elsewhere McLellan sits, pipe in hand at the door of A Company's mess, mud-spattered waders reaching over his knees [211]; Minchin and Wright, both just back from eight days leave, share a joke outside [212]; Lee hunches with notepad in B Company's trench, writing home [213]; Burgess and Hamilton lean nonchalantly by D Company's mess, enjoying

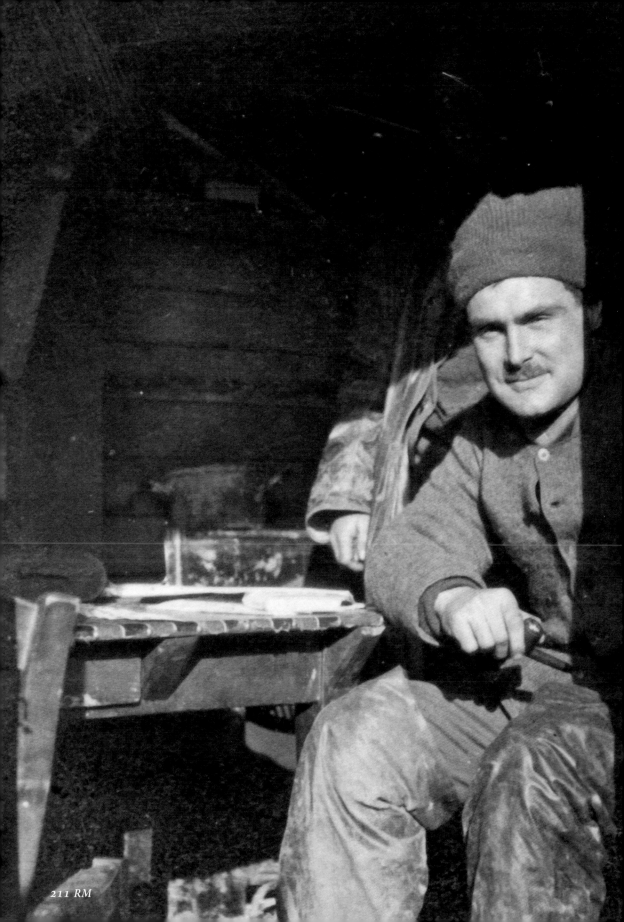

214 RM

the private joke of their nameplate "Sloper Court" nailed above a glass window torn from a nearby farmhouse [214].

Money's captions for the pictures spin off private jokes – Lee is nicknamed Napoleon B, McLellan is "Picture House Bill at the door of his shack out west", Burgess wears his Teddy Bear "in which he lives, sleeps and has his being". These are my friends, his photographs say, these are the men I will remember.

And a new face appears. Both Money and Fred photograph Lieutenant Granville Skipwith, posted with the Cameronians as forward observing officer for the Royal Artillery – a belated response to Robertson's insistence that artillery officers need to spend more time in the trenches. He does three-day stints with the battalion, often climbing the ruins of Water Farm, to monitor the success of the British shelling. The Germans soon spot his eyrie and redouble their efforts to wipe out the old farm.

Skipwith's pluck and youthful charm – he is just 21 – win him friends. In Money's photograph [215], he is standing, grinning, outside Robertson's makeshift HQ, soon to be rebuilt further back after shelling makes it unsafe. In Fred's [216] he stands mud-spattered, binoculared, by a planked wall carrying the stencilled dragon of the Royal Welch. Fred simply notes his name. Money's caption carries an affectionate dig: "Gran Skipwith disguised as our F.O.O." The RA officer dies in action just four months later. The smile on his face suggests he enjoyed the Cameronians' banter.

But what a ramshackle world they have built. Fred photographs the haphazard telephone system at Robertson's forward base, two men to make a call, a tangle of wires framing a sergeant while a soldier holds the pole supporting the line in his right hand [217]. Little wonder the lines are continually broken with daily shelling.

215 RM

216

Then Fred photographs groups, taking
pictures of two of his teams at the end of
February – stretcher bearers, orderlies
and patients, posing in the orchard
behind Bois Grenier's dressing station
where Stirling is buried. The men look
drawn and haggard, some exhilarated,
others tense. In the first photograph,
one rests his hands lightly on the friend
in front, above him a shell hole in the
wrecked brewery almost halo's his
head [218].

In the second, the 10 look like they are
waiting for a sports whistle, the field
with its poplars and willows flattening
out behind [219]. In reality these men
had the most dangerous of jobs, the one
where you were least able to drop instantly when a volley came, where the
probability of being shot in the buttocks and head was high. Backwards and
forwards, backwards and forwards, the bearers' work in battle never stops.

217

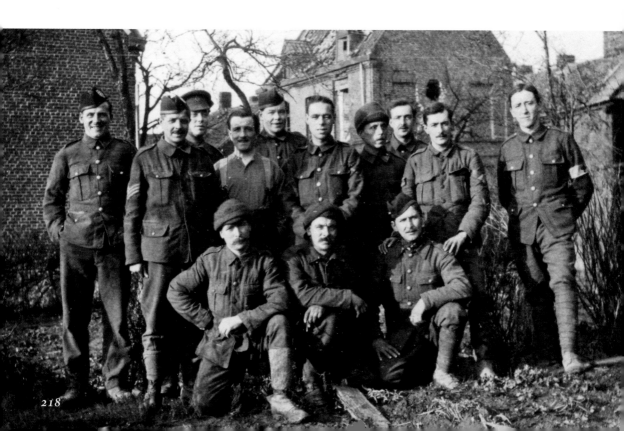

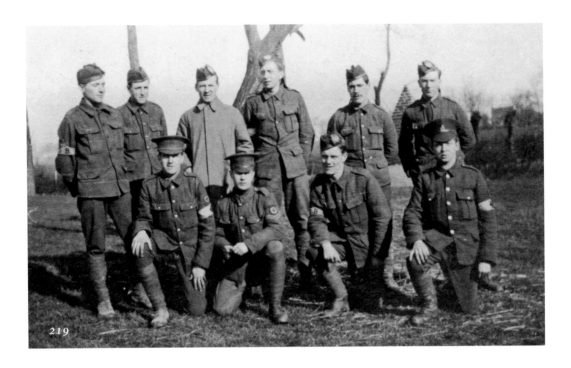

219

But out of battle, there is less to do. For Fred, the work of MO is as much as you want to make it. Sick parade, billet inspection, sanitary inspection, the rounds of other MOs in other aid posts and dressing stations, and the slow trickle of those wounded by sniper or shell. So you make yourself useful, you walk the routes, you minister. And again you wait.

By the month's end they can feel the game is changing, a new pattern asserting itself. The Germans are utilising short-range, barrel-loaded mortars – minenwerfers – that are proving more destructive in the trenches than heavy artillery. Cheap to make, easy to manoeuvre, fast to load, the minenwerfers start to flatten the buildings behind the British line.

Grand Flamendrie's barn is now a tangled mess of iron, its outhouses slateless, its fields cratered [220, 221]. Money photographs the six-foot hole created by one mortar leaving a self-binding harvester – used for cutting and tying sheaves just months before – as shattered wreckage [222]. Water Farm, Skipwith's observation base, is just a clutch of broken walls [223].

221 RM

The regiment is growing now, sending in more battalions. The 5th Cameronians are holding the line just two miles to the north, outside Chapelle d'Armentières. The 2nd, previously stationed in Malta, is billeted five miles to the south-west, preparing for action at Neuve Chapelle. Many of its men and officers have served with the 1st battalion. It is the command that Robertson dodged back in 1913, when he preferred to stay where he was.

222 RM

Yet as Easter approaches, all sides are jittery. The worry of an imminent attack obsesses the generals, rumours fed by a gossip mill turned by jingoistic media coverage. The same audience that wants photographs from the front wants also to know: Who is winning? Who is behaving with honour? Who will be the first to advance?

223 RM

Sitting in the officers' mess at Streaky Bacon Farm in early March, Fred can read reports from Armentières in *The Times*. They describe an uneasy stalemate, and are illustrated with out-of-date maps that seem at variance with what the men on the ground know, placing Bois Grenier behind German lines. Often the correspondent struggles to maintain his prescribed, upbeat tone.

The spirit of the Allies and their efficiency are good, while on the material side constant progress is registered. It is not, on the whole, a brilliant phase of the war, but it is a necessary one, and it is producing those results which were anticipated.

In other words, it has protected the Channel ports from German occupation. But with the Belgians, British and French now dug into a continuous trench system from the sea to the Swiss Alps, where will the breakthrough occur? And at what cost?

Those who think that the Allies might have done more in the West during February should remember that the state of the ground has been most unfavourable, especially in the north; that the strength of the German armies in our front has not materially changed; that only one German Army Corps has left this front for the East since the beginning of the year; and that questions of reinforcements, guns and ammunition all have to be weighed.

Questions that include, perhaps, the ones about why the British seem to run out of shells so quickly, and why the Germans are so much better prepared for trench warfare, from the smallest of equipment – telescopic sights – to the largest of guns. And whether the rumours of prickly relations between Britain, France and Belgium are true.

We can be confident that the reciprocal action of the Allies in the East and West is the subject of constant solicitude to General Joffre and Sir John French, and that there will be no lack of spirit or decision when the hour strikes for a general advance.

The sense of righteousness, the worth of the cause, the importance of King and Country, are still intact. It will take at least a year of suicidal advances, gaining so little, to start shredding those.

Beside the reports, the letters pages carry rows over escalating coal prices at home, and the problem of horseracing – why hasn't it been suspended? With correspondents banned from the front, papers have also begun to carry accounts from officers detailing their own heroics. It is becoming a war bogged down in detail, with an audience demanding more.

The front page of *The Times* also carries among its personal ads – surrounded by love notes, pleas for financial help and rewards offered for possessions lost – this small paragraph:

WAR SNAPSHOTS - £5,000 is offered by the Daily Mail in prizes and payment for war photographs, illustrating fighting by land, sea or air. Name of sender confidential. All photographs submitted for censorship before

publication – Address Art Editor, Daily Mail, London.

Lord Northcliffe is stepping up his battle with the *Daily Mirror,* wheeling out his biggest guns yet to flatten an enemy which has been advertising for "War snapshots that will win £1,000: amateurs' chance". And in consequence, the government's Official Press Bureau, set up in August 1914 by the War Office, is struggling to cope, issuing "D" notices to publishers insisting that all photographs must be published with an official logo to show they have been passed by the censor. The worry is that public demand may now endanger soldiers' lives, encouraging the Army to shoot pictures, rather than Germans …

<p style="text-align:center">* * *</p>

At Bois Grenier, the weather warms, freezes, then warms again. Lee and McLellan help train the Canadians, now arriving in force. Money gives machine-gun classes. Becher oversees bomb throwing. In this stalemate the old sweats have become a resource for newbies to draw on. You learn, you keep fit, you maintain readiness. And you sense something will happen soon, as senior officers take leave before a spring offensive.

Robertson returns to England in early March, so Oakley signs off the February war diary, listing the improvements made.

Each company has two or three pumps which go continuously. Besides putting all this material in the Trenches, it all has to be carried up, which is no little work, as the Tracks are so muddy and slipping. The MO now has a Rest House in Bois Grenier where he detains those not quite well and who need a short rest. Each man gets a bath and change of clothing every 14 days. Grease is issued before going into the trenches to prevent Frost Bite. The Rations continue to be as excellent as ever.

Given that Oakley is the thinnest officer in the regiment, that recommendation may not be taken at face value. But the trenches are improving, with better dugouts, deeper communication routes. Soon messengers can bicycle down 1,000 yards of Shaftesbury Avenue, a sunken lane dug from Bois Grenier to the front line, invisible to the enemy. Three men abreast can walk it. Or wade it, in winter.

Most importantly, all now connect, so that companies can move into each

other's trenches without slithering overground. The communal mess at Streaky Bacon means the officers are more tightly bonded than ever – not split into different factions, run from opposing company HQs.

For Fred these are productive days, showing his rest house will prove effective in keeping the sick numbers down. The doctors' argument, that sending exhausted men back to the main dressing station, when they can recover as quickly closer to the front line, is gaining support, as the thought-through bureaucracy adapts to experience learnt in the field.

But the need for more information, for a clearer view of what the enemy is planning, pushes the generals to demand more risks. Patrolling is stepped up, new tactics adopted to discomfort the Germans: bombarding, pretending an all-out assault, then nothing, then bombarding again, then sending out small groups to bomb selected parts of the line.

By 10th March the Cameronians can hear the agitated rumbling of artillery at Neuve Chapelle, a continual pounding that proceeds a very real offensive as the British push forward. The regiment's 2nd battalion is involved, as is Bertie, Fred's brother, whose Indian Army provides half the attacking force. This, the men sense, could be the turning point, the beginning of the end as the Allies push through the German lines and drive round the back of Ypres.

Everyone is on edge. By the 12th the Cameronians are back in their Bois Grenier trenches, and the Royal Welch send a party of 25 through to raid the German line. It is schoolboy stuff, but deadly serious, creeping, searching, shouting German greetings to fool the enemy, throwing bombs, running, scuttling, crawling back. A cacophony of artillery smashes the ground either side of the group, while lights flash from the trenches to indicate their return path. The enemy send up flares, flash their own lights, machine-gun the stragglers. Among the Royal Welch, five are wounded, one killed.

Fred walks the trenches on nights like these, surgical haversack to hand, or sits uneasily in the support line aid post, a large dugout with table, shelves and four stretcher beds. A coded map of the trench system peels off the wall. No one stays here long, as the carry to Bois Grenier's dressing station has been eased by the widening of Shaftesbury Avenue. And it's dank, muddy and unsafe, the soil on its corrugated iron roof little protection for a

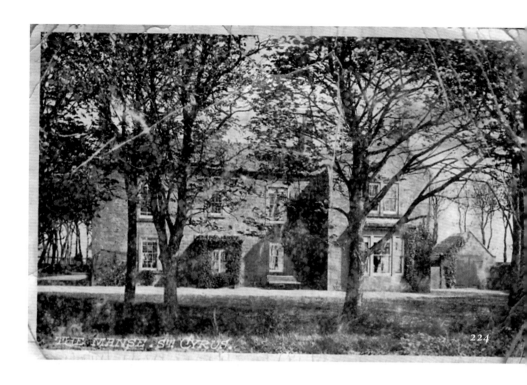

direct hit, its stink of pipe smoke and Eusol unwelcoming.

On a shelf Fred has propped a battered postcard of home [224], one of just two photographs he carries with him. The other, a snapshot of his mother's

grave on the day of its completion [225], a cold, cloudy winter morning, little over a year ago, sits in his top pocket. It is the picture they sent his brother Jack in Canada, 4,000 miles away, to help him understand. The large granite cross, a symbol omitted from the church itself, is a statement of intent. Beside it, in a glass case, sits a decorative floral tribute. It is morbid, Fred knows, and he is now a long way from being a believer, but it is what is left.

And he yearns for spring, for fresh leaves and new beginnings, and wonders whether they would even notice it here, among the gun-scarred willows and snapped-off poplars. He dreams of a place to garden like his father's, but bigger, warmer, away from the North Sea gales, flush with roses and rhododendrons and exotic cedars and low lawns and very little fruit.

The Reverend is obsessed with his apples, raspberries and gooseberries, one year he even had the constable round after all his apples were scrumped.

–Who do you think took 'em? asked the minister, puzzled.
–Well, said the constable, casting a wary look at Fred's giggling brothers …

They are a mob, his brothers, but they have each other. Who does he have?

Saturday 13th March 9 am. Becher is standing in C Company's trench beyond Grand Flamendrie farm chatting to Hill when there's a crack, and he falls dead, a small trickle of blood at his temple. A sniper has got his sights into the line, and another of the Contemptibles has gone. The son of a Durham vicar, schooled at Marlborough, aged just 25, Becher had only been promoted to Captain three days before. He is buried beside Stirling and another casualty, Wedderburn, in the brewery orchard. Later his grief-stricken father commissions a stained-glass window in his memory at Ross Cathedral, in Ireland, where he takes a new parish. In the years to come, Becher's younger brother rises to become a Brigadier in the Cameronians.

For Fred it is another friend buried, another son of the church, another who had welcomed the young medical officer when he arrived in 1913. By then, Becher, lean and confident, had three years' experience with the regiment under his belt.

More patrols go out that night. The Germans are out too, hurling bombs at D Company's trenches. Two wounded soldiers are brought in to the aid post, a third dies en route. Fred is gloomy as he cuts, cleans and binds around the men's wounds, before sending them back to the dressing station. The two will recover, they will return, and then what? Patched up to be shot again. And again. Until finally they are dead.

Then Fred is off along the trenches, back to C Company where another patrol is going out, searching for the sniper's nest, eager to pay back for Becher and eager to soften up the enemy, before the push that must inevitably follow Neuve Chapelle. It feels warmer, spring may be in the air, this must be the turning point, surely.

Fred has plenty of time to study the wreckage beyond Grand Flamendrie, and consider what machine can do to machine, let alone what it does to

human flesh. He has four bearers with him behind the breastwork, waiting, smoking, counting off the minutes before the inevitable shouts start the patrol's attack. A powerful German spotlight, positioned on higher ground way behind the enemy lines, is already sweeping the ground in front.

It's colder now, unnaturally quiet. Fred can see his own breath as the faintest of mists dissolving into darkness. He has a small flask of VAT69 that he passes down. The bearers nod, sip, hand on, return, joke about it being Davidson's local brew. As young doctors go, the medico is alright. They have heard of martinets at other battalions, RAMC officers who are sticklers for form, brutal docs who shirk action but think nothing of pushing the bearers over, and waiting, cosy in their funk-holes. Their medico knows what he's doing, says little, but looks after those who need it. He's proved it on the retreat, he's proved it in the trenches. And he's tight with the Colonel, which saves them all a lot of grief.

Fred is tapping out his pipe slowly on the wooden board at his feet, when he hears the first whistle blown, faintly, then louder, carried on the wind. Then the bombs, the crack of rifles, the machine guns' steady judder, flares, smoke, cordite, screams. His boys? They're coming home.

It's stupid to look over the parapet, but impossible not to, bullets fly close enough to feel like little flicks of wind. It takes time for his eyes to adjust. Five men crawling, faint khaki squirms closing, closing, two others down splayed, moaning, 50 yards away. The machine gun is stuttering now, pushing up pencils of soil, then it stops, reloading. The bearers are up and over like rabbits from a hole. Fred is four steps behind.

The first pair have a man on the stretcher in seconds, turn, lift. Fred run-scuttles on. The second pair are crouched over another now, Fred kneels, the man is shot in arm and back, through the lower stomach, twisted in agony, convulsing. Out here, in this darkness, under this threat, a doctor must work, and he can talk, he can reassure. Fred whispers low in the man's ear, squeezing his good arm. Then he wraps a makeshift dressing over the stomach, no cleaning here in the mud, not too tight, and the bearers lift him onto the stretcher quickly, a movement which elicits a gagging scream. As if alerted by the sound, the enemy sends a fusillade of bullets over and around them, and a flare. They drop flat, one bearer shouts.

–Hit in the ankle.

A searchlight starts to sweep the area, looking for them, pinpointing. Squirming his head back, Fred can see anxious faces bobbing above the breastworks of the Cameronian trenches, caught in the glare. Down, down, don't add to this mess. He wriggles over to where one bearer curses, clutching his ankle. He makes a hand signal, the man nods and starts crawling back.

Three left behind, no help coming. Two minutes become five then 10. The firing is constant. Keep down, keep down. Then the choice. Best to wait or best to face up and push for home? Simple. Wait. No. He remembers a line he has read. Facing it – always facing it – that's the way to get through.

The shooting lulls, Fred turns.

–Lift, go, he whispers, taking one end of the stretcher. The bearer nods and takes the other. The searchlight is sweeping past again, past them, back, it has them.

Fred is punched hard twice, spun off his feet, burning, bruised. The fucking Hun. Hip. Hand. He is down now, feels nothing, who hit him? Then the shakes are starting. Lacerated. Perforated. He won't call for his Ma. This doesn't happen to him. He is lucky Fred, he is Thomas, he is different, he is God Almighty.

He holds his heart with his good hand, squeezes the top pocket, can taste gritty soil. Above him, the night looks like day, illuminated by searchlight, brightness with a sombre ceiling, black like the lead in the pencil that writes to his father, the telegram Rose's mother got, the cursory, hand-scribbled missive no one wants, short because no one has the words.

Deeply regret to inform you that Captain F. C. Davidson RAMC was killed on 13 March, no details received. Lord Kitchener sends his sympathy.

His brothers at the manse, his father at the service, nearly Easter, he has the words. Wind blowing. Bang, bang, bang, thumping at the door, earth is sprayed over him with every shell that falls, Fred wants to get in, he wants to sing. The organ wheezes, his mother is playing now, back swaying, turning, mouthing, encouraging. There is a green hill far away, without a city wall.

Fred is holding on, rationalising, remembering. He can feel warmth pooling under his hip. *Wounds of the back, loin or hip to be treated as abdominal wounds.* Tell the bearer, they will come, they always come, he loves his bloody bearers.

What was he doing? Doing what he could. You can't sit in the ruddy trench following orders when people are crying out. That's where the directors and deputy directors and assistant deputy directors get it wrong. What was he supposed to do, sing a hymn? Or sit there with his fingers in his ears, just wait wait wait for a patient to roll in on a stretcher?

Can they see me? Cold wind. Heather. Waverley is hiding from the soldiers. They will find him. Not if he is with his men, with his flock. For the empty, vacant home where the silent footsteps come ...

It will kill Pa, he misses Ma, he misses Jack, where's Bertie when you bloody need him, why isn't Bertie bloody here? He's only a couple of villages away ... Then it goes dark.

* * *

The next day, the Germans hoist a dummy above their line opposite B Company. It carries a placard: "Hands Up U Mercenaries". To the enemy the Cameronians are just opportunists.

15

OUR MEN

We do not intrude on their great sorrow. The heart knows its own bitterness. We commend them to the god of all comfort, whose consolations never fail. In wiping the tears of others, our own will cease to fall. For the empty, vacant home, where the silent footsteps come, lord of living and of dead, comfort thou.

– Reverend Robert Davidson addressing the family of Captain Norman Fraser, 2nd Cameron Highlanders, St Cyrus's first victim of World War One, from the pulpit in March 1915.

NEWS OF the action at Neuve Chapelle is filtering north. What many had thought to be a great victory is proving anything but – many of the gains made are lost in a desperate German counter-attack. The cost in lives for both sides is calamitous. Over 11,000 British and Indian troops die to secure a mile of new territory. A template has been established for the war: poor artillery support, inadequate communication, men charging well-defended, entrenched positions, slaughter.

The Cameronians' 2nd battalion has paid a terrible price: 13 officers killed, nine wounded; 113 ranks killed, 304 wounded, 21 missing. Darling, filling in the 1st battalion war diary while Robertson is absent on leave, breaks from his regular account of the events at Bois Grenier to list the dead officers he knew who had previously served in the 1st – Bliss, Hayes, Ellis, Lloyd, Dodd, Kennedy ... Bliss had stepped in for Robertson back in 1913.

The sense of shock in the 1st battalion is tangible. These are our men. The 1st and 2nd are rivals but family, and the need for more officers to rebuild the 2nd is clear. Oakley and Money, who started his service after Sandhurst in the 2nd, are asked to move across. Chaplin steps up as commanding officer of the 1st – Robertson is not due to return for another fortnight. The new, stand-in CO has the honour of entertaining "certain press correspondents" in the trenches on 17th March, the first visit paid by journalists to the Bois Grenier sector, part of a government drive to control press coverage by overseeing access.

Robertson returns on the 29th March to find Fred Davidson gone, and a new medical officer in situ.

* * *

Fred is in Eleven o'clock Square, the centre of Armentières, where the tower clock never moves, punctured by a Hun shell. He is rolling, swaying around it, tables are out, the cafes are full, drinks spilling, men shouting, singing, raising their glasses then inky pinky down he trips over rubble everywhere, falling, hurting his hip, warm mud underneath. A steam

engine shudders and toots, then gulls' cawing, and he takes a deep draft of the briny smell of the sea.

He wakes in a wide room with a spring sun burning through long sash windows. Lush curtains, smooth linoleum, clean sheets, the rich scent of pheasant-eye daffodils in a vase on a tablecloth. In a wicker chair a girl is reading, turning the pages of her magazine softly, elbow on table, head on hand. She wears a watch on the inside of her left wrist, poking above a starched white cuff [226]. It ticks past 11 o'clock as he stares. She breathes.

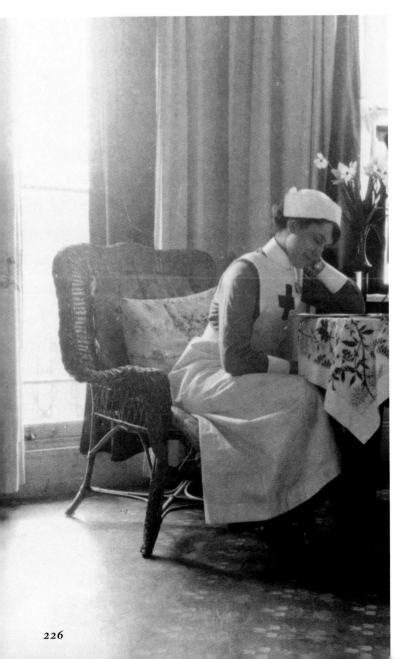

–Folkestone.

She says it out of nowhere, in an English accent he cannot place. Of the south but northern, too. She has the hint of a smile, a look that says she knows her own heart, she anticipates and answers. Fred can only stare around blankly. So this, he thinks, is what comes next. Cushy.

His luck has held. Found by bearers and pulled back to C Company's trench, Fred has followed the path well-worn by so many of his own injured, back to the advanced dressing station in Bois Grenier, back to the old hospital in the south of Armentières, then patched and pushed onto train and boat and back to Blighty, oblivious in his opiate haze. Hampson in the 19th Field Ambulance simply records in his diary for 14th March:

"At night MO the Cameronians was brought in shot through hip and hand. Had a busy night."

The Cameronians' own war diary doesn't mention Fred's departure at all. One doctor goes, another comes. They are in the regiment but not part of it, not like those who died at Neuve Chapelle only days before. The MOs are just another service supplied.

It takes five days to ship Fred back to Britain. He will spend a month recovering in Devonshire House, a private nursing home converted to military use, in Sandgate, a small coastal town subsumed by Folkestone in the 19th century. It is best known in Edwardian times as the home of the popular author HG Wells.

Two beds stand in Fred's room. In the other a young Irish lieutenant from the Leinsters, wounded in the arm, recuperates. He fought at Neuve Chapelle, he has the stories. Fred knows Bertie was there too with his Meerut Division. They took a pasting, they all took a pasting.

–How you doing, old man?
–Better with a glass of this, grins the lieutenant. Fred photographs him in genial pose receiving his medicine from Miss Keast, one of the Voluntary Aid Detachment nurses attending [227]. He later captions the picture: "Lieutenant Crowe rapidly convalesces on stout."

* * *

The nurse he woke to introduces herself. Marie Jacques, from Cheriton, just up the road. Fred is cautious, but intrigued. He has heard about the influx of VAD assistants. They have a mixed reputation – posh girls wanting to help, rapidly trained and quickly assimilated into a medical infrastructure thrown together to cope with the war. The Army never planned for this many wounded. It never foresaw the effect of heavy artillery, of multiple machine guns, of protracted trench warfare. Despite serving a

nation that prided itself on organising the biggest empire the world had ever seen, it was blind. Now it needed old doctors to replace young ones sent to the front, and it needed village halls and nursing homes to become hospitals, and it needed nurses, rich and poor. Initial suspicion has been replaced by gratitude.

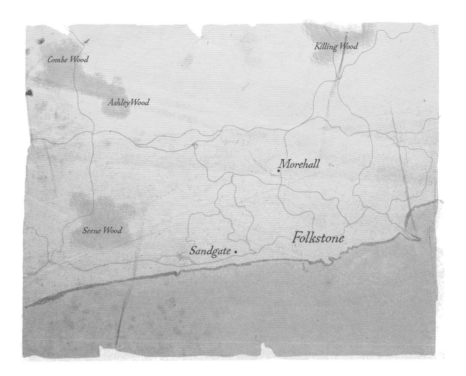

So here was Miss Jacques – French name, northern family, daughter of a prosperous Lancashire businessman. Fred is good at getting detail from her, he is a doctor, after all. Her father, Preston-born, had started a marble business, employing masons, but later made his fortune in Barrow running steam laundries, set up to service Liverpool's White Star shipping line. By 1900 he had moved south to buy Enbrook Manor in Cheriton, and a clutch of businesses in booming Folkestone. His laundries there get regular work from the town's grand hotels, and from the Shorncliffe army camp expanding nearby. Marie is his only child, doted on, used to getting her own way and already 26 years old. When she insists on nursing, they cannot stop her. When she accepts an offer of marriage at the start of the war, she gets her way too. She is engaged to another officer serving in France when she meets Fred. But she catches his eye. He sees his mother's determination come to life again.

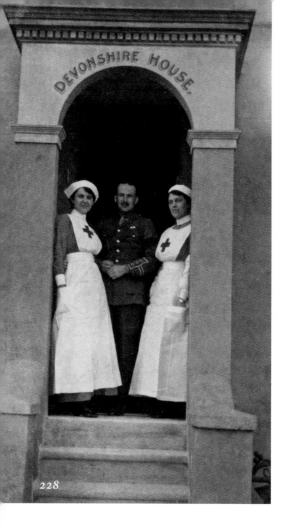

228

He leaves Devonshire House in April, but not before he poses with Marie and another nurse by the entrance steps [228]. Fred holds his injured hand tentatively, his left arm already carrying the blue band worn by wounded officers, his chest the purple and white ribbon of the Military Cross. Of his valour and his hip wound, he is always dismissive. "Shot in the posterior," he would chuckle, for years to come.

And then he is off up north, to see his father. Before he goes, however, there is an invitation to tea at Marie's home. Harry Jacques is there, every inch the 58-year-old plutocrat, posing in stiff collar and bowler outside his ivy-covered manor house [229]. Fred takes another picture of Marie plus friend, the chaperone always required on such occasions. Marie's confident grin, eyes to camera while her companion looks away, tells Fred enough [230].

229

230

On his way home, Fred stops in Lancashire to see an old friend, Dick
Fawcitt, the pal he made in Edinburgh. Fawcitt, son of a country doctor, has
a Ford Model T which the two can tour in, seeing the sights. The "buzz-
box", as Fred calls it, is still a novel sight, launched in America in 1908,
made in Manchester from 1911 – the first affordable motor-car [231, 232].

They take turns photographing each other behind the wheel. Fred looks older, wearier – the result of eight months of war. Behind him the river Duddon runs picturesquely out to the sea through unravaged countryside, so different to what he left behind in France. He has always photographed landscape, tapping into the pastoral impulse that convulses modernising Britain. Now he has another motivation: this is what he is fighting for. It is also a landscape familiar to Marie, close to where she grew up in north-west England.

233

Back in the south, awaiting his next orders, Fred has time to capture another novelty, the SS-1 airship, a giant blimp being developed by the War Office to scout for submarines and to counter the increasing menace of German Zeppelins.

It motors gently overhead, buoyant with hope, before disappearing over the rooftops [234, 235, 236, 236], another example of how Britain's industrial knowhow should enable it to outstrip the Germans and end this war quickly. Just days later it hits telegraph wires outside Dover and is destroyed in a ball of fire.

234

235

236

237

Fred returns to France in June – not to the Cameronians, but to the 18th Casualty Clearing Station at Lapugnoy, outside Béthune, 30 odd miles from Armentières. Why doesn't he go back to the regiment? Perhaps because in a clearing station – which operates as a small hospital – you can do real work, rather than just bandage and move on. Perhaps because you could be part of a real team, rather than just MO to a band of men who will never see you as one of their own. Perhaps just because he was told to, as his experience was invaluable, and to put him back in the front line would likely have seen him killed and that experience wasted. But he always kept his photographs of the Cameronians.

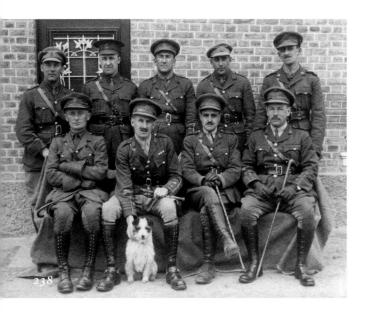

By May 1917 he was a Lieutenant Colonel, heading the 74th Field Ambulance [238], with eight officers and 224 men under him, supporting the 24th Division as it fought through Vimy Ridge, Messines, and the third battle of Ypres. In France, Fred – always the dog lover – even adopted a terrier which was to follow him home to Britain [239]. He called it Cambrai, after the battlefield where he found it.

And by then he was a married man too. In July 1916 he wed Marie Jacques [240], a year after her fiancée was declared missing in action. Family folklore has it that the two met again when she turned up in France, looking for the man she lost, and then found Fred. She was always strong-willed, and Fred – who stopped taking photographs in 1915, as his responsibilities grew – was an officer rising fast. He came home on leave the month before Armistice was declared in November 1918. By the time he returned, Marie was pregnant with twins, due the next June. Fred had enough luck to see out the war unscathed – for which we, his descendants, are grateful.

240

THE END

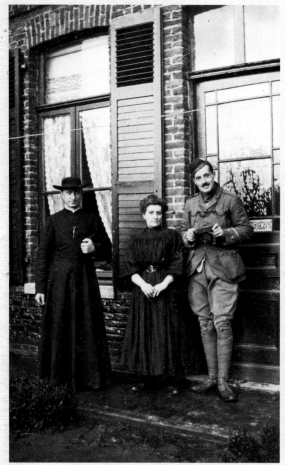

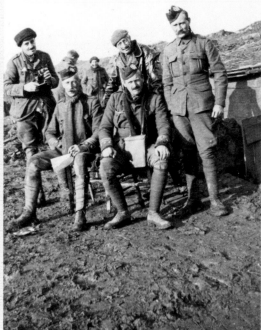

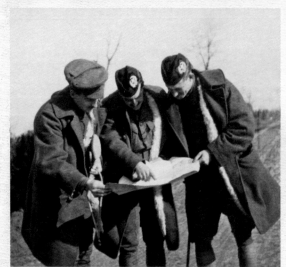

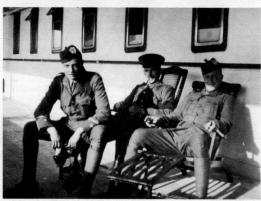

16
EPILOGUE

Don't flourish your camera about in the face of
generals ... don't take pictures that could possibly be
of the smallest assistance to the enemy ... Don't ever
photograph the horrible, such as the execution of a
spy; you will find war quite horrible enough, without
perpetuating the seamy side of it.

– FROM "PHOTOGRAPHY AT THE FRONT: SOME
PRACTICAL NOTES FROM ONE WHO HAS BEEN THERE",
IN THE *AMATEUR PHOTOGRAPHER* MAGAZINE, MARCH
1915, CARRYING THE BYLINE "MEDICO"

FRED'S LUCK would run out, but not till much later. He resigns from the Army in 1919, after receiving orders sending him to Egypt. Marie will not have it. Cairo's reputation as the world's leading city of vice – troops had regularly rioted there during the war – may have swayed her hand. Fred argues to his commanding officer that he cannot abandon his wife, as she is expecting twins, or force her to follow. Instead, he sits a course in public health at Oxford, and ponders his future. Eventually his father-in-law buys him a General Practice in Camberley, Surrey, near Sandhurst's military academy, where he can continue doctoring and where fellow Contemptibles like Tom Riddell-Webster are now teaching. There Fred's affluent patients roll up, many of them service families, to be treated by the quiet Scotsman with the careful manner and exemplary war record – one of the first doctors to win the Military Cross, and a wounded hero. Unsurprisingly, the practice is swiftly among the area's most successful.

Marie, one eye always on advancement, also makes changes, principally to the family name. Dr Davidson now becomes Dr Churchill-Davidson, bumping up his middle name in a way that immediately gives him famous English lineage – rather than simply a place where his Scottish grandfather kept a carpentry shop. Marie argues that it makes the medical practice more distinctive, especially as there is another Davidson doctoring nearby. The reaction of Fred's father is not recorded, nor that of his five, far-flung brothers – Bertie still with the RAMC in India, Jack in business in Canada, Harry on a coffee plantation in Kenya, Edwin and Reginald ministering in Scotland. You can only imagine it increases the distance. Perhaps Fred feels it is payback for all those years of calling him Thomas.

He has his own burgeoning family to focus on, anyway – four boys: the twins Ivor and Ian, then Harry, then Dudley. And the Churchill-Davidsons prosper in the decade that follows the war, as the economy picks up, and the south of England booms. The boys attend Summer Fields, the

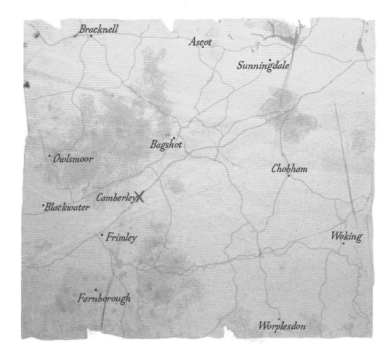

upmarket prep school in Oxford favoured by aristocracy, while Fred builds
his practice. He also returns to at least one regimental reunion with the
Cameronians in Scotland. There, over long boozy dinners, remembering
friends lost and found, he encounters Robin Money, his old camera
chum, now a Major and as gregarious as ever, offering a choice of his best
photographs, complete with captions, to be put into albums for fellow
veterans of the Armentières campaign. Fred, like the others, takes his pick.
He also starts to organise his own pictures.

Then in April 1929 tragedy strikes at home. Fred's twins contract polio. Ian
recovers, though maimed for life with a withered leg. Ivor dies. And after
that, things are never quite the same.

Two years later, Jacques money buys Fred and Marie the land to build a
large new home in Camberley. They commission a three-storey, eight-
bedroomed, Tudorbethan mansion, called Beverley, where Fred bases
his practice, and around which he designs an impressive garden with
rockeries, ponds, rose walks, a tennis court hidden in rhododendron
woods, and an elegant lawn curling round an old cypress tree. It is a world
away from Reverend Robert's walled fruit garden, clinging to a cliff in St
Cyrus, yet provides some of the same purpose.

BEVERLEY

For the other Davidsons, it is a symbol of the old differences widening. When Fred's nephew Murray, Jack's son, visits from Canada in 1932, he marvels at the sheer size of the place, and its servants, in a letter home. "Set in the midst of about five acres of all sorts of trees and rock gardens, it is a sort of castle and inside it is a treat, with bathrooms to darn near every room". There is a "a cook, a maid, a nurse for Dudley and a general man". He finds his aunt "very nice ... but in a coldish way ... very English and very much society", and his cousins dauntingly posh. "They talk big words all day long ... 'I say', 'Bah Jove'...". Fred, on the other hand, "looks very military" but "is a real good guy, practically exactly like Dad ... He was in the garden when I came, cutting the grass or something".

For Fred, like many veterans of the war, to be outside, at peace, among nature, not to have to explain what he saw, is solace enough. From there he can watch his remaining boys grow up. Driven by their parents' ambition, they are educated at Charterhouse and Cambridge, and follow high-flying careers in medicine. Ian, a pioneering radiologist, is instrumental in setting up the Richard Dimbleby cancer research laboratories at St Thomas' Hospital in London. Harry, a famous anaesthetist, co-writes the best-selling textbook *A Practice of Anaesthesia*, also based at St Thomas'. Dudley, a respected orthopaedic surgeon with his own private practice, operates on patients around the world.

And Fred stays put. Just like his father at St Cyrus, he never moves from Camberley, never leaves the garden he works so hard to create, never pushes that brilliant mind beyond his general practice which he runs from home. He sticks with his own, and runs his affairs in an idiosyncratic way: the rich pay, the less well-off have bills waived. Years later, the local vicar leaves Fred a legacy, in thanks for all the attention he receives for free. Whether Marie – who oversaw the practice's accounts – approved of this, is not recorded.

Fred's father, Reverend Robert Davidson, dies on 3rd May 1936, after remaining minister in St Cyrus for more than half a century. Robert had seen five of his six sons go the Great War – Fred and Bertie to the RAMC, Edwin and Reginald, temporarily sidestepping the Church, to the Royal Scots RGA and the Royal Field Artillery, Harry to the Indian Army – and all five return safely. It's not just Fred who is lucky. Outside the kirk they build a granite memorial to the fallen. "The men of St Cyrus parish who died on service in the Great War". Thirty names are inscribed, including a son of the Porteous family, the lairds who finance the church. Not one of the minister's six sons is on that stone – reason enough, perhaps, for him to dedicate his life to one place and its people.

Another war intervenes, and Fred, promoted to Colonel, returns to the RAMC, overseeing hospitals in Egypt and Italy, and later becoming Assistant Director of Medical Services in London from 1943 to 1945. Over the same period one cousin, Andrew Cunningham, becomes Admiral in charge of the Mediterranean Fleet, then First Sea Lord, then Viscount of Hyndhope; another, Alan Cunningham, is a General, then commandant of Camberley's Army staff college, then High Commissioner of Palestine. If ever the Davidsons felt outranked by their cousins, World War Two confirmed it.

The war over, Fred comes back to fight for his old patients and negotiate his way into the new National Health Service – so similar in bureaucracy to the military set-up. Then he retires. His is a very English way of life. He attends Sandhurst Chapel on Sundays. His sons visit weekly. Marie's mother comes to live with them. And Fred holds court over pre-lunch drinks at home, smoking through a cigarette holder, not saying much but commanding attention, "very much the Colonel", according to another impressionable nephew who visited him there. His Military Cross is framed, and perched on the piano in Beverley's main reception room.

Fred and Marie occasionally motor up to Scotland in the summer and stay at Gleneagles Hotel, where he invites his minister brothers to visit and play golf. They, inevitably, think him rather grand, and their wives find this bald, bespectacled, quiet man rather daunting. Ask him to walk you round a garden, though, and the warmth will suddenly flow.

For Fred, St Cyrus – with its wild winds and clifftop precariousness – is left well behind. Fred shifts from Church of Scotland to Church of England; his sons soon lose religion altogether. Like most doctors of their generation, they will find it hard to reconcile a belief in God with a devotion to science and its possibilities. But little bits of Fred's old life at the manse pass down the family line. The love of cameras and working with your hands is imbued in Ian, his boffin-like first-born, who works painstakingly at dismantling and rebuilding radios and projectors, and fills Beverley with model galleons, built from kits, before transferring that same precision to his work in radiotherapy. Handsome Harry inherits an eye for the ball and a love of games, playing soccer and squash for Cambridge, with an easy way for making the complex simple and a charm that reassures every patient. Gregarious Dudley, a lieutenant-colonel in the Royal Marine Reserve, has a love of the military and the meticulous, for people, pageantry and plants. All bright, all different, but very much sons of Fred and Marie.

Fred dies at home on November 8th 1959. His death certificate states as cause "intestinal haemorrhage, secondary carcinoma of the liver, and carcinoma of the colon". Years later Dudley says that his father had known he had cancer of the colon for a long time, yet deliberately ignored the symptoms.

–Silly bugger, he adds, shaking his head.

Perhaps Fred had had enough. He asks to be buried in Folkestone with Ivor, close to Marie's old home, where he found love, and there he is today, sharing a gravestone with the son he lost.

* * *

BRITISH MEDICAL JOURNAL – DECEMBER 1959
OBITUARY: F. CHURCHILL DAVIDSON MC MB CH DPH

Dr F Churchill Davidson died at his home at Camberley, Surrey, on November 8, after a long illness borne patiently and with great fortitude. He was 70 years of age.

Frederick Churchill Davidson, who was born on January 1, 1889, was indeed a son of the manse. His grandfather was the Very Rev Dr Cunningham, of Crieff, Moderator of the General Assembly of the Church of Scotland, and his father was minister of St Cyrus, near Montrose. His mother was a sister of the late Professor Daniel Cunningham, the distinguished anatomist and dean of the faculty of medicine at the University of Edinburgh, a man who was held in high esteem and affection, and whose sons did outstanding service to their country in the Forces of the Crown. Frederick Churchill Davidson was educated at Fettes College and at Edinburgh University, where he was a brilliant student. He had a phenomenal memory which enabled him to quote a lecture verbatim many hours after he had heard it delivered. He was also a fine athlete, and gained his hockey blue. On graduating MB ChB in 1912, his uncle advised him to follow the family tradition and join the RAMC as a regular officer. After his special training he was appointed medical officer to the Cameronians and went overseas with the first draft in the first world war. Very early in 1915 he was one of the first medical men to be awarded the Military Cross, which was founded in January of that year. While in hospital at Shorncliffe, after having been wounded in 1915, he met Marie Jacques, of Embrook Manor, Cheriton, who was acting as a VAD and whom he eventually married. When the war was over he stayed on in the Army doing special work, during which period he took the Oxford DPH. In 1921 he went into general practice in Camberley, and became a member of the staff of the local cottage hospital and medical officer of health for Frimley and Camberley Urban District Council. He continued in practice there for thirty-eight years, and his opinion was much valued by his professional colleagues. During the second world war he was again called upon for military service and was in charge of the surgical unit at Netley Hospital. He also worked for a period in North Africa. After the war he returned to his practice. A doctor of the very best type, he always kept himself well abreast of the times. His work came first in his life, hence he had the affection, confidence and respect of all who consulted him. His patients were his friends and his friends were his patients. He leaves a widow, who was his devoted and constant companion, and three sons, of whose medical achievements he was justly proud. Two are on the staff

of St Thomas' Hospital, where they all trained, one a radiotherapist and the other an anaesthetist, while the third is a surgical registrar. To them and his widow we offer our sincere sympathy.

RF writes: More than fifty years ago, when I attended my first lecture at Edinburgh University, I found myself sitting next to the man who was to become my greatest friend. He was in one of the university halls, I in another, but, when we found that working in hall in those days was not very easy, we decided to join forces and go into digs. This arrangement proved a very happy one and lasted throughout our student career. We graduated on the same day and went our different ways, but the friendship lasted a lifetime.
He spent most of his holidays in my home, where we enjoyed many country pursuits and where my father – himself a country doctor – gave us much helpful advice. His death has made a great gap in my life, for the early student friendship became a family one and extended to the next generations. Fred, as he was known to his many friends, had great personal charm and sympathetic understanding. These qualities, combined with his devotion to duty and his absolute integrity, make me echo what was once said of him, "Happy the patient who was in his care."

[Author's note on the BMJ obituary – it would have been hard for Fred's uncle to have advised him on a career in 1912 as Professor Cunningham had been dead since 1909, however the point made is valid.]

LIFE AND WORK, THE MAGAZINE OF THE CHURCH OF SCOTLAND
A TRIBUTE TO THE REV. ROBERT DAVIDSON B.D. – JUNE 1936

*Those who know St Cyrus will cherish happy memories of its late parish
minister, the REV. ROBERT DAVIDSON B.D. who died on 3rd May after
having for half a century preached in its "visible" kirk and been the genial
guide, philosopher and friend of its parishioners and visitors. A true "man
o' the Mearns" Mr Davidson was a distinguished student at Edinburgh and
Aberdeen Universities. His ministry began in Stonehaven where for six years
he was colleague to Rev. Alex. Silver of Dunnottar. Ever a welcome visitor
in the homes of fisher folk at the shorehead and in the cottar houses in the
landward part of the parish, his able and eloquent preaching attracted large
congregations to the historic church beside the "Covenanters' Stone" where
Sir Walter Scott met "old Mortality".*

*Transferred to St Cyrus in 1884, Mr Davidson's ministry there has been
a record one not only in duration but in fidelity, virility and earnestness.
He was a lifelong student, a lover of books, of nature, and of men. His
outstanding characteristic was his love of truth and uprightness, an
innate scorn and fearless condemnation of all unreality and sham. A keen
educationist, he did yeoman service in School Board and Educational
Authority, and his care of the aged and the poor was not confined to the
Parochial board or Parish Council, but to all in sickness and sorrow his
pastoral ministrations were ever most sympathetically and generously
given. The affection and esteem in which Mr Davidson was ever held was
abundantly witnessed by his Presbytery, his congregation, and the community
at the celebrating of his jubilee in 1928.*

AND AFTER

Captain Ronald Herman **Brodie**

Brodie serves as an officer in the Middlesex regiment throughout most of World War One. He later becomes an Intelligence Officer in Montenegro and Albania, and is ADC to Lord Allenby when the War ends. He returns to the 1st Cameronians in 1923 and is promoted to Major in 1931. He retires to become an estate agent, and later serves with the Middlesex again in World War Two. He dies in Shrewsbury on 27th November 1969, aged 78.

Major James Graham **Chaplin**

Chaplin takes over command of the 1st Cameronians in May 1915, and is awarded the DSO that summer. Later that year, at the Battle of Loos, he countermands staff orders to send his men over the top, arguing that the orders were provisional on other units being successful in their advance. When his inaction is queried, he demands the order to attack is given in writing. No order comes. He rises to Brigadier General before retiring in 1929. He dies in Newbury, Berkshire, on 15th January, 1956, aged 82.

Captain John Collier Stormonth **Darling**

Darling is promoted to Lieutenant Colonel in 1916 and given command of the 9th territorial battalion of the Highland Light Infantry. He is killed in action at the battle of the Somme on 1st November 1916, aged 38.

Lieutenant Ernest Leslie **Ferry**

Ferry, wounded in 1914, returns to the war with the Argyll & Sutherland Highlanders' 5th battalion (territorial force), serving in Egypt, where he is promoted to Captain. He dies in 1940 aged 58.

Lieutenant Douglas Alexander Henry **Graham**

Graham is invalided out of the war after being shot at La Boutillerie in 1914, but returns with the 2nd Cameronians in 1916. He finishes the war as Brigade Major, having been mentioned in dispatches, and awarded the Military Cross and French Croix de Guerre. He rejoins the 1st Cameronians in 1925, commands the regimental depot in 1932, and takes command of the 2nd battalion in 1937. He commands the 153rd Infantry Brigade, part of the 51st Highland Division, in World War Two, winning the DSO at the Battle of El Alamein. He is later given command of the 56th Division of the 8th Army for the rest of the North African campaign and the invasion of Italy. He later commands the allied force in Norway, and is awarded the CBE. Major-General Graham retires in 1947 but returns to become Colonel of the Regiment in 1954. He dies in Montrose, Angus, on 28th September 1971 aged 78.

Captain Francis Alexander Chetwode **Hamilton**

Hamilton is promoted to Major in 1915, after winning the Military Cross at Bois Grenier in June. He later commands a Territorial Force battalion of the Gloucester Regiment, and becomes a Lieutenant-Colonel in 1923, before retiring in the same year. He dies in Stamford, Lincolnshire, on 10th October 1956 aged 81.

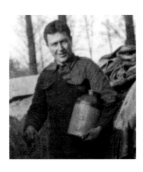

Private Fred **Hawes**

Hawes survives the war, awarded the Mons Star and clasp, and returns home. It is not known what happened to him thereafter.

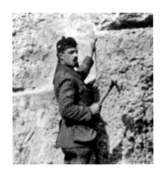

Lieutenant Jacobus Darrell **Hill**

Hill is promoted to Captain in 1916 and awarded the Military Cross, and serves with the 1st and 2nd battalions after the war, promoted to Major in 1931. He serves with the 1st battalion in India and is appointed to the Staff of the Embarkation Headquarters in Calcutta at the start of World War Two. He retires to Sussex in 1947 to follow his passion for archaeology and later writes an anonymous account of his experiences in World War One, now kept in the regimental museum in Hamilton. He dies in Cheam, Surrey, on 16th June 1973 aged 82.

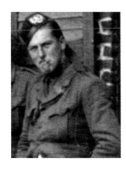

Lieutenant Ernest William James **Hobkirk.**

Hobkirk transfers to the 11th battalion of the Cameronians in Salonika in 1916, then is seconded to the Army Signal Service in 1917 where he remains after the war. He dies in 1968, aged 78.

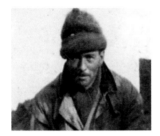

Captain James Lochhead **Jack**

Jack is given command of the 2nd West Yorkshire in 1916, and is wounded in 1917, returning as commanding officer of 1st Cameronians in 1918, before being given command of the 28th Brigade in September the same year. He wins the DSO and bar, and is twice mentioned in dispatches, later commanding the 9th Cameronians in 1919, and retiring from the Army in 1921. He commands Market Harborough's Home Guard in World War Two, before taking appointments in the Territorial Army. He dies on 22nd December 1962 aged 82, and finds fame posthumously as the author of *General Jack's Diary*, an account of his life in the line as a professional infantry officer.

Captain Harry Hylton **Lee**

Lee is given command of the East Surrey Regiment in 1915, and is wounded three times before World War One ends. He is awarded the DSO. He commands the 2nd Cameronians as Colonel from 1923 to 1926. He then becomes Colonel in charge of Records, until retirement in 1931. He dies in Hove, Sussex, on 16th January 1946, aged 68. He is remembered as 1st Cameronians' finest polo player.

Captain Allan Ronald **Macallan**

Macallan is taken as a prisoner of war at La Boutillerie and held by the Germans until 1917, when he is repatriated through Switzerland, and appointed to the Staff of the War Office. He returns to the Cameronians in 1924, taking command of the 2nd battalion in 1927. He retires in 1933, before rejoining the War Office as an Assistant Adjutant General in 1939. He remains an accomplished golfer, and dies in St Andrews, his home town, on 26th September 1943 aged 64. At his funeral the Royal and Ancient sends its professional to carry its historic collection of balls and clubs draped in black behind Macallan's coffin.

Captain Thomas Rainsford **McLellan**

McLellan is arrested in July 1915 for "certain inactions" in the month before – refusing to send his men to engage the enemy. He is cleared of all charges. He is promoted to Major in April 1918, and leaves the Army in 1919. He later becomes a member of Kircudbright District Council and acts as Scout Commissioner for the area. He dies in January 1942 aged 58.

Lieutenant James Humphrey Cotton **Minchin**

Minchin transfers to the Royal Flying Corps in July 1915, before returning to the Cameronians in 1919. He leaves the Army a year later as a Captain, and goes on to edit *The Legion*, a celebrated book of short stories about the war for the British Legion, with contributions from Hilaire Belloc, Aldous Huxley, PG Wodehouse and others. Minchin later becomes a British consul in Washington, playing a key role in persuading America to enter World War Two. He dies in London on 28th May 1966 aged 72.

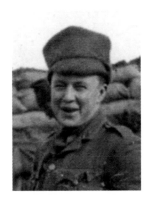

Lieutenant Douglas Graham **Moncrieff Wright**

Moncrieff Wright joins the HQ staff of 1st Division in 1916, and returns to the 1st Cameronians in 1917. Wounded twice and moved to the 2nd Cameronians, he wins the Military Cross and bar, and is twice mentioned in dispatches. After the war he takes part in campaigns in Iraq and Waziristan, before retiring from the Army in 1930 as a Major. He later becomes a JP and an authority on improving salmon rivers. He rejoins as commander of the Cameronians' 10th battalion in 1939, promoted to Lieutenant Colonel. He later becomes Deputy Lieutenant for Sutherland in 1946. He dies on 1st May 1983 aged 89.

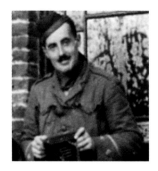

Lieutenant Robert Cotton **Money**

Money transfers to the 2nd Cameronians in March 1915, and is wounded by shellfire in May the same year. After recovering in Britain, he is transferred to the Middle East, where he continues to take photographs. He is given command of the 1st Cameronians in 1931, then the 15th Scottish Division in 1940, and becomes a district commander in India in 1942. He retires from the Army in 1944 to work for the Ministry of Transport. He dies in Buckinghamshire in 1985 aged 96, leaving his collection of World War One photographs to the Cameronian regimental museum and the Imperial War Museum. They go on to provide the best-known images of the British Expeditionary Force's first nine months in France.

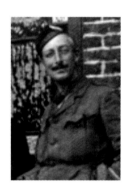

Major Richard **Oakley**

Oakley takes temporary command of 2nd Cameronians from 18 March to 26 April 1915. He later commands the 10th Queen's and the 12th Machine Gun Corps battalions, winning the DSO, before heading the 63rd Brigade, 37th Division. He is also mentioned twice in dispatches. He commands the 2nd Cameronians again from 1919 until he retires from the Army in 1923. An enthusiastic game shooter, he dies in Bedfordshire on 22nd November 1948 aged 76.

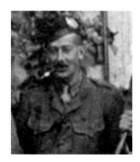

Captain Thomas Sheriden **Riddell-Webster**

Riddell-Webster remains a staff Captain for the 19th Brigade until 1915, when he becomes deputy assistant adjutant general. The following year he is promoted to Major. By 1922 he is deputy assistant quartermaster general at Sandhurst staff college. Promoted to Colonel in 1927, he commands the 2nd Cameronians in 1930 and later is quartermaster general to the forces in 1942. He steps down in 1946, a knighted General, remaining as Colonel of the Regiment until 1951, when he retires to farm in Perthshire. He dies in Perthshire on 25th May 1974, aged 87.

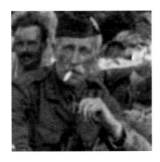

Colonel Philip Rynd **Robertson**

Robertson takes command of 19th Brigade as Brigadier General in June 1915. At the battle of Loos he countermands orders to advance after the failure of attempts to gas the enemy. Despite such independence of thought, he is promoted to Major-General and commands the 17th Division in 1917, then has temporary charge of the VII Corps. He is mentioned in dispatches seven times, created a CMG in 1915, CB in 1917 and KCB in 1919, and receives the French and Belgian Croix de Guerre and the Belgian Order of Leopold. He commands the 52nd (Lowland) Division until 1923, when he retires. He remains as Colonel of the Regiment until 1927. He dies in Bideford, Devon on 11th May 1936, aged 70.

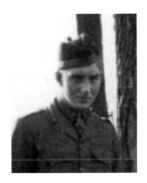

Lieutenant Charles Douglas Willoughby **Rooke**

Rooke recovers from wounds received at Bois Grenier and returns to the front line in May 1915. He is shot through the heart on 19th June 1915 while leading a raid on a German listening post, and later buried beside his fellow officers Becher, Stirling and Wedderburn in Bois Grenier. After his death, Robertson, now a Brigadier in charge of 19th Brigade, writes personally to Rooke's mother: "We shall all so miss his bright face and personality among us ..."

Major Crofton Bury **Vandeleur**

Vandeleur is promoted to the command of the 1st battalion Cheshire Regiment late in 1914, and is wounded and captured by the Germans. After only six weeks, he becomes the first British officer to escape in World War One, and makes his own way back from enemy captivity in Holland. He later commands the 2nd Cameronians, is seriously wounded again, and after long recuperation returns to command the Regimental Depot in Hamilton. He is mentioned in dispatches, and later receives the DSO in 1919. He retires from the Army in 1922, and concentrates on developing the Regimental Association. He dies in Bothwell, near Glasgow, on 26th September 1947, aged 80.

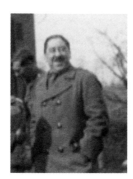

Quartermaster George **Wood**

Wood is wounded and twice mentioned in dispatches in 1916, then court-martialled for drunkenness in December the same year. Found guilty, he is sentenced to be severely reprimanded, but continues in the Army. Promoted to Captain in July 1917, he becomes an Army instructor in catering in 1919. A year later he is court-martialled again, after being found unconscious "lying on the sands outside the Casino, Calais". He is dismissed from the service, without a pension, after 29 years of service. He then applies repeatedly for an overturning of the verdict, to no avail, and by 1923 is "under observation for insanity" at Stobhill Hospital, Glasgow. Fellow officers fight a long campaign to win a pension for Wood's wife and children. Robertson, Vandeleur and Hamilton support his case, stressing that injuries received under bombardment "had unhinged his mind". Eventually they are successful, but Wood dies on 12 September 1931 in Woodilee Mental Hospital, Glasgow, aged 61, leaving a widow and daughter, and a son in the Royal Marines.

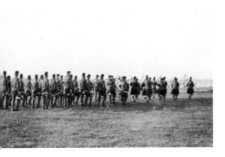

The **Cameronians** (Scottish Rifles)

The Cameronians (Scottish Rifles) go on to provide 27 battalions to World War One, losing 7,000 men, and fighting with distinction at Loos, the Somme, Ypres, Passchendaele and Cambrai. In World War Two the regiment fights in India, Burma and the Middle East. After nearly 300 years of service, the Cameronians are disbanded in 1968, having chosen not to amalgamate with another Lowland regiment following further reforms of the British Army.

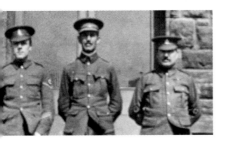

The **Royal Army Medical Corps**

The RAMC loses 743 officers and 6,130 soldiers during World War One, and wins more Victoria Crosses than any other regiment. In World War Two it helps develop the use of penicillin and blood transfusion. It supports the British Army to this day.

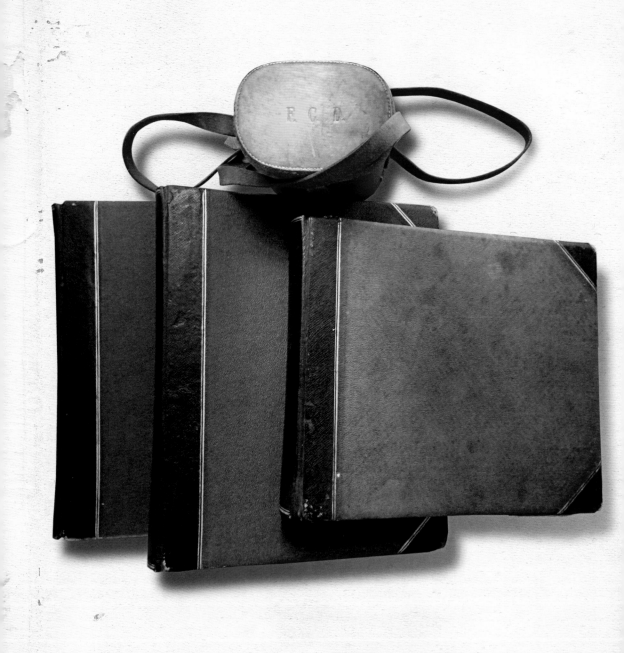

EXPLANATIONS & ACKNOWLEDGEMENTS

"We never spile't a story by considerin' gin 'twas true ..."

– RESPONSE OF SCOTTISH TROOPS TO A SCEPTICAL LISTENER, 1915

THIS STARTED with three battered photo albums and a pair of folding binoculars, passed on to me by my Uncle Dudley in 2000. Two of the albums were 10″ by 12″, full of captioned photos from the Great War. One was 9″ by 11″, showing many of the same men, in uniform and out, training and at leisure, in uncaptioned pictures. The binoculars came in a brown leather case monogrammed F.C.D. They had been in the family for nearly a century, the possessions of my grandfather Fred. We had always known the albums contained photos of his friends from the war, but I was never quite sure what I should do with them.

So I kept the albums in a spare bedroom for 10 years, though they seemed to migrate round the house as people looked at them. My eldest daughter took them into school for a project on the war, and various friends studied them and said "You really should write something about this", because the pictures tell a story – the same men, going through the same war, in some extraordinary places. And they show a different truth to the one we sometimes accept about that war: the misery and hardship, the horror and the stupidity.

These were the Old Contemptibles that the Kaiser besmirched – so fitting a title as they got older and grumpier in the public memory – yet Fred's

photos show young men on a lark, professionals proud of their skills, posing with teammates, laughing at the shell-holes. Look, this one just missed me! Many show the innocence of a family on vacation, the holiday album snap that just happens to say Houplines, December 1914. It was how they wanted to be remembered. And behind that were other narratives: what was really happening to them, how a doctor was really treated in a battalion, what the snapshots were really a buttress against.

And I never knew Fred. He died two days after I was born, pleased – I was later told – that he had a grandson. So when I was growing up, he was an absence, not there on weekend visits to my grandmother in Camberley, not there pruning his roses as he had been, every Sunday before. Granny was going deaf, a chain-smoker, a rare smiler, but still a sharp mind, honed from the Bridge Club she ran for decades from a large, purpose-built cabin in the vast garden outside. She was also tough, an only child of a Lancashire laundry millionaire, a woman who inherited a fortune and reputedly ran Fred, a gentle GP, as if he needed a firm hand. That was how we understood it, anyway. An air of belligerent sadness clung to her, from losing her first fiancé in 1915, from losing her young son in 1929, and all the more after losing Fred 30 years later.

My sisters, eight and 10 years older, have only a few memories of Fred: kind, forever in his garden, always outside. He loved to plant, and he looked after his patients well. And he was proud of his sons' impressive medical careers.

A bullet two feet higher in March 1915, or a bomb with a fuse that worked, and those sons would not have been around to make that contribution. And that got me thinking about how little I knew about Fred's war and the man himself. He rarely talked about World War One and what he'd seen (in common with many other veterans). He used to joke that he'd been shot in the bottom – as if it was a bit of a laugh.

I did know he had won many medals, as my Uncle Dudley had been so angry when they had been lost to the family following Uncle Ian's death. And I had seen the photograph my sister had of Fred in his Colonel's uniform at the end of World War Two. But other than that, there was so little, no papers, no diaries, no archive of reminiscences. Most who knew him are dead now. But I am guessing we share a few family traits – finicketyness, memory, love of being outside, being among but apart. And

we have both lost a child. My daughter Rosa died aged 19 in 2008. His son Ivor, Ian's twin, died of polio aged 10.

Yet all that is left is these three black albums, with everything the photos inside say about war and friendship, taken when it was expressly forbidden to do so, and at a time when the world was about to change radically, an old way of life disappearing, little the same again. So if I could tell their story, perhaps I could tell part of Fred's.

That was in the summer of 2012. And what I have learnt has turned much on its head. Initially I assumed Fred took all the pictures, as they include snapshots of his future wife, and it was likely he was a camera obsessive. I could remember how Uncle Ian, a brilliant radiologist, loved to dismantle and rebuild anything technical – he even built his own home cinema in the 1960s – so that knack must be inherited from Fred. It turns out, however, that while my grandfather was a keen photographer, authorship of the photographs in my possession is a bit harder to pin down.

At least one of Fred's albums is the work of his fellow officer, Captain Robert "Robin" Money, copied and shared among his friends in the Cameronian regiment, and sold to British newspapers. The same photographs can be found in the Cameronian archive in Hamilton, and in The Imperial War Museum. The other two albums may include photographs taken by others which Fred pasted in next to his own as they became available, much as we still share snapshots today. Some could be the work of Lieutenant Douglas Moncrieff Wright, whose parents arranged for the developing of prints and for the postage of film out to the front line under plain wrapper – though most of their son's own photographs are now lost. But given the sequence numbering in Fred's albums, and the personal nature of some pictures, and the fact that the Davidson boys were camera fanatics, I am guessing that most of the photographs were taken by my grandfather himself.

A century later, perhaps it doesn't matter. Digging back, showing the albums to academics, visiting Fred's birthplace and battlefields, working in various archives, reading the scattered, unpublished memoirs of fellow Cameronians and RAMC doctors, I have tried to put together the stories behind the photographs piece by piece. Most of this book is fact. Some is conjecture. I am not attempting to offer answers to the bigger questions of how and why World War One happened, simply to offer an account of

what it must have been like for one individual, from a singular background, to participate in its early stages. This is how and why he got there. This is what he went through, this might be what he thought. Through that I wanted to find answers to other questions: how did they cope, what were they prepared for, what effect might it have had on the rest of their lives?

Of course, I kept coming back to another question I could never answer: why were the officers in this battalion continually breaking Army orders to take photographs which might have been invaluable to the enemy, had they fallen into German hands? No other battalion took as many personal photographs at this early stage of the war. I can only presume it was because its commanding officer, Colonel Robertson, rather liked having his picture taken, and never enforced the ban. The Cameronians had a history of taking photographs – they had been doing so for decades. Fred's pictures of the battalion in bivouac at Barry Camp show officers looking at albums. And perhaps Money, whose father was a senior officer in charge of Le Havre's transit camp, just had the confidence to do it even though it was banned, and others followed.

You can understand why. For some back then, Ansco and Kodak's wonderful folding cameras were akin to the smartphone for today's young people – unthinkable to be without. Photography was becoming mass-market – by 1905 around 10% of the British population had access to cameras – and the notion of memorialising, driven by the Victorians, was strong. The industrial revolution and then war had led to a heightened sense of fragility, everything that could not be preserved should be pictured and remembered. Perhaps the surprise is that more soldiers did not take clandestine photographs in 1914. The authorities realised they soon would, and brought in their own official photographers late in 1915. That calmed the demand from newspapers which were openly advertising for pictures, if anyone just happened to be taking them ...

For the purposes of this book, I decided to treat all the photographs in Fred's albums as one – whoever took them. I know that would please the men involved. Quibbling over who took what is unlikely to have impressed them, as they fought together as a unit, and it is probable that they passed cameras round, and later shared the pictures.

Because the albums only cover the period of time Fred was with the Cameronians, the focus is restricted to just eight months. The pictures

only show the first part of a long war that can, from the soldiers' point of view, be divided into three very different phases: that of the professional Army, then the volunteer Army, then the conscripted Army. Fred's war here is that of the professional Army, keen to fight, worried that it might be over too soon. Morale declined and cynicism rose with each of the three phases. After recovering from his wounds, Fred rejoined a war that became very different to the one he first embarked upon, and faced carnage far worse than he experienced between August 1914 and March 1915. But the inevitability of that slow, mad slide into industrial killing was plain to many after that first Christmas. My hope is that in some small way Fred's story makes the inexplicable easier to understand. My surprise is that so many of his fellow officers survived into ripe old age – a result, I would guess, of them being first into the war and then rapidly promoted out of the front trench. The ranks were not so lucky; the Cameronians lost the equivalent of seven battalions over the course of World War One.

A word on sources: because of the sheer volume of material, both official and personal, written about the war, it is possible to know fairly accurately what nearly everyone was doing at the front on any individual day. Because Fred did not leave any written memoir, however, I have had to use the memoirs of others, and informed speculation, to suggest what he achieved, and what he went through. The following unpublished diaries, papers and memoirs have been invaluable: those of Lieutenant Hardinge, Private Honeyball, Captain Jack, Captain Lee, Lieutenant Money, Captain Ritchie, Captain Rose and Lieutenant Wright in the Cameronians; and of Lieutenant Hampson, RAMC, in the 19th Field Ambulance. Keen-eyed readers will recognise the words spoken by the unnamed MO in a French estaminet in September as those of Hugh Shields, medical officer in the Irish Guards, whose diaries and letters are kept by the Wellcome Collection. I have also used extracts from the memoirs and diaries of all the above as dialogue.

Many books have also provided essential information, but the following have been key: *Morale* by John Baynes; *Fighting Fit: Health, Medicine and War in the 20th Century*, by Kevin Brown; *Medicine and Modern Warfare*, edited by Cooter, Harrison and Sturdy; *No Hero This* by Warwick Deeping; *The War The Infantry Knew 1914–1919* by JC Dunn; *The Camera As Historian* by Elizabeth Edwards; *The Beauty and the Sorrow*, by Peter Englund; *Shots from the Front* by Richard Holmes; *Six Weeks* by John Lewis-Stemple; *Captured Memories 1900–1918* by Peter Liddle; *Her Privates*

We by Frederick Manning; *War/Photography – Images of Armed Conflict and Its Aftermath*, various authors, produced by The Museum Of Fine Arts, Houston; *The Greatest Benefit to Mankind* by Roy Porter; *A Medico's Luck in the War*, by David Rorie; *Private Pictures: Soldiers' Inside View of War* by Janina Struk; *General Jack's Diary*, edited by John Terraine; *War and Medicine*, various authors, produced by the Wellcome Collection; *Doctors in the Great War* by Ian Whitehead.

However, as any reader will quickly find, I have not written an annotated work of military or medical history, nor an academic study. I have simply tried to solve the conundrum of Fred's albums – how would I explain to family and friends what was really going on in the photographs? To do that, I would have to tell a story: how Fred got there and who he was with and what he went through and what happened to everyone after.

So that is what I have tried to do. I am very conscious that no one has produced a book like this before, perhaps for good reason. But I think it is important that these photographs are understood, and brought alive for new generations, simply because so much is missing or misunderstood. There is no definitive account of how Fred won his Military Cross. He would laugh it off in later life, and offer little detail beyond that he was treating a soldier in No Man's Land. As the first batch of MCs awarded was large, no official record was given of exactly why each recipient had won his medal. The battalion war diary does not record it. The regimental history only records the fact that its officers had won the new award – and doesn't mention Fred anyway, as he was in the RAMC, not the Cameronians, and doctors had that strange position of being essential but not really "part of the show".

That much I learned fairly quickly. The lingering prejudice against doctors inside the Army which reforms tried to address was still palpable. I could understand why a bright, ambitious man like my grandfather, having committed himself to a career in the Army in 1913 – following a path advocated by an uncle who had worked hard to get the best doctors into the services – might equally walk out six years later, determined to control more of his own life, after everything he saw and all he experienced. I can also understand why he might later stop in one place, when he found a community to make his own, rather than advance himself. Just as his father had.

If you go to St Cyrus kirk today, and look in the vestibule to the left as you come in through the broad oak doors, you will see a picture hanging on the wall of my great-grandfather, the Reverend Robert Davidson, minister in this kirk for over 50 years. Fred's father looks fine, hair pulled back, broadly foreheaded, moustache waxed above his clerical collar. He also looks young, still in his 30s, as he was when he arrived in this remarkable, windswept parish. My attempts to photograph this portrait would have exasperated Fred – it is impossible to find an angle on which light doesn't bounce off the frame's glass, reflecting a window opposite; the young Reverend Robert Davidson is there, refracted, just as he is here [242].

Now, 45 minutes' drive south of Aberdeen, St Cyrus is bustling again, part of the commuter belt for those made wealthy by the oil services boom on Scotland's north-east coast. It even has a batch of new houses in a new cul de sac, near the pub, named Davidson Place, after the good Reverend. In his day, it was a tougher place, villagers' livelihoods dependent on catch sizes and grain prices, hostage to the weather's ferocity. Tragedies were commonplace – drownings, accidents, infant deaths. Succour was found in faith, and whisky. Parents were torn between wanting their children to stay, and hoping they could leave to find better lives for themselves.

I need to thank a lot of people who helped me to write this book. My father's cousin, the Reverend Ian Davidson MBE (son of Fred's brother Reginald), has been tireless over the past year in answering my questions about family, faith and Scotland. He and wife Isla fed me teas in their Edinburgh apartment over long conversations. This book would have been hard to do without them. He has also answered my numerous emails with diligence and patience. Another cousin, Edwin Davidson (grandson of Fred's brother Edwin), has long been a chronicler of family history and provided invaluable leads. A third cousin, Ian Davidson in Nova Scotia

243

(grandson of Jack), whom I found via one of those leads, was unfailingly generous with his time, scanning and sending invaluable photographs and letters from the Canadian side of the family. How touching that Jack Davidson, exiled from home, should keep so much that has simply disappeared over here. The Reverend Robert burnt many papers and letters before he died. Most of Fred's papers were destroyed after his death. So the photographs sent from Nova Scotia of Fred's father Robert in the 1920s, in his garden and by his church, reproduced here [243, 244], had been lost to my side of the family.

245

Just as poignantly, Jack's scrapbook also kept pictures of Fred's twins, Ivor and Ian, as babies with Marie [245], and with my own father Harry, as boys [246].

In St Cyrus, I must thank the Reverend Colin Dempster, current minister of the parish, for taking the time to discuss the church and the history of the area. Likewise his neighbour John Adams, who runs a website about St Cyrus and helped me check a number of issues, and introduced me to the Linzi family, current owners of the old Manse, who kindly invited in a complete stranger, knocking on their door with a host of old photos – me. I am grateful, too, to Luke Devlin and Raymond Vettesse at Montrose Library for digging up press cuttings from the war years. Hats off to you all (repeatedly, I'd guess, in that east wind).

On the military side, I should start by saying thank you firstly to Barrie Duncan, assistant museums officer at South Lanarkshire Council, and overseer of the Cameronians' archive in Hamilton. He sits in a busy council office, built into the north stand of Hamilton Academical football ground, where he offered me a desk and a warm welcome. There I was able to read the unpublished memoirs kept in the regimental archive. Barrie kindly gave me permission to reproduce the Robert Money photographs that my grandfather had collected – whose copyright is held by the council – and answered my emailed questions over many months. The council also runs a fine Cameronian museum in Hamilton which is well worth anyone's visit.

I am also indebted to Andrew Murray, wise old archivist at Fettes School, for entertaining me in his book-lined basement cell, and generously giving of his time. Dr Steven Smith, professional researcher (proresearch85@ gmail.com), did much invaluable legwork in the National Archive for me. I must thank, too, Ian Proctor, curator at the Imperial War Museum photographic archive, and the academics and librarians at the National Army Museum, the RAMC Library at Keogh barracks, the Liddle Collection at Leeds University, the special collections at Edinburgh University and the Wellcome Library – all of whom have chipped in with suggestions and help.

I forget who remarked early on that the Cameronians' love of photography was worthy of a PhD thesis, but give me time... To the kindly cloakroom attendant at the Wellcome who asked me what I was researching and then said "I'd buy that, when it's out" – you tend to remember these things – thank you. Here is your chance.

In fact, the kindness of everyone from whom I asked help has been one of the features of this endeavour. In France, merci to Marie Josée Teyssier in Soissons for talking me through the scenes depicted in the photographs taken there. To the tourist office in Armentières, which looked at Fred's albums and immediately put me in touch with Laurent Joye – and lent me their intern to interpret – again thank you. To Laurent, ex-Foreign Legion and World War One fanatic, I salute you. He spent his day off from work showing me around Armentières, Houplines and Bois Grenier, where Fred fought, lived and drank. The fields there are still flat, still scratched with ditches, but Grand Flamendrie Farm has been rebuilt, Water Farm renamed, the cemetery where Stirling, Wedderburn and Becher lie, behind the old brewery, is now partway-down an innocuous suburban road, and all is peaceful and affluent, the only sign of past conflict being the defunct shells and pump parts piled in farmers' yards. Laurent has been badgering his mayor to open a museum to the war in Armentières, partly so he can show his own vast collection of bullets, bombs, relics and findings. You want a working World War One trench pump? Laurent has it. He is also insistent that Mademoiselle d'Armentières was never sung before February 1915 – others insist he is wrong. Please Mr Mayor, give him his museum.

On the home front, a bevy of friends and family have helped. To Ian Hislop, thank you for suggesting I write it, and for checking regularly. We may yet be forgiven for boring our wives senseless with World War One arcana. To Martin Brierley, my agent, for the books suggested and for ringing repeatedly for progress reports at 8 am (as he walked to work), look, I've finished, you can stop. To publishers Rebecca Nicolson and Aurea Carpenter, and designers David and Rachael Eldridge, for sharing the vision, thank you. To Geoff Dyer for lending me the Houston Museum of Fine Arts' magnificent study, *War/Photography*, and letting me pick from his long shelf of 1914–18 literature, yes, I will keep practising my pingpong. To Clive Crook, always helpful in his advice on photography and design, I owe you. To Briony Fer and Adrian Forty, for giving me *The Camera As Historian*, and offering guidance on photography and architecture, thank you. To Julian Berger, Chris Hughes, Shaun MacDonagh and Rufus Olins,

for keeping my spirits up, it's appreciated. On the family front, my sisters Diana Tettmar and Caroline Freedman, fellow curators of Fred, allowed me free rein to write as I found – not easy in families, in my experience – so thank you. I must also thank my niece Dr Pippa Farrugia, go-to woman for medical advice, and my nephew Ben Farrugia, who with wife Emily hosted me in Edinburgh – still loving the spare room.

Finally to my wife Vanessa, who left her mother's bedside in Italy to drive me round Armentières, Houplines and Soissons, grazie mille. This really wouldn't have been possible without your love and support. To my daughter Elena, likewise. And here – who knows? – you might find a few pointers to dominant family characteristics.

But really, of course, I should say thank you to Fred, for staying alive, and for making his contribution. Fred, whom I never knew, but who left me some clues.

THEN AND NOW

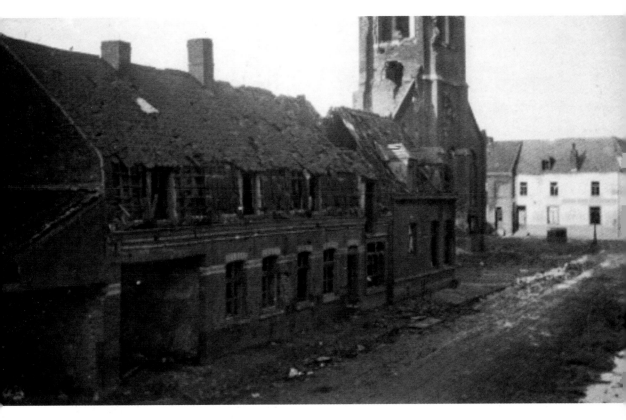

Bois Grenier Church in 1915

In 2013

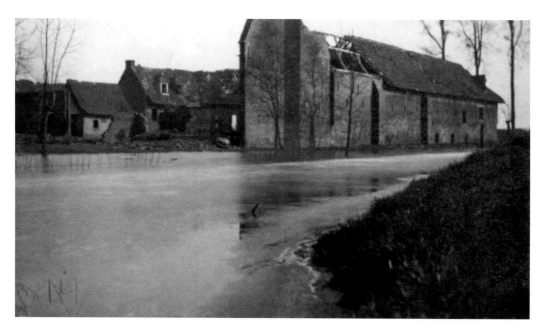

Grand Flamendrie in 1915

In 2013

Water Farm in 1915 and 2013

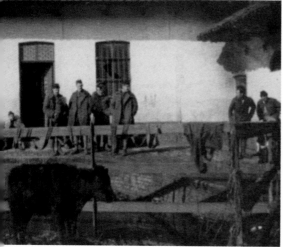

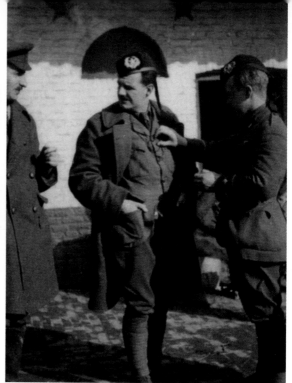

Streaky Bacon Farm in 1915

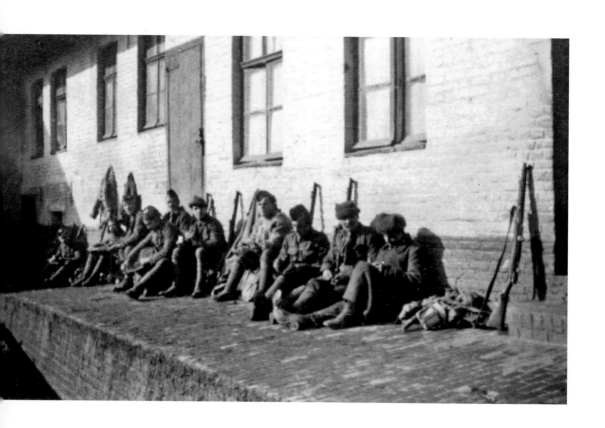

In 2013

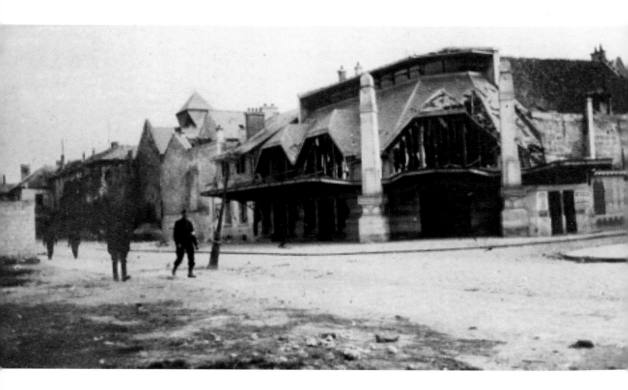

Soissons Market in 1915

In 2013